The Surrealist Voice of Robert Desnos

Mary Ann Caws

The Surrealist Voice of
Robert Desnos

University of Massachusetts Press 1977

Acknowledgements

My thanks to the following journals for permission to reprint, in altered form, articles which first appeared in their pages: "Poems and Surrealist: Becker, Frénaud, and Desnos," *Contemporary Literature* 12, no. 1 (Winter 1971), pp. 181–97. © 1971 by the Regents of the University of Wisconsin; "Techniques of Alienation in the Early Novels of Robert Desnos," *Modern Language Quarterly*, December 1967; "Une Structuration surréaliste," *Le Siècle éclaté: Dada, surréalisme, et avant-gardes* 1, 1974, Lettres Modernes, Paris; "Robert Desnos and the Flasks of Night," *Yale French Studies*, Intoxication issue, Spring 1974.

My gratitude to Michel Fraenkel and Editions Gallimard for permission to reproduce, from Robert Desnos, *Domaine public,* © Gallimard (1953), the original versions of "Un jour qu'il faisait nuit," "Vent nocturne," "Au Mocassin le verbe," "Idéal maîtresse," "A présent," and "Identité des images." And English translations of the following works of Robert Desnos: selections from *Rrose Sélavy,* from *L'Aumonyme,* "Vent nocturne," "A présent," "Idéal maîtresse," "Au Mocassin le verbe," "Coeur en bouche," and "Un jour qu'il faisait nuit" from *Langage cuit,* "O Douleurs de l'amour," "J'ai tant rêvé de toi," "Les espaces du sommeil," "Si tu savais," and "Non l'amour n'est pas mort" from *A La Mystérieuse,* "La Voix de Robert Desnos," "Infinitif," "L'Idée fixe," "Trois étoiles," "Chant du ciel," "De la fleur d'amour et des

chevaux migrateurs," "Avec le coeur du chêne," "Vieille clameur," "Le Suicidé de nuit," "Pour un rêve de jour," "Désespoir du soleil," "Identité des images," "Paroles des rochers," "Jamais d'autre que toi," "En sursaut," and "De la rose de marbre à la rose de fer" from *Les Ténèbres*, selected passages from *Sirène-Anémone*, from *Siramour*, from *The Night of Loveless Nights*, "Apparition," "Fête-Diable," and "Le Boeuf et la rose" from *Les Sans cou*, "Tandis que je demeure," "Tour de la tombe," and "Le Paysage," all from *Domaine public* © Gallimard (1953); selected passages from *Deuil pour deuil suivi de La Liberté ou l'amour!* © Gallimard (1962); "Epitaphe" from *Contrée, suivi de Calixto* © Gallimard (1962); and "Sur l'autre rive" from *Peine perdue*, as well as "La Chambre close" from *Bagatelles*, both in *Destinée arbitraire* © Gallimard (1975). From the Camille Dausse-Paul Eluard collection in the Museum of Modern Art in New York, for permission to publish the manuscript of the fragment of "O Sœurs" and the drawings found with the manuscript of *The Night of Loveless Nights*, as well as the pages taken from the latter, and to refer to the manuscript of *C'est les bottes de sept lieues la phrase "Je me vois."* I should also like to express my appreciation to Michel Fraenkel, to Espinouze, to the Bibliothèque Littéraire Jacques Doucet, and to François Chapon. To Marie-Claire Dumas I owe a special debt of friendship as well as counsel. To Jean Schroeder for her intelligent preparation of the manuscript, to Angela Turnbull for her editorial help, and for their assistance, Joan Dayan and Helen Wehringer, my warm thanks.

I am grateful also to Edouard Morot-Sir and to Malcolm Call, Editor of the University of Massachusetts Press, for their encouragement. And especially, for their helpful and perceptive remarks in various stages of work on this manuscript, to Hanna Charney, Tatiana Greene, Sarah Lawall, Neal Oxenhandler, Michael Riffaterre, and Eric Sellin. For all that and more, to Peter Caws.

Contents

Abbreviations

Specific editions of works by Desnos are denoted in the text by the following abbreviations:

C	*Calixto, suivi de Contrée* (Paris: Gallimard, 1962)
DA	*Destinée arbitraire* (Paris: Gallimard, 1975)
DP	*Domaine public* (Paris: Gallimard, 1953)
DPD, in LA	*La Liberté et l'amour,* reprint, with *Deuil pour Deuil* (Paris: Gallimard, 1962)
LA	*La Liberté ou l'amour!,* 1962 reprint as above
PD	*La Papesse du diable* (Paris: Eric Losfeld, 1966)

Il a levé l'ancre pour toujours. Il
vogue. Son sillage enserre le monde.
Les éléments, les frontières et les
hommes ne peuvent rien contre lui, et
son étrave immatérielle est de celles
qui brisent les récifs les plus aigus.
("Le Cuirassé Potemkine," *Cinéma*)

(He has raised anchor forever. He is at
sail. His wake includes the world.
Elements, limits, and men are power-
less against him, and his immaterial
bowsprit is able to shatter the most
difficult shoals.)

La poésie peut être ceci ou cela.
Elle ne doit pas être forcément ceci ou
cela . . . sauf délirante et lucide.
Réflexions sur la poésie

(Poetry can be this or that. It does not
necessarily have to be this or that . . .
except delirious and lucid.)

1 Introduction: The Poet-Adventurer

The following remarks on Robert Desnos are intended to represent differing approaches—thematic, impressionistic, and image-centered on the one hand, grammatical, analytic, and stylistic on the other—in an attempt to respond to the many-sided nature of the poet, to his singularity and his variousness. The primary emphasis is placed deliberately on certain moments and perspectives of his work from 1922 to 1929, on his cinematic criticism, his two early novels, and his love poems, as on the metaphors guiding and governing the entire period. After 1930, Desnos forsook what I interpret here as the language of poetic adventure for the more traditional forms which had always interested him, and for a more popular vein. The obsessions so appealing in his major works give way to an attitude which might be called humanistic (see the eulogies of Rosa Buchole) or journalistic (see the remarks of André Breton in 1930 after Desnos' separation from the surrealists), but it is in any case entirely different, determining a style of a kind unlike that upon which I concentrate my discussion in these pages. It is essential to make clear that Desnos' work before 1930 is of a sufficient scope for a linguistic and imaginative adventure of genius, structured around such typical surrealist oppositions as dream and reality, nocturnal and diurnal vision, presence and absence, and including poetry, novels, and essays.

Accompanying the remarks are varied translations taken from a wide

range of works, including many of those discussed in these pages. They will be marked in the text by an asterisk after the title within the most extensive analysis of the poem (*), but it should be pointed out here that certain poems recur in the successive analyses, each time from a different perspective. Five of the automatic drawings of Desnos are given and their connection with the poetry pointed out. An unpublished poem is included, or the fragment of a poem, as well as a study of the manuscript of his longest poem, as an illustration of his way of composition *en collage*.

The majority of important texts examined in these pages have as their center the notions of movement, myth, and voyage, the latter as an end in itself. All these notions are intimately connected—whatever their component of dream or of reality—to the parallel concepts of language and of love. The poet who "ventured further than any other," in Breton's words, was also to discover the temptation of silence and, worse, of banality, once the persuasive facility of sleep-writing had been transcended. In the case of Desnos, when the obsessions diminish, the language of poetry weakens:

La marée sera haute, et l'étoile a failli.
(*DP*, p. 218)

(The tide will be high, and the star has faltered.)

Of all the poets of the surrealist period, Desnos shows the greatest involvement in the question of language, the most intense preoccupation with his own poetic voice—thus a constant meta-textual reference which is of special appeal to contemporary poetics. After a discussion of his relation to the surrealist group, this essay treats certain aspects of his criticism, his theoretical work on the cinema, and above all his two novels and his poetry before the year 1929 and his separation from surrealism, comparing this writing to the later writing, which does not seem to participate in the same adventure.

The closest attention is given to his poetry as it moves from representative verbal games and grammatical deformations toward a more complex poetry of love, in which however, the language is as self-reflective as in the earliest poems. A specific analysis is undertaken of the poetry as it evolves from mobility to fixity, from experiments with language to an obsession with silence, and of the early novels as they construct and simultaneously destroy their own myth so brilliantly elaborated in a manner identical with that of Desnos' greatest poems.

In an apparently conscious projection, epic adventure appears always to be juxtaposed with and perhaps even absorbed by the mockery of that adventure. For it is evident that the building up and the tearing down of emotion, the creation and undoing of myth, the development and destruction of adventure, apply also to our reading. Our involvement is increased and then parodied as the poet stresses, and then mocks his own emotions, attacking the pathetic repetitions of love, the sameness of myth, the melodrama of adventure, as well as the conventions of literature.

"Banalité! Banalité!" for we might say of our page, as he does of his own, that it is a desert, or a deserted beach where we might wander in the guise of an explorer or a madman, at the mercy of the wind. Yet we might also maintain that these self-reflections are the highest tribute we can pay to the voice of Robert Desnos, and the most faithful witness to its appeal.

One concern rises immediately upon the first reading of Desnos and the perusal of this poetry. In the period studied here, the work is marked by cadavers, ice floes for the stranding of vessels, and shards of broken bottles. The constructions are as desolate as the geography and the landscape: the deserted corridors of a palace, the bare stretches of a desert, or an endless beach where the figure of a mermaid forsakes the shore forever, or a path where all the foliage is withered. In an obsessed and obsessive universe, amid all the images of desolation, the problem of the reader's attitude poses itself with insistency. It is to some extent true also that the self-mockery often deflects the attention away from the textual situation.

Surrealist poetry allows us, by its own tenets, no safe spot from which to look on; this is a cardinal point of surrealist poetics. But here the case is different from that of reading Breton or Péret or Eluard or Aragon, none of whom force such a frequent awareness of the page as page, of the obsession as obsession. For that reason, Desnos' writing, close to contemporary sensibility in its self-consciousness, finds forms of irony and tragedy sufficiently complicated to retain our interest even after much close reading, even as they occur with a rare predictability. Of course the individual reader's attitude to the larger question of reading, toward the theories of the reader as writer, of the text as center refusing its "author" as subject, and so on, may determine his outlook on Desnos as on any other author. In the reader's place, which an author like Desnos would seem to invade, we may be forced to concur in the

presence and the distance at which Desnos places himself in regard to this text, in the self-reflective or meta-texts where he becomes, and outspokenly, his own reader.

It will be understood that the personality can of necessity be no more than hinted at here, beyond the cursory biography. I have chosen to stress the peculiarities of the text or, looked at in a different perspective, of the voice. The choice was to some extent imposed by the nature of the text itself. Whereas in the case of another poet, the very being of humanity of the living man might involve one—whether willingly or not—in a discussion, evident or implied, of his being beyond his poetry, the opposite has been my experience with Desnos. Between the jovial, hard-drinking, infinitely generous, courageous, and obstinate man whose legend has come down to us,[1] only some of which I try to convey in the biography here, and the images of tragedy which abound in this poetry, devastating its inner reaches, the contrast is extraordinary. Is the legend then irrelevant to the text?

Not entirely: it is at least worth remarking that the works on which I concentrate in these pages—especially the poems of 1926 and 1927—are coeval with Desnos' unrequited love for Yvonne George. Similarly, the evolution of Desnos' writing after the extraordinary poetic novel *La Liberté ou l'amour!* towards a far easier and more "public" kind of verse and the drearily "realistic" and moralizing tone of his later novel, *Le Vin est tiré*, coincides with his departure from surrealism and may be seen to have some relation to his eventual enthusiasm for advertising jingles. His resistance poetry, like that of Eluard and Aragon, is, of course, of a completely different nature from these complex and intro-verted works examined here; but it is easy to trace the gradual develop-ment of a "story" in his longer poems of 1929–30 ("L'Aveugle," "Le Poème à Florence," "Siramour," "Sirène-Anémone"). They already lack the density, the complex self-examination and self-doubting elo-quence of the 1926–27 works as well as the adventuresome linguistic playfulness of the works of 1923–24.

Finally, all the themes and structures I will trace, the fascination with shipwreck underlying even the firmest faith in voyage, lead directly to a discussion of his most tragic poetry at the peak of its epic power. The collections called *A la mystérieuse* (1926) and *Les Ténèbres* (1927) are, in my reading, a commentary on the impossibility of a permanent ad-venture of language, on the inevitability of failure and eventual silence. Desnos' comments on language often represent a deep pessimism: letters fall to the ground unread, songs are lost, and the voice of Robert

Desnos, while it summons worlds and hurricanes, cannot elicit a re-
sponse from the single person about whom the poet cares. More often,
the poet's speaking is seen as separate from the poet's being, so that he
becomes only the spectator or auditor for the poem, removed from it
as we are, and still more critical.

mon propre coeur est seul à me désespérer
(*DA,* p. 104)

(my heart alone makes me despair)

That each text carries within itself its own criticism, its own self-reflec-
tive irony, aggravates the sense of inevitable loneliness, increases the
complexity, and makes of the whole series of works a meta-linguistic
epic of self-alienation. It is in this particular aspect that Desnos is im-
portant to us and appealing to a contemporary sensibility.

In *Les Nouvelles Hébrides* (published in the issue of *Europe* devoted
to Desnos), he says of himself: "Mon ombre alors sur les toits des
hangars, mélangée à celle d'un individu et d'un objet. Quel regret de
ne pouvoir projeter seulement la mienne propre." (My shadow then on
the roofs of hangars, mingled with that of someone else and an object.
How I regret not being able to project only my own.) The goal of this
study is to project, insofar as it is possible, the unique shadow of Desnos,
particularly as seen against the background of a surrealism which, having
been commented upon at great length, has perhaps become too clear
to retain all its mysterious sharpness.

Quelle heure sera-t-il le jour
où ce que j'attends arrivera?
(inscription in Desnos's own
copy of *Deuil pour deuil*)

(What time will it be on the
day when what I am waiting
for happens?)

2 Situation

A Cursory Biography Robert Desnos was born into a bourgeois family of Norman extraction on July 4, 1900;[1] he grew up in the old Saint-Martin quarter of Paris, a quarter haunted by memories of alchemists and magicians; Nicolas Flamel and Gérard de Nerval were his heroes, together with Hugo and Rimbaud.[2] For him, Nerval was an "alchemist of the word, possessor of the philosopher's stone of all poetry." Desnos shared Hugo's attraction to the spectacular, the passionate, and the heroic, and Rimbaud's fascination with solitude, colored by the mythology of adventure and of the adventuring imagination: "My imagination nourished by catastrophies of the sea, I sailed on beautiful ships toward ravishing countries" (*La Révolution surréaliste*, no. 6 [1926], p. 18).

A poor student at the Communal School on the rue des Archives ("talkative, disorganized, disobedient, scatter-brained, negligent, unattentive, deceitful, and lazy") and the Turgot commercial school, he then worked as a drug salesman for a company of wholesale druggists, and translated medical prospectuses for the Darasse Brothers pharmaceutical laboratories from 1917–19. He had made friends with Vitrac, Limbour, Péret, but while they engaged in Dada activities, he did his military service from March 1920 to May 1921 in France, and in Morocco from May 1921 to January 1922 with the Thirtieth Regiment of Algerian

artillery. On leave he met Breton and Tzara, but had no real relations with the future surrealist group except through letters from Péret, until September 1922. Desnos finally became a doctor's secretary before turning to journalism. In 1916, he had begun to transcribe his dreams, to draw, and in 1917 to write his own poetry, usually in a rather unadventurous alexandrine form. Always fascinated with words, with their power of evocation and persuasion (hence his equal interest in the alchemy of language and in journalism), he excelled in the verbal experiments and the writing games played seriously by the surrealists, and in the rapidity of pure automatic writing and speaking, particularly in the era of hypnotic sleeps, where he outdid all the others in "spoken thought," communicating with Marcel Duchamp (some of his word games, illustrated here, are played in the name of Rrose Sélavy, Duchamp's alter ego) as well as Hugo and Robespierre. In his "Manifesto" of 1924, Breton said of Desnos that he was

> of all of us, perhaps the one who came the closest to surrealist truth, the one who . . . in the course of the multiple experiences to which he has lent himself, has fully justified the hope which I once placed in surrealism and who encourages me to expect a great deal of it still. Today Desnos *speaks surrealist* when he chooses to. The prodigious agility he displays in following his thought orally produces all the splendid discourse we could want, all of it lost, Desnos having better things to do than to write them down. He reads in himself like an open book and makes no effort to retain the sheets flying away in the wind of his life.

During the great surrealist period 1924–30, he shared the typical surrealist attitudes toward suicide (playing Russian roulette, for instance), toward collective endeavor (in 1923 he wrote *Comme il fait beau,* a play in collaboration with Péret and Breton), and in particular toward the exaltation of woman. For ten years he devoted his entire admiration to Yvonne George, famous for her renditions of sailors' songs at the Empire and at the Olympia; she was the inspiration for *A la mystérieuse, Les Ténèbres,* and *La Liberté ou l'amour!* When she died in a sanitorium, Youki, who had been the wife of the Japanese painter Foujita[3] before her marriage with Desnos, replaced her as the incarnation of the mythological heroine.

But at the same time the interests of Desnos diverged from those of the surrealists: he worked in "public relations" and, at the invitation of Eugène Merle, became a journalist for such periodicals as *Paris-Soir,*

Paris-Matin, Paris-Journal, Le Soir, and *Aujourd'hui.* Again, as in the period of surrealist sleep-writing, he was known for his spontaneous facility with language, simply telephoning his pieces to be published without changes. In 1928 he visited Havana for meetings of a press congress, and there developed a great interest in Cuban music ("these new songs with a new accent but which, more human than any others, spoke a language familiar to me").[4] From 1927 to 1929, during the period when Breton and the others, having turned from anarchism to communism, were chiefly involved in the effort to reconcile surrealism and political activity, Desnos gradually separated himself from the group:[5] he had come under attack for his "non-involvement" and the strain led to the open break in 1929 and to Desnos' own "Third Surrealist Manifesto," quoted in another section.

From 1932 to 1939, Desnos worked in radio advertising, for Paul Deharme in "Information et Publicité," doing what he called another sort of poetry. In the postface to *Etat de veille* (Waking State), he explained: "I threw myself passionately into the almost mathematical, yet intuitive, work of adapting words to music, of fabricating sentences, proverbs and mottoes for advertising, the primary exigency of this work being a return to the people's taste in the way of rhyme." He adapted poems, novels, plays, popular songs for the radio, convinced of the importance of wide communication. From this period comes little poetry as such, but many productions in a popular vein, such as the *Complainte de Fantomas* (1933), the *Complainte du pirate* (1936), the *Sans cou* (The Neckless), the texts of some documentary films, some songs set to music by Poulenc, Honegger, and a few cantatas, one of which, the *Cantate pour l'inauguration du Musée de l'homme* (1938) was set to the music of Darius Milhaud, and *Les Quatre Eléments.* All these are, as we have noted, of a more public character than the surrealist works studied here: there is no indication of shadows (*Les Ténèbres*) or mystery (*A la mystérieuse*) or of the battle between love and freedom (*La Liberté ou l'amour!*). Rhythms mattered now more than images, and these productions are the result of a desire to combine poetry and music and poetry and mathematics, as Desnos explains in a note to *Fortunes,* the collective title for the poetry of this period.[6]

When war broke out and his work for radio was halted, Desnos returned to his poetry, but it was now of a different bent from that of the years between 1923 and 1927, and far more accessible in content and form, this development already having started in the longer poems of 1929 and 1930, as we explain elsewhere. The poet of the Resistance

was no longer either the poet of surrealism or of an individual love: he was part of the Front Commun, joined in communist and surrealist manifestations, wrote in *Commune* and in *Europe*.

Desnos was conscripted in 1939, sent to the south of France but was back in Paris in the fall. Between 1940 and his departure in 1944 for the series of concentration camps in which he was to spend the last part of his life, his resistance poetry (some of it in slang appeared under the names of Lucien Gallois, Pierre Andier, Valentin Guillois, and Cancale: the title of the 1944 collection, *Etat de veille*), with its emphasis on alertness indicates the mood of the poems. He was demoted by the Nazis to the lowliest tasks at the newspaper *Aujourd'hui*, he joined the group gathered around the journal *Combat* and the resistance group Agir. Just before his deportation, he wrote the light verses of *Trente chantefables et chantefleurs pour les enfants sages (à chanter sur n'importe quel air)*, the "realistic" novel *Le Vin est tiré*, and the graver poems of *Calixto* and *Contrée* (1943), all these in classical verse forms, the former peopled with mythological personages (the nymph Calixto, Alcestes) and the latter, descriptions of town, country, and landscape revolving around questions of heroism, virtue, dreams of the past and the reality of the present. When the Gestapo came to arrest Desnos, who had been denounced by Alain Laubreaux, he was preparing the satirical underground journal *Les Nouveaux Taons*.

He was sent to Fresnes, then to Compiègne (see the poem "Sol de Compiègne," 1944, signed Valentin Guillois), where Youki saw him for the last time as he was being deported. Then he was sent to Auschwitz, to Buchenwald, to Flossenburg, to Floha, and finally to Theresienstadt. The stories which come to us of Desnos' behavior in the camps all indicate his rare thoughtfulness and enormous generosity toward his fellow prisoners and his courage in the face of his captors: sharing his bowl of thin soup with someone who needed it more, insulting a guard who mistreated one of the captives, and who took revenge smashing Desnos' glasses, riposting—to the psychological torture of the German declarations that all the prisoners were soon to die—by telling a cheerful fortune from the hand of each prisoner.[7] Desnos died of typhoid fever on June 8, 1945. Before he died he was recognized by the student Joseph Stuna from his picture in Breton's *Nadja*. His answer to Stuna's question: "Do you know the poet Robert Desnos?" was simply: "Le poète Robert Desnos, c'est moi." The contents of a tin box in which Desnos kept what he was writing during his imprisonment were thrown away

so we have only, for the last part of his life, the legend of that poet, the real indications offered by the traditional poems of *Calixto* and *Contrée,* and the irony of the loss.

Desnos the Surrealist

The situation of Robert Desnos within the surrealist movement must be taken into account before any individual assessment of his works can be undertaken, or any detailed analysis attempted. Even after Breton's attacks on him, even after his supposed formal separation from the movement, which he had "betrayed" by his writing of formal alexandrines, his occasional mockery of the sacreds of surrealism, and, finally, his journalism, Desnos never ceased to call himself a surrealist. He used the term "in its most open sense," as he explains in his own *Troisième manifeste* (Breton wrote prolegomena for a third manifesto, but never the manifesto itself).

The remarkable powers of Desnos in regard to automatic writing were alluded to frequently by the other members of the group, especially Breton, who was generous in his praise. Desnos' talent was first recognized in the era of "hypnotized slumbers": these experiments with sleep-writing were intended to liberate the unconscious and give it free creative rein. In *Une Vague de rêves,*[8] Louis Aragon describes the heady exaltation of this period in which Desnos' particular prowess became evident: "Their slumbers are lengthier and lengthier. . . . They fall asleep just from watching each other sleep, and then they carry on dialogues like persons from a blind and distant world, they quarrel and occasionally you have to snatch the knives out of their hands. Real physical ravages, difficulty on several occasions of pulling them out of a cataleptic sleep where a hint of death seems to pass. . . ."

Aragon describes Desnos' particular talent thus:

> In a café, amid the sound of voices, the bright light, the jostlings, Robert Desnos need only close his eyes, and he talks, and among the steins, the saucers, the whole ocean collapses with its prophetic racket and its vapors decorated with long oriflammes. However little those who interrogate this amazing sleeper incite him, prophecy, the tone of magic, of revelation, of revolution, the tone of the fanatic and the apostle, immediately appear. Under other condi-

tions, Desnos, were he to cling to this delirium, would become the leader of a religion, the founder of a city, the tribune of a people in revolt.[9]

Either through some extraordinary effort of the will or through some even more extraordinary chance, Desnos demonstrated an incredible fertility of imagination, dictating, writing or drawing feverishly, answering questions with a sustained lyric power at first impressive to Breton and the others but finally discouraging to them. As Desnos points out, Breton, who bent for hours over a manuscript, was not likely to accept with good grace this spectacle of facility. Perhaps Desnos exaggerated this dramatic side of the experiments precisely to impress the leader of the group—Breton had on repeated occasions to force Desnos to awaken—but perhaps also it was in the long run exactly this drama and this facility which served to turn Breton against the poet who had been more impressive than the others.

The rift between the two men, far apart in temperament, is apparent as early as 1926–27 and Desnos' expulsion from the surrealist "chapel" in 1929 is hardly surprising. He had already left that chapel of his own volition, declaring its dogma too narrow and too "mystical," its claims to freedom unjustified, and its total rejection of traditional forms too limiting. The separation culminated in a message he sent to a meeting on the rue du Château in March, 1929:[10] "Absolute scorn for all activity, whether it be literary or artistic or anti-literary or anti-artistic, an absolute pessimism concerning social activity." He did not at this point reject any possibility of further collaboration, but he firmly refused what seemed to him too arbitrary a discipline. In the "Second Manifesto," Breton condemned him for not choosing between "marxism and anti-marxism," and Desnos, insisting always on the absolute freedom of the poet, condemned in his turn what he called the obscurantism of Breton.

Claiming that Breton's lofty exaltations of the illogical, and diatribes against the heretical, "paved the road for God," Desnos turned to interests of a sort which seemed to him more genuinely liberating. Breton always considered *journalism* a pejorative term, indicating a concern with the lesser and the trivial at the expense of the essential and the poetic. Desnos, on the other hand, considered the *journalier* or the daily affairs of life including the most trivial, to be the possible matter of the poetic.

A comparison may be made here with Blaise Cendrars' eulogies on the poetics of advertising (in *Modernités*, 1927, the essay called "Pub-

licité = Poésie"). It is, he says, an affirmation of optimism and pleasure, a proof of vigor and art, a triumph of lyricism. Desnos' attitude is similar. Nothing farther from the strict surrealist principles can be imagined, however, and it is not hard to see why, from that point of view, Desnos' comportment was shocking. What was to him openness was to Breton non-revolutionary and therefore non-poetic: it was commercialism.

But it is not in fact the themes of Desnos' work or its subjects which are the most revealing in the context of his separation from the surrealist group. It is true that these become more "realistic," that the images of mermaid and dream which will be studied here make way for other images and for the eventual condemnation of dream and dream-inducing drugs in his late novel Le Vin est tiré.[11] It is true that in many cases these latter images are more expected, more trite. It is true that his resistance poetry is far more simplistic than his surrealist poetry and therefore less interesting to the critic. More germane, however, to the basic split between the surrealist way of seeing and expressing and Desnos' own vision and expression is the problem of traditional and novel style. Desnos, always an experimenter, tried out a variety of styles: he wrote simple verses and much intricate prose poetry, some meditations on the dream adventure, extremely complicated in structure, and then alexandrines, and sonnets in a classical form. One of the main points of Breton's public attack on Desnos in the Second manifeste was the latter's fondness for quoting alexandrines and composing them (see, for example, the pseudo-Rimbaud at the beginning of La Liberté ou l'amour!). In the surrealist code, a liberated or novel form must bear witness to the new vision; more precisely, a traditional form, however brilliant, betrays that vision. But Desnos was not content to experiment in present and future forms, and constantly experimented in the forms of the past as well.

Some of his last poems, in Contrée,[12] are in fact written in sonnet form: we might interpret this as a regression toward fixity, voluntary or involuntary ("Je me sens me roidir avec le paysage" [I feel myself growing rigid with the landscape], he says in one of these). Or again we may see them as a further experiment in openness to all forms, or as a simple statement that any form is as viable as any other to a poet of the modern consciousness. (Desnos always wanted to combine one thing with its opposite: poetry with mathematics and dream with logic, as in the postface to Fortunes; the delirious and the lucid (Réflexions sur la poésie, DP); the mind and the senses (De l'érotisme considéré

dans ses manifestations écrites). These poems might then, in the very fixity of their form and landscape, be a deliberate contrast to an expression of freedom, just as the poems now published with *Contrée* and given a title reminiscent of mythological culture, *Calixto*, might be seen as using the traditional landscape of myth and the traditional alternations of light and dark images for a statement of what seemed to Desnos a "present" reality.

From the point of view of style only, after 1928, a slight increase in verbosity is noticeable, and a slight diminution of emphasis on concise points of focus: however, the configuration of Desnos' universe does not change at this moment. For that reason, 1928 makes a good cutoff point for the stylistic analyses, although I will make extensive thematic reference to works published as late as 1930, and occasional allusions to the rest.

The Landscape of Surrealism

The major adventure of these early years is an inner one, that of dream —also identified with poetry. The predominant landscape is that of darkness. For the possible and always awaited perception of the marvelous which is the stated goal of all the poets who adopted the surrealist attitude, the fixed landmarks of logic and the "normal" or daytime vision must be abandoned. Whether Desnos was or was not in the habit of *simulating* a sleeping condition for his friends ("Dormons, dormons, / Ou faisons semblant de dormir" [*DP*, p. 212], [Let's sleep, let's sleep, / Or let's pretend to sleep]) does not affect the importance to his poetry of his constant evocation of night, which furnishes this poetry with its most striking themes. In these years darkness was always to be preferred over waking: compare with the title "Waking State" the following plea: "Et meure le chant du coq" (*DP*, p. 105) (And let the cock's crow die) and its answering assurance: "Le lit roule jusqu'à l'aube sa bordure d'écume et l'aube ne paraît pas / Ne paraîtra jamais" (*DP*, p. 233). (The bed rolls to the dawn its foam border and dawn does not come / Will never come.) Against this constant background of shadows, the texts of Desnos are profiled in an extraordinary clarity. In spite of the enormous range of formal experimentation he practiced, all his creations of the surrealist period are unmistakable, in their continuity of

tone—melancholy and lyrical, exalted and emphatic—and of motif. Until his open break with the surrealist group, the poetic universe of Desnos is as coherent as that of Mallarmé, the images and figures as constant and as obsessive. Moreover, certain elements constant in Mallarmé are constants also in the poetry of Desnos: shipwreck, chance and fate ("arbitrary destiny," as in the title of the recently published texts of Desnos), the swan and the sign—"cygne / signe"[13]—and a predominantly physical sense of the abstract notions of presence and absence. Five of the seven drawings made by Desnos at the time of *The Night of Loveless Nights,* and used in the present essay as illustrations,[14] are concerned with themes associated specifically with Mallarmé or generally with the symbolist movement: "Leda is present among us," "Encounter of Two Explorers[15] in formal dress with the Mysterious Beast," "In the center of Pointing Fists and Fingers," "Vanity Memory of the Swan," and "The Angel of the Bizarre."

Desnos is not of course the only surrealist to have been fascinated by Mallarmé. As Man Ray reminds us in his autobiography, *Self Portrait* (New York: Atlantic, Little, Brown & Co., 1963), the film *Au Château de Dés* was so called because the château of the Noailles resembled in its cubed form gigantic dice of granite, which immediately set it in the framework of chance. (One of Marcel Janco's more extraordinary Dada paintings is structured about one die.) The typographical form of Breton's poem "Il y aura une fois" (Once upon a time there will be) has much in common with "Un Coup de dés" and so on. But such lines as the "Maints éventails flétris tombent sur les paliers" in *The Night of Loveless Nights* are remarkably close to Mallarmé in tone, in vocabulary ("maints," although Mallarmé would more probably have used the singular: "maint éventail flétri"), and in imagery (not only the fan and its withering, but particularly the fall: "j'ai aimé tout ce qui se résume dans ce mot: 'chute' " [I love everything that is contained in the word "fall," "Plainte d'automne"]).

The images at the center of Desnos' preoccupation during the period of his major poetic creations are contiguous to each other: they can all be seen as depending on the constant metamorphosis of a small number of images and on deliberate ambiguities of language. Thus the frequent figures of the sea horse and the mermaid, the star and the starfish,[16] the anemone and the coral, the voyage, the ship, and the shipwreck, the bottle, the forest and the sea, the night and the shadows always associated with love,[17] form integral parts of the vision of dream and adven-

ture moving across a background of non-prosaic possibility essential for surrealist creation.

This poetic motion may take place in the nighttime dream, as it does in the prose poem *Les Trois Solitaires,* or in the half-dreaming state of fireside contemplation responsible for the magnificent collection of poems called *Les Ténèbres.* Or again, it may take place on the actual page which Desnos makes equivalent to the mind of the poet. The poetic novel *La Liberté ou l'amour!,* discussed at some length later from two different perspectives, is a primary example of the latter voyage, best described in two lines from the manuscript poem "O Sœurs" quoted here in the unpublished documents. The surrealist atmosphere of creation is spoken of as the privileged place of adventure,

> Où la sirène joint l'étoile et le diamant
> Et l'étoile la glace et le diamant la page.

> (Where the mermaid joins the star and the diamond
> And the star joins the ice and the diamond the page.)

And it is this voyage, guided by just these emblems, which marks the unusual nature of Desnos, setting him off sharply against Eluard, Péret, and Breton, as a writer of deliberately chosen limits, endowed (or afflicted) with an extraordinary self-consciousness at once disquieting and brilliant.

After Surrealism

Desnos is a writer's writer, a poet always aware of his being as a poet, prone to a constant self-reflection for which he was much criticized by Breton. The structures of his universe are obsessive ones, the guides to it are few in number and assume mythical proportions in their ritual recurrence and their various transferences and mergings. Expressed in this obsessive pattern and these shiftings of significance, the passionate self-involvement takes on an intensity which, perhaps, could not have lasted. The most intense and intensely obsessed experimenters of surrealist adventure, Desnos and Artaud, exhausted the limits of that adventure more rapidly than others; their final exclusion can be seen, from the other side (as surrealist theory prompts the reader to look always "de l'autre côté") as a *dépassement,* a going beyond. A text in *Calixto* com-

bines the notions of shipwreck, storm, and landscape, stating quite plainly that by experiencing all possible "naufrages," "orages," and "paysages," a man might pass beyond time itself:

> Tel atteignit un paysage
> Au-delà des nuits et des jours

> (Such a man reached a landscape
> Beyond nights and days)
> (C, p. 25)

Shipwrecks are, like storms and nocturnal navigations, the occasional preludes to the discovery of an unbounded landscape. Breton once said that no one could ever plunge headlong into all the paths of the marvelous like Desnos, with such a "romantic taste for shipwreck"; the shipwreck is seen as essential to the voyage, as its obvious end. Desnos seemed to indicate that he had indeed discovered a landscape beyond surrealism, that he had indeed passed through the limits conceived by the others who were his former friends and that he had reached a new kind of freedom. The reader is not at liberty to dispute his own sense of his voyage, but I have already said, from my own individual point of view, that the works of Desnos' surrealist period, before his more public-oriented productions, seem greater; and that the longer poems of the transition period from 1929 to 1932, still centered on the same themes of mermaid and star, on the same images of ocean and bottle, are by their length and occasional unevenness of a greatly inferior density, complexity, and emotional projection than the poems and novels of 1923–28 which occupy us here. As for the late "classic" poems, traditional in form, they lack the vigor characteristic of Desnos at his best, just as the late and "realistic" novel *Le Vin est tiré* lacks the scandalous and lyric spirit and the structural fascination of *La Liberté ou l'amour!* Or compare the resistance poetry, of a deliberate facility, and the childrens' poems or the popular poems, sometimes charming, always of an engaging warmth, with the brilliant early games and the endlessly rich formations of the poems before 1928. I try here to give sufficient examples of all the periods through which Desnos passed, but I try also to make clear my preference and the abundant reasons for it.[18]

But the dualities, attitudes, and desires characteristic of the surrealist temperament and of Desnos' writing in 1926 and 1927 remain in his work after his surrealist period. Even in the last poems he wrote, he expresses a bitter regret at the limiting character of the banal sensibility

we are cursed with: "Par nos cinq sens ligoté / Notre univers rapetisse" (C, p. 47).[19] (Tied down by our five senses / Our universe shrinks.) In the same poem, which has the ironic title "La Moisson" (The Harvest), the poet feels himself obliged now to settle for this domain with boundaries far narrower than those of the dream, a compromise pathetically reiterated in the better-known "Le Paysage" (The Landscape), where the intense, stormy, and fast-moving scenery of surrealism makes way for the calm, ordered, and anonymous scenery of the "ordinary" world. Yet again "Le Paysage" is complemented by the more optimistic later visions of "La Ville" (The Town), where the poet accepts again the partial confusion of dream, refuses the paralysis of total clarity, and demands every day a "new sky."[20]

His own conclusion about himself is never a real conclusion at all, rather an opening. Marked by uncertainty ("peut-être") and self-interrogation, it takes place always on another level from ordinary conclusions. The lament from the early A la mystérieuse, about the passing of love, adventure, and poetry:

> Il n'est plus temps, il n'est plus temps d'aimer
> vous qui passez sur la route[21]
>
> (DP, p. 121)
>
> (There is no longer time, there is no longer time
> to love you passing by on the road)

becomes, in Desnos' last poems, a question at once quiet and anguished:

> Puis-je défendre ma mémoire contre l'oubli?
>
> (C, p. 45)
>
> (Can I defend my memory against oblivion?)

The poet addresses this question to himself, as his assertions are often followed by questions, and by self-doubt:

> Un jour je serai un amant surprenant
> Toutes les femmes m'aimeront
> mais j'ai tellement peur de ne pas comprendre.
>
> (DA, p. 34)
>
> (One day I shall be a surprising lover
> All the women will love me
> but I am so afraid of not understanding.)

This is, doubtless, one of the things we shall remember him by, this reflection on his possible incapacity juxtaposed with the certainty of his own singular being, both composing what we might call the reflexive voice of Robert Desnos.

O vous, garçons de mon âge, cœurs
vibrants de foi et que les vieillards
disent sceptiques, où cacherons-nous
nos paupières brûlées par le jour, où
passerons-nous nos nuits en proie aux
rêves et aux hallucinations?
("Mélancolie du cinéma")

(You my contemporaries, whose hearts
are vibrant from faith, whom the old
men call sceptics, where shall we hide
our eyelids burned by the daylight,
where shall we spend our nights, prey
to dreams and hallucinations?)

3 Film and Possibility

Dream, Poetry, and Action Desnos attaches great importance to the possibilities of the cinema as an expression of the otherwise inexpressible longing for the fusion of vision, movement, and imagination. The cinema could provide in its unlimited suggestion of possibilities the basis for a sustained revolution against fixity, the exact opposite of the formal efforts of "literature" and "art." While Desnos made of his dream / reality meditations the basis for a series of poems focusing on the imagery of darkness and mystery, he also utilized them as sources for a corresponding series of scenarios and film criticisms.

Against the triviality, the false seriousness, and the genuine banality of the "ridiculous" life we lead, as Desnos terms it, the film poses a world of possibility. If those old in spirit no longer dream, if they suffer the sterility of knowing what to expect, the endlessly fertile and youthful imagination of those who know how to dream transports them to the surprising atmosphere—what Desnos calls the "infinite and the eternal," a cinematic composite of the unexpected, the sensual, the baroque, and the uninhibited. Even the cinema hall itself is for him a place of marvelous encounter, ideally suited to the dual spiritual and sensual nature of dream and love. The darkness links the minds of the observers to the actions portrayed and their dreams to each other, opening a physical-spiritual intimacy based on chance. In his poems Desnos laments the

solitude of dreaming, its threat to sentiment, as the dreamer is separated from other beings, even the most passionately loved. But the cinema is a dream shared, a "revenge" of the many upon their daily surroundings. This multidimensional life in unison takes its source in imaginative transformation of reality and in the insistence on mental freedom, both essential ingredients of the surrealist dream.

The man of the cinema is not just a man of letters, an occupation for which Desnos has only scorn. At the very opposite pole from the "mediocre literary satisfaction" which he refuses for himself and for all the authors and creators he respects, stands the idea of poetry, defined by Desnos as the attitude of those who are willing to run risks. Situated at the other pole from poetry, art is for Desnos the spoiler of the most moving experiences, a dedicated opponent of the unconscious in its revolutionary force. No surrealist ever ceased to wish himself the conveyer of the seeds of revolutionary action. Desnos is convinced that only the structure of the film can keep the architecture of the barricades from falling into oblivion. All the reactions to the poetry of cinema are violent, since it is itself a creator of energy, a center of revolutionary fervor. True poets will, he says, imprint violent kisses on the screen, or set fire to it. These liberated beings, immune to the temptations felt by those to whom Desnos concedes only "mediocre souls," "vulgar souls," "bourgeois souls," long for the storm, the unremitting violence of the absolute:

> Born in the forebodings of the tempest, we await it with its procession of clouds of thunder and lightning, and there are many among us—I write on behalf of extreme and virile souls—who give to this future and perhaps imminent cataclysm the name of Revolution. (*Cinéma*, p. 174)

Attila the Hun did more for human evolution than Pasteur, says Desnos. The *impassioned,* those burned pure by their capacity for exceeding the normal limit, are the true heroes of our time.

The heroic cinema must be a vital summons to the living, a witness to the eternal in the temporal, a combination of seeing and hearing, of suggestion, perception, intensification, and exaltation—humor and tragedy carried to their extremes. Above all, it has nothing to do with talent or work, with the patience of description or the elegance of wit—and everything to do with the genius of spontaneous decision, the profound impoliteness of passion.

Extremes and Anguish

According to Desnos, only the man of tepid wishes, the mediocre being whose stability depends on the classic notion of measure or of a middle ground between two extremes, can find himself at ease in our universe. The "hero of profound desire," the champion of revolution and of unrest, is prey to a constant torment which ennobles him and all he touches. Desnos returns again and again to expressions of this almost romantic notion of torment in its varied manifestations: everywhere he sees and approves a human dissatisfaction matched only by the mobile constellations he associates with the changing scenery of dream. From the static outlook he deems constant in traditional fiction, the ideal of a life willingly consecrated to anxiety and frenzy might appear misdirected. Yet this chosen unrest exerts its powerful disturbing force on all the tranquil representations of order, undermining them by a black humor perfectly suited to the landscape of shadows which surrounds Desnos' most characteristic poetry of the period we are studying. Thus his varied interests fit one with the other, the shadows of dream and those in the darkened movie hall.

For Desnos as for Breton in his *Anthologie de l'humour noir*, humor at its most profound, its most violent, and its darkest—*metaphysical humor*, as he calls it—is allied with an eternal tragic sense. The unsmiling face of the early Buster Keaton (then called "Malec") and the frenetic pace of the Marx brothers are perfect representations of that humor, which he takes as the basis for a revolution in sensitivity. Since the humorous and the tragic are at opposite poles, their transformation each into the other is supposed to generate a dynamism parallel to the choice or the finding of the surrealist image whose elements are taken from two opposite fields in order to create an extensive shock. Pushed several steps further, this contorting of perception from the stable to the exaggerated provokes a chronic state of uncertainty or even anguish, resembling the reaction of the sensitive mind to the construction and deconstruction of myth in Desnos' narrative works.

Many of the strongest passages in Desnos' work are those in which this form of the tragic is apparent—the unmoving ennui in *La Liberté ou l'amour!*, closely akin to the haunted canvases of de Chirico, the solitary anguish of the lonely dreamer in *A la mystérieuse* and *Les Ténèbres*, the exceptional disquiet of the individual and of the city in the later works *Le Vin est tiré* and *Contrée*.[1] Tragedy is consistently pictured by the poet as the extreme height of sentiment, answering the savage

Robert Desnos

requirements of our imaginations. In a piece for *Le Soir* (May 7, 1927), to which Desnos gives the title "Mélancolie du cinéma," he insists that we have gone beyond any belief in the materialistic picturesque, that we can only respond to the marvelous or surrealist torment of our age. The only mysteries capable of stimulating the tragic sensibility are those of "the night, the day, the stars, and love." These provide the focus for his own most successful poems, those included in *A la mystérieuse* and *Les Ténèbres,* where the dreamer's anguish turns about the relations of love and dream, stars and sun, presence and absence, central images in the backdrop of surrealist unrest and in Desnos' own personal torment. "Give us films on the level of our torments! . . . Our world is too petty for our dreams to be the brother of reality, we must have heroic years" (*Cinéma,* p. 175). The picturing and the arousing of this heroic unrest is Desnos' definition of the cinematic, an expression of surrealist *inquiétude* on the grand scale.

"We must have . . . we must have": in keeping with his admiration of the extreme, Desnos always speaks, as do the other surrealists, in the tone of the absolute, never in that of the "normal" or neutral. "And I say loudly . . .": his language itself is, in its sometimes irritating exaggerations, the mark of what he calls an "extreme and virile soul." The sense of pathos which he identifies with the poetic is never to be confused wtih weakness. The essay "Mélancolie du cinéma" underlines the uselessness of our lives, all the despair apparent in "these acts: closing a door, opening another, speaking, seeming to speak. The doors which we are opening open on trivial landscapes, and close on other trivial landscapes. Our lyric hearts are absent from most of our conversations (*Cinéma,* p. 175)."

But in fact, even in the distant marvelous visible on the screen, Desnos is fully conscious of the everlasting sameness of the eternal as it oddly parallels the melancholy of reality. Thus the "Mélancolie du cinéma" which ends with its own beginning lines, "Voici bientôt l'été," escapes from the prison of the circular only by the addition of a rhetorical question, which itself implies once more this very paradoxical monotony of the marvelous:

> The summer is almost here. The trees of Paris are green, as we would have liked them to be this winter. But already we perceive the premature burnings of the August sun, the autumn fall of leaves, the naked branches of December.
>
> Will the man writing these lines long delay in answering the call

of the eternal greenery of faraway forests, the touching monotony of eternal snows? (*Cinéma*, p. 176)

Scenarios

Four of Desnos' scenarios were published during his lifetime, and eleven brief sketches and synopses were found in his papers. Two of the longer published scenarios, "Minuit à quatorze heures" of 1925 and "Les Récifs de l'amour" of 1930, are interesting in their relation to the critical essays, to that of the poetry of the same period, and, although in a less instantly obvious fashion, to that of his personal evolution in attitude during those five years.[2] Although they were not realized as films, the range of possibilities they offer is great.

Both scenarios begin and end with a sweeping view of the countryside, as if to stress openness, in preference to the claustrophobic atmosphere of domestic realism. In both, the initiator of the action is a woman, ambiguously drawn, who is the central interest of two men; and in both, the action itself is suggested rather than described. But in the apparently slight contrast between the two, a definite change is visible.

In the first scenario, the woman is visited by a young man with whom she exchanges kisses in her lover's absence. While she takes a walk with the visitor, the lover drowns in a lake: the circles formed in the water as he disappears return in other guises progressively more menacing to the new couple. The force of the scenario lies in the obsessive quality of these circular objects and in the suggestion of crime, remorse, and punishment which they assume before our eyes, for the vision of the spectator is identical with that of the couple, as the circle of the fishing pole's cork is repeated in the sun, the pupil of the woman's eye, the doorknob which will turn to let in a giant ball less ridiculous than threatening. In their separate dreams, the man sees the Great Wheel, and she, with a more detailed vision, sees a series of hoops, the circular host at a mass celebrated by a haloed priest, outside of which a beggar pours from his hat a torrent of coins. After this dream, the form of the coins, the halo, and the host is echoed "in reality" by the eye's pupil in closeup, by the shape of tennis and croquet balls, anything but reassuring, since they prefigure the final scene where the giant ball, already having forced entry into the house on various occasions, entirely swallows up the house and its contents, leaving a giant hollow. As the

accumulated horror of these round objects fuses into a recurring obsession, this obsession inevitably becomes ours. This most visually detailed of all the scenarios succeeds in effectively suppressing the distance between the spectator and the spectacle in a psychological as well as in an aesthetic sense.

The scenario published in 1930, while still indicative of Desnos' concern with suggestion and intense emotion, moves toward a more traditional vision, parallel with his own move away from strictly surrealist concerns. Here again, the woman betrays the hero but now there is no mysterious force in evidence, no obsessive remorse, and only a single hint of any interest in the visual translation of psychological state into form—that is, the opening and concluding scenes of the anguished hero carving the initial "I" on the tree trunks of the forest where he wanders. On the request of her present lover, the woman Irene is first seen throwing the hero's picture into the fire, thus immediately proving herself unworthy of his love. (The instant and obvious reading by the spectator of the scene—fickle woman betraying love—is indicative of Desnos' growing acceptance of the cliché vision and the cliché interpretation, as is the obvious presentation of the hero as *hero*.) The ensuing flashback does not suggest, it rather explains how the characters came together in a series of melodramas: robbery, murder, duels, a suicide by drowning. Although the latter episode may recall the drowning of the first scenario, the voluntary choice leaves no room here for the suggestion of a fatal force. A brief epilogue shows the "hero" far away trading in diamonds, while Irene wears them, a too-easily marked contrast of effort and luxury, and ends again with the trees engraved with the initial "I" as the night falls.

There is nothing of the marvelous here, and little mystery, although Desnos calls this initial "the mysterious I." Carving initials on trees immediately indicates some sort of love, temporary or permanent, and not knowing to whom the initial belongs simply implies ignorance; it does not confer a mysterious atmosphere.[3] Irene's gestures elicit an equally ordinary reaction: women as notoriously unfaithful creatures, unworthy of the passion they inspire, and so on. Night falling at the end of the introduction and at the end of the film seems in this context a mere echo of the former invocation of the shadows, as the now accepted atmosphere of melancholy and mystery. (It is of course exactly on this point that the distinction between works of original inspiration and those of derivative, merely fashionable, and knowingly or unwittingly traditional ambiance must be made, and it is a difficult point.)

The first scenario, "Minuit à quatorze heures," is instantly apparent as a successful development of the cinematic possibility of obsessed imagination and obsessive form; whereas, "Les Récifs de l'amour," in spite of the allusion in the title to the love / voyage theme of Desnos' second novel *La Liberté ou l'amour!,* takes its energy more from melo-dramatic action or passion and traditional plot interest than from the typically surrealist elements of suggestion and obsession. Their compari-son should serve as an illustration of the difference between a surrealist film of the first order and a second-order replica.[4]

Compared to other surrealist films, such as the well-known *Chien andalou* (An Andalusian Dog) of Dali and Buñuel or their *Age d'or* (The Golden Age), the scenarios of Desnos are sheer romanticism. No eye-balls sliced open by a razor blade as the moon passes, no hand crawl-ing with ants, no barren rocks covered with skeletons holding mitres and wearing cardinals' hats. *L'Etoile de mer* (The Starfish), made by Man Ray in 1928 from Desnos' "antipoem" called *La Place de l'étoile* (1927), connects the images as if in a dream, street to room, starfish to star: it is similar to Desnos' poetry in its obsessive themes and repetitions of images. Where the films of Buñuel and Dali can be seen as paranoiac-hysterical, or as brittle at the very least, the scenarios of Desnos indicate transitions, lyrical flow, and some sentimental depth.

All the better-known scenarios of later date lack the unique tone of Desnos the poet, melancholy and mocking, obsessed and aware of his own obsessions. However, some of the scenarios and synopses found in his papers are far more interesting to the reader of the early Desnos. Along with the considerations on the cinematic possibilities of industry (robots as images of the "man-tamed matter"), on the idea of the opera-film (for which he had in mind such themes as the Novels of the Round Table),[5] on science fiction (for example, time flowing backwards so that parts of downed airplanes take flight again and chickens go from the plate to the oven to the courtyard) there are projects for two scenarios which are in their preoccupations, their tone, and their im-agery immediately distinguishable as his work. "Une Etoile filante" was to be the simple story of three young people making wishes on a falling star, a girl wishing "to be loved forever," a young man wishing "to love, to love forever," and a second girl wishing "never to love." Although the young man marries the second girl, he gradually falls in love with the first, and finally makes the choice of saving her, instead of his wife, from a fire whose unexplained origin has a suggestion of fatality. The rights of desire are acknowledged, the separate wishes crystallize into

one under the influence of the recurring image of fatality, and the marvelous is seen at last within the natural context of passing time. Whatever the date of this scenario, the tone is unmistakably that of the early Desnos: "Above the smoking ruins a falling star will arouse their last wish: 'To love one another.' Surrounding the scene there should be a village, the work going on in the field, the succession of seasons, the aging of the world." Desnos is clearly concerned with the endings of his scenarios, as with those of his poems, where there is often, as here, a spatial or temporal opening-out; one might expect that of a poet fascinated with the notion of voyage. In another scenario recently found, the poet's song is that of the heroic departure:

"Namouna (scenario in the manner of Alfred de Musset with the author's authorization)" associates love with ships, the night, the sea, and song. The surrealist Desnos is above all the poet of the mysterious star and of the ill-fated voyage, both more appropriate to the visionary than to the visual; the fact that these last two scenarios were neither published nor even completed during the poet's lifetime fits that image and that theme. Within them is a necessarily incomplete response, at a great distance, to his laments on his own verbal incapacity, and to the remarkable poems of *Les Ténèbres, A la mystérieuse,* and "Sirène-Anémone." Image answers image in spite of the changes in the poet's attitude. His own farewell to surrealism, as he pointed out, was never a complete one.

In 1975, two previously unpublished documents appeared (in *Création,* Vol. viii), a scenario called *La Part des Lionnes* and a sketch called *La Part de la Lionne,* dating in all probability from 1928. In its form, the latter work offers, as M.-C. Dumas describes it, an interesting "counterpoint," with its private diary doubling its impersonally depicted adventure. Both documents abound in paradigmatic images: a de Chirico setting, a disembodied hand, a woman's glove, glances exchanged from one taxi to another, dead pearls, and diamonds consumed—the very stuff of surrealist poetry.

Le but? Mais c'est le vent même, la tempête et quel que soit le paysage qu'ils bouleversent, ne sont-ils intangibles et logiques?

Ce sont les hommes qui sont imbéciles, ayant basé les voiles des navires sur le même principe que la tornade, de trouver le naufrage moins logique que la navigation.

(*La Liberté ou l'amour!*)

(The goal? But it is the wind itself, the tempest and whatever the countryside that they upset, are they not intangible and logical?

Men are idiots, having based the sails of ships on the same principle as the tornado, to find shipwreck less logical than navigation.)

4 Direction, Distance, and Myth in the Early Novels

For Desnos, the novel or the poem is often seen as a voyage, in whose adventure the reader is occasionally a companion, to which he is often a hindrance, in which he can sometimes become involved if he chooses and if the author permits, but from which he is likely to be abruptly alienated. Like René Crevel, Desnos takes more often the latter position —the adventure goes on without us, in a location many of whose most important details we are not privileged to see. They can only be surmised. Ironically, it is when Desnos judges his own work to be a shipwreck rather than a success, sees his words as confined to cemeteries and to the desert of the page rather than as guides to the open sea, that the reader feels closer to a participation in the text. For he has shared the poet's obsessions, appreciating their gradual transformation into a persuasive myth, playing an essential role as the witness to the power of his word, which is constantly challenged by Desnos himself. This all too appropriate irony Desnos would have greatly appreciated.

Ship and Desert: *La Liberté ou l'amour!*

All surrealist thought is based on the assumption of an absolute mental freedom or *disponibilité:* the exaltation of the possible is forever in-

separable from the marvelous. The present era of mobility, openness, and metamorphosis is seen as succeeding the past epochs of fixed outlines and the stasis of categories. All the key images or the central myths (the latter word taken here and elsewhere in this study in the positive sense, as a source of creative energy) create about them an atmosphere of change and interchangeability.

Desnos' famous novel of 1927, *La Liberté ou l'amour!*, is above all a lyric invocation of movement, of the possible range of the adventuring spirit, and an examination of its limits. In the brief space of the book the action is governed neither by chronological nor spatial laws: the scene shifts from an unidentified desert to the Place de la Concorde, back to the desert, to an English boarding school, to the beach at Nice. The main characters, Corsair Sanglot[1] and Louise Lame (and her double, the mermaid), in their unending wanderings from one place to another constantly encounter, or just miss encountering, an assortment of others; as it was pointed out earlier, personal encounters replace plot, being the human equivalents of the image in its marvelous juxtapositions. Paragraphs and even sentences start with one situation and end with, or remain suspended in, a completely different situation. The entire text is full of the agents, the memory, or the means of motion, such as railroad tracks still hot from the passing of a recent train, the smoke of a moving locomotive, the sirocco in the desert or the wind over the city, elevators and buses; the countless ships, boats, steamers, yachts, and galleys, are the privileged vessels of adventure. To which the author's own pen must be added, as a winged instrument of poetic risk: "Ma plume est une aile et sans cesse, soutenu par elle et pour son ombre projetée sur le papier, chaque mot se précipite vers la catastrophe ou vers l'apothéose" (*LA*, p. 47). (My pen is a wing and every word, borne by it and by its shadow on the paper, rushes either toward catastrophe or apotheosis.) Rapidity is the determining characteristic of surrealist writing in its automatic phase, a means of releasing the mind from its inhibitions. (It is interesting to note, in this connection, that Breton established a table of speeds at which the automatic texts of *Les Champs magnétiques* were written.)

For the ordinary or prudent people who care about the crops they can raise in their enclosed and protected fields, who have no knowledge of the wind's existence or of the exalted climate of dangers, as Desnos phrases it, he has nothing but scorn. His angriest outcries are directed against the persons, real or fictitious, who might prevent the free adventuring of the hero-poet. "Si j'avais été l'un des rois, ô Jésus,

tu serais mort au berceau, étranglé, pour avoir interrompu si tôt mon voyage magnifique et brisé ma liberté . . ." (LA, p. 22). (If I had been one of the kings, you would have been strangled in your cradle, Jesus, for having interrupted my glorious voyage so soon, and for having destroyed my freedom. . . .) When Louise Lame shouts repeatedly at Corsair Sanglot that he must not leave, he shoves her aside and rushes down the stairs as she sinks to the floor, disheveled and sobbing. For the adventuring hero who is always the center of Desnos' films, novels, and poems, the idea of friendship holds the same dangers as that of love, both being fatal traps ("pièges à loup") to be avoided at the cost of any suffering, his own or that of others. Hence the ambiguous title of the book, where we may read "Liberty or Love!" either as a demand for both at once, if they are seen identical, or for one above the other, if they are seen as opposed. In fact, the entire novel turns upon this very ambiguity.

More surprising, but characteristic of Desnos' extreme dualism of attitude, even the notion of adventure itself is taken as a possible hindrance to the peculiar exaltation of the Corsair's enthusiasm, or more precisely, his reverse enthusiasm ("enthousiasme à rebours"). "Depuis qu'il avait compris et accepté la monotonie de l'Eternité, il avançait droit comme un bâton à travers les aventures, lianes glissantes, qui ne l'arrêtaient pas dans sa marche" (LA, p. 87). (Once having understood and accepted the monotony of Eternity, he pursued his unswerving path through all the adventures, slippery vines which did not halt his advance.) This paradoxical rejection of temporal adventures and metamorphosis for the dull freedom of eternity, as unexciting as anything else in Desnos' terms, can be seen as parallel to the author's rejection of realistic or colorful scenery for his narration, in favor of the open spaces of desert or ocean; both are refusals to narrow the field of the action, even if the result is often an abstract background. The combination of rapid transformation and transmutation with various techniques of repetition give to the novel the hypnotic power of plainsong as well as a certain cinematographic interest, easily the equal of that provided by the scenarios.

From the opening poem through the last pages of the novel, the image of an ebony ship recurs again and again, as the promise of unrestricted adventure and as the reminder of risk. Like Breton's wish that the crow would replace the dove in Noah's ark, like the replacement of humor by black humor in the surrealist universe, the darkness of the

ship's wood is one of the true images of surrealist hope, balanced only by the clarity of the other vessel which is the bottle or its crystal fragments (the instrument through which the poetic mass is celebrated, the "Dive bouteille" of Desnos).[2]

"Navire en bois d'ébène parti pour le pôle Nord . . ." (Ebony ship under way for the North Pole . . .): beyond the typical contrasts such as the ebony darkness and the icy glare of the North Pole, this phrase reveals an element of the voyage perhaps unexpected in the light of the emphasis on *disponibilité* or mental liberty. The ship set out with a definite destination, whereas one might more easily imagine complete freedom in the image of an undetermined movement, without a specific goal. But it is clear that for Desnos, a vivid sense of the concrete and the particular is an indispensable ingredient of the marvelous, commanding both his lyricism and his parodies of lyricism. The idea of order or direction, far from being irreconcilable with a notion of liberty, is essential to it.[3] The ship, which does not drift about aimlessly in the sea, is considered here the positive image of freedom, later to be called in question by the figures of mermaids and the theme of shipwreck.

And the pirate hero of the book is in no way a man of disorder, although at times he wanders lost. In a visit to an asylum for the insane, a passage set in the classic framework of heroic pilgrimage, lesson, and departure, he is taught the guiding role that the senses are supposed to play. To be deprived of "sens" is to be at once without feeling, without one's natural senses, and without direction. (Here it is interesting to note that Desnos intended to give the title "Sens" to a collection of poems he was putting together at the end of his life: see the note of Marie-Claire Dumas in the Desnos issue of *Europe* [May–June 1972], p. 220.) Again the idea of freedom is seen as antithetical to the abstract wandering of the unattached hero: "Stupide évocation de la vie libre des déserts. Qu'ils soient de glace ou de porphyre, sur le navire ou dans le wagon, perdus dans la foule ou dans l'espace, cette sentimentale image du désordre universel ne me touche pas" (*LA,* p. 49). (Stupid evocation of the free desert life. Whether the deserts be made of ice or of porphyry, located on the ship or in the train, lost in the crowd or in space, this sentimental image of disorder does not move me.) That the Corsair should spend a night in one of the cells, watched over by an ebony angel whose color is also that of the ship, may not seem to befit his character, but the scene creates nevertheless a scenic parallel to the personality of his figurative double, the madman pictured here in a

straitjacket. The freedom of this two-sensed "senselessness" (exactly that which Breton extols, but finally refuses in *Nadja*) is a useless freedom for the surrealist hero, who leaves at dawn, determined never to be imprisoned in ordinary traps or domestic settings, in prosaic or normal temporal limits. Here, as often in reading Desnos, we think of Mallarmé, specifically of the poem "Brise marine" with its refusal of the calm lamp on the domestic table in favor of the "songs of sailors." (Yvonne George's singing of exactly those songs at the Olympia lends to the thought a special appeal.) Mallarmé's white page, in its paralyzing purity, seems itself to be the double of this disordered desert which is also a page. As Mallarmé's page is also a frozen winter lake imprisoning the swan whose potential traces, like his wings, are captive, so Desnos' desert, to which he compares the page of his own writing, is also itself the ice floes imprisoning the ship—*La Liberté ou l'amour!* The galley slave of love is doomed to have his servitude fixed or immortalized on the page as in the ice, thus making at least a verbal mockery of his potential freedom. The question of similarity and distance between Gide's "disponibilité" and the ideal liberty of "l'amour fou" or surrealist love is worth debating.

The surrealist hero grapples with these dualities in an epic scene: "L'éternité voilà le théâtre somptueux où la liberté et l'amour se heurtent pour ma possession. . . . Je ne saurais choisir, sinon que demeurer ici sous la coupole translucide de l'éternité" (*LA*, p. 62). (Eternity is the sumptuous theater where liberty and love struggle each to possess me. . . . I could never make any choice except that of remaining here under the translucent cupola of eternity.)

Eternity, seen as the tedium of the infinite, is the marvelous monotonous backdrop glimpsed or invisible behind the rapidly changing surface of the adventure. The sun is immobile, and a desperate and eternal cleanliness surrounds the action. At times, such movement as there is has not the slightest implication of vigor or nobility: in one of the city landscapes of ennui, the only being is "un personnage minuscule qui circulait sans but défini" (*LA*, p. 88) (a minuscule person who moved about aimlessly), with exactly the "senselessness" Corsair Sanglot refused. Corsair Sanglot himself, as the embodiment of dualities, has the proportions of myth, an impassioned and immoderate love of action both physical and imaginary. The heroic qualities of his person and his adventures are seen in their true perspective in the realm of the mental. Even when lost, he is "plus perdu dans sa vaste intuition des événements éternels que dans l'étendue sablonneuse de la plaine

équatoriale" (*LA,* pp. 100–101) (lost more in his own vast intuition of eternal events than in the sandy reaches of the equatorial plain). The surface phenomena seem far less real than the events taking place in spite of them: the hero and the heroine converse inside themselves, they meet each other's gaze in spite of all the apparently restrictive screens of "obstacles, maisons, monuments, arbres" (obstacles, houses, monuments, trees).

Within the constantly alternating patterns of balance and opposition to be traced in all the great surrealist prose poems, the movement of metamorphosis and journey is contradicted by a cessation of motion at once terrifying and desired. The free motion of the ship may represent the ideal form of directed openness, but the arresting of the ship's movement is a corresponding form of imprisonment. All the voyage offers in variety and epic connotation is threatened at the moment when the ebony ship is stopped in a negative landscape of absence:

> Navire en bois d'ébène parti pour le pôle Nord voici que la mort se présente sous la forme d'une baie circulaire et glaciale, sans pingouins, sans phoques, sans ours. Je sais quelle est l'agonie d'un navire pris dans la banquise. . . . (*LA,* p. 49)

> (Ebony boat underway for the North Pole, death now presents itself in the guise of a circular and frozen bay, without penguins, without seals, without bears. I know the agony of a ship caught in the ice floes. . . .)

Closely linked to the image of the ship is that of love, already seen as a trap, but here identified with a more noble if equally imprisoning set of ideas: "Tu n'es pas la passante, mais celle qui demeure, la notion d'éternité est liée à mon amour pour toi. . . . Je me perds dans ta pensée plus sûrement que dans un désert. . . . Tu n'es pas la passante, mais la perpétuelle amante et que tu le veuilles ou non" (*LA,* p. 114). (You are not the one who passes, but the one who remains. The idea of eternity is linked to my love for you. . . . I lose myself in your thought more surely than in a desert. . . . You are not the passerby, but the perpetual lover, whether you wish to be or not.) The real setting of this novel is the mind, and it is only in this setting that the hope of love someday reconciled with liberty can be realized, in spite of, or, from the surrealist viewpoint, because of its contradictions. Speaking of the slave galley where he will be a willing prisoner, Desnos perfectly exemplifies the

constant ambiguity of perception on which its abnormal exaltation depends: "Qu'elle soit bénie, cette galère! . . . qu'elle sera luxueuse la chaîne qui nous unira! qu'elle sera libre, cette galère!" (LA, p. 46) (Blessed be that galley ship! . . . what a luxurious chain will link us! how liberating that ship will seem!)[4]

Techniques of Novelistic Alienation

It is in his lyric novels that Desnos writes his most characteristic and involved prose poetry: the narrative often seems secondary to the style, for which it serves as a mere prop. The details of structure within Deuil pour deuil and La Liberté ou l'amour! such as the repetitive or litanic form, the play of dualities, and the extended catalogue, are simple in appearance and vastly complicated in inner variations. To consider only one example: in the ninth chapter of La Liberté ou l'amour!, three paragraphs begin with the line "Perdu dans le désert, l'explorateur casqué de blanc." Three poetic modulations follow, the last of which is the most tragic:

> Perdu dans un désert de houille et d'anthracite, un explorateur
> vêtu de blanc . . .
> Perdu entre les segments d'un horizon féroce, l'explorateur casqué
> de blanc . . .
> Dans le désert, perdu, irrémédiablement perdu, l'explorateur
> casqué de blanc . . .[5]
> (LA, pp. 97–98)

> (Lost in a desert of coal and anthracite, an explorer dressed
> in white . . .
> Lost between segments of a ferocious horizon, the white-helmeted
> explorer . . .
> In the desert, lost, irremediably lost, the white-helmeted
> explorer. . . .)

The echoing color white of this line with its nasal resonance, "blanc," is made to contrast exactly with the blackboard of an auditorium in ruins, with the anthracite desert, and with the less material "esprit noir des circonstances" (LA, p. 96) and the love of night (LA, p. 98). This contrasting device depends on the all-important concept of duality, on

the aesthetic of two violently opposed and mutually illuminating contraries; it is in large part responsible for the peculiar and tragic atmosphere of the majority of Desnos' own poems.

Of course *Deuil pour deuil* and *La Liberté ou l'amour!* are also written in the form of novels, a form they undermine by the easy predominance of their images and their odd lyricism over any pretence at plot. All question about occurrences or development of situation or psychological characterization would be as pointless as a demand to know what happens next after the encounter between the sewing machine and the umbrella on Lautréamont's dissection table. The essential value of the perception is grasped instantly or not at all. Surrealism always emphasizes the moment in its constant novelty rather than traditional continuities and temporal developments. "Toujours pour la première fois" (Always for the first time), said Breton. Differing perceptions are linked to each other by the strength of a connecting wire, or a *fil conducteur,* as are distant elements of experience or imagination, but again these links do not imply any organic, logical, or chronological enchaining. Metamorphosis takes place chiefly within the observer's eye, and it is always rapid. Since instantaneous observation replaces structured unfolding, usually only the most formal architectural framework of the sentence or the poem holds the perceptions together. (It has been remarked that the "normal" linguistic patterns of surrealist prose or poetry are often radically opposed to surrealism's "freed" content or vision. We shall see that this is usually not the case with Desnos, who deliberately contradicts syntactical as well as semantic norms.)

As for the essential scenery and figuration in the Desnos novels, which are in reality long narrative poems in prose, the meetings or associations between a light blue jacket, a skeleton, and a blonde virgin, or between a white-helmeted explorer, a pirate, and a woman clothed only in a leopard-skin coat are signs of the marvelous, encounters whose importance will be magnified by all the resources of surrealist genius until they assume the proportions of myth. The background of deserted and sunny squares pervaded by ennui remind us not only of the early de Chirico, but also of Breton's meditation on ennui in "Poisson soluble" and of his "mysterious road where fear lurks at every step"; the evocation of human loneliness by the presence of ruins and deserts, of hotel rooms and vast expanses of sea, is a successful surrealist and post-symbolist technique. Furthermore, the transformation of coffee into tea, of wine first into a dove and then into a crown, and of the

wineglass into an hourglass and finally into a glass eye can be taken as perfect illustrations of Breton's remarks on openness and fusion.

Desnos' novels are linked to those of the other surrealists by a whole range of similarities, including imagery, scenery, and general statement. To take only one example, both in *La Liberté ou l'amour!* and in Louis Aragon's *Le Paysan de Paris,* there are to be found, in juxtaposition, extensive catalogues of varieties of sponges on the one hand and of city streets on the other, two objects which one might see as complementary, the former absorbing and the latter offering for exhibition. Compare, in this light, the passage in Desnos' novel which describes Bébé Cadum and the bath (soap and sponge) and that in Aragon's describing the barbershop (lather, soap, and sponge); or the description of the place de la Concorde in the former, and that of the passage de l'Opéra in the latter. So much for the apparently trivial: both novels make, specifically and by their entire implication, the point that ideas can be concrete only, never abstract, which in itself explains the intense interest of specific images and scenes. In both, the latter are far more striking than the hero's wanderings which serve as their pretext. One might make a case for each as a latter-day picaresque novel, with Paris as the overall scene for the peregrinations, whose stopping points are each the source of a lyric construction.

But Desnos always makes a point of denying any element of the marvelous to be found within writing itself. He repeatedly asserts the value of life against the sterility of the word, far more frequently than the other surrealists: many aspects of his style can be seen as directly related to that attitude. The encounters, that take place on the page— all the supposed witnesses to a marvelous chance, to an intimate link between outer circumstances and inner desire—are vain ones for him. The surrealist hope of a writing so efficacious that the paper will reflect, like a mirror, all the poet's perceptions is illusory (*LA,* p. 58). Each mention of the marvelous is subsequently mocked; juxtaposed with his celebrated creed—"Je crois encore au merveilleux en amour, je crois à la réalité des rêves" (*LA,* p. 45) (I still believe in the marvelous when it concerns love, I believe in the reality of dreams)—is an ironic paragraph, beginning "Banalité! Banalité!", where Desnos pokes fun at the "sensual" style and the flowing prose in which writers usually, he says, speak of love, and commands his own style to be absurd, insufficient, and paltry, in a deliberate contrast to the vivacity of the action. His novels are marked by his tragic perception of the separation between the poet's voice or his letter on the one hand and the surrealities of

life or love on the other: it is just these stylistic witnesses to his vision which gives to the novels their peculiarly poetic finality.

The structure of the novels is a structure of assertion and denial, both linguistic and thematic, of which there are several striking forms. For example, the irrelevance of focus in an entire passage indicated only at its conclusion:

> Forêts traversées à coups de couteau, étendues de lianes et de grands arbres, prairies, steppes neigeuses, luttes contre des Indiens, traîneaux volés, daims abattus, vous n'avez pas vu passer l'invisible corsaire. (*LA*, p. 30)[5]

> (Forests hacked through with a knife, stretches of vines and great trees, prairies, snowy steppes, fights against Indians, stolen sleds, slain deer, you haven't seen the invisible corsair pass by.

Or again, the mockingly forgetful tone which cancels out all the preceding statements:

> Corsaire Sanglot aborde au port. Le môle est en granit, la douane en marbre blanc. Et quel silence. De quoi parlé-je? Du Corsaire Sanglot. Il aborde au port, le môle est de porphyre et la douane en lave fondue . . . et quel silence sur tout cela. (*LA*, p. 45)

> (Corsair Sanglot reaches port. The breakwater is of granite, the customs house of white marble. And what silence. What was I talking about? About Corsair Sanglot. He reaches the port, the breakwater is of porphyry and the customs house of molten lava . . . and what silence over that scene.

In the latter example, the simplicity of the repeated "silence," which easily outweighs the importance of the "untruth," almost makes us overlook the denial within the paragraph (given here in its entirety), as if the author really were so engaged in his own lyricism as to merit an excuse for changing unimportant details—a further trick, insulting and successful, since the passage plays on our own lyric sensibility.

The reader has no choice but to feel himself alienated from a straight narrative line when he is cut off from the story at the precise point when he is most interested in it; the device is scarcely aimed at a direct communication by the written word. Desnos mocks us, his hero, and himself:

Corsaire Sanglot s'engage dans, Corsaire commence à, Corsaire
 Sanglot, Corsaire, Corsaire Sanglot.
La femme que j'aime, la femme, ah! j'allais écrire son nom.
J'allais écrire "j'allais dire son nom."
Compte, Robert Desnos, compte le nombre de fois que tu as
 employé les mots "merveilleux," "magnifique . . ."
(LA, p. 48)[6]

(Corsair Sanglot undertakes, Corsair Sanglot begins, Corsair Sanglot,
 Corsair, Corsair Sanglot.
The woman I love, the woman, ah! I was going to write her name.
I was going to write: "I was going to say her name."
Count, Robert Desnos, count the number of times you have used
 the words "marvelous," "magnificent . . .")

By his circularities, haltings, and change of tone, Desnos stands outside
his writing and forces us into the same position. The disengagement is
intensified by the author's insistence not just on the dizzying foreground
of the text where we are accustomed to concentrate our attention, but
on the pre-foreground, so to speak.[7] Our gaze is directed toward the
ink on the author's fingers or on the paper, toward the actual pen and
the inkstand, so that the impossibility of equating object and expression
is greatly aggravated. Desnos effectively communicates to us his own
vision of the manuscript as an arid plain, and of books as an actual
cemetery of words. Whatever is going on in his mind, it is rarely ob-
vious on the surface of the text, which is all we are given to see. To
some extent, of course, Desnos' attempt to show himself as disen-
gaged from what he writes can be associated with the similar attempt
of the "new novelists" in their ironic techniques of interruption, sus-
pension, contradiction, omission, etc. In each case the illusion of litera-
ture is to be destroyed both for the author and for the reader—but
Desnos seems more deliberately self-conscious in his style ("Compte,
Robert Desnos, compte . . .") and more elusive. The process can be
compared to the logical category called the self-controverting discourse,
by which the speaker shows, even in making an explicit statement, that
he disbelieves what he states or is not primarily interested in it, thus
canceling out his first meaning to make way for another meaning.

Among all the other techniques of distancing the reader from the
narration, the object from its names, and the scene from the descrip-

tion, the most essential one touches the one thing Desnos takes most seriously: "Mais toi, enfin, je te salue, toi dont l'existence doue mes jours d'une joie surnaturelle. Je t'aime rien qu'à ton nom"(*LA*, p. 113). (But all hail to you, whose existence grants a supernatural joy to my days. I love you even just from the sound of your name.) We know from exterior evidence whom he is addressing, but since he does not reveal the name on the page itself we are shut out once more; the gap between the written and the audible is already great. When it is emphasized, as it is here, especially in combination with the chasm deliberately provoked between those who do not have privileged knowledge and those who do, the intention of distance is clear.

Furthermore, all the real action and the summits of lyric description seem to take place in the future, or are referred there. Even if we might have hoped to share this future by our enthusiasm for the text, the ground slips out from under us as the narration is once more situated, by a simple tense change, at a permanent remove. We are thus forced to acknowledge that we have been plunged into the realm, not of the real, but of the poetic, or, of the semiotic. Thus our interest in narrative is transferred to that other realm on which the techniques of Desnos seem to insist.

> Et la perle éternellement fixée au gouvernail s'étonnera que le bateau reste immobile éternellement sous un océan de sapin sans se douter du destin magnifique imparti à ses pareilles sur la terre civilisée, dans les villes où les chasseurs de bar ont des dolmans couleur du ciel. (*DPD*, in, *LA*, p. 137)
>
> Je partirai vers la côte où jamais un navire n'aborde; il s'en présentera un, un drapeau noir à l'arrière. Les rochers s'écarteront. Je monterai.
>
> Et dès lors mes amis, du haut de leur observatoire, guetteront les faits et gestes des bandes de pavillons noirs répandus dans la plaine, tandis qu'au-dessus d'eux la lune dira sa prière. Elle égrènera son chapelet d'étoiles et de lointaines cathédrales s'effondreront. (*DPD*, in *LA*, p. 145)

> (And the pearl eternally attached to the rudder will be astonished that the boat remains eternally immobile under an ocean of oak without suspecting the magnificent fate met by its equals on the civilized earth, in the towns where the bus boys have sky-colored jackets.)

(I shall leave for the coast where no ship ever touches; one will arrive with a black flag at its stern. The rocks will make way. I shall climb aboard.

And from then on my friends, from the height of their lookout tower, will spy the deeds and gestures of the bands of black pennants spread out in the plain, while above them the moon will say her prayers. She will count her rosary of stars and faraway cathedrals will crumble.)

The reader may prefer to be counted as one of these friends, but he is in any case not to be reassured by the text. *La Liberté ou l'amour!* ends as the sharks are closing in on the boat of Corsair Sanglot, with the inconclusive statement, "C'est alors que le Corsaire Sanglot..." (*LA,* p. 118). (It is then that Corsair Sanglot...)

Desnos says much later and with some pride that he has learned to write poems whose ends remain as if suspended—but in fact he had already mastered the technique in 1927. In all probability, he never expected us to share with him his brilliant "course à l'aveugle vers des horizons mobiles" (*LA,* p. 114) (blind race toward mobile horizons), and he certainly never intended the horizons to be just the limits of the literary work. None of the surrealists advocated literature as literature, but most demonstrate a faith in the magic of the word even when written and in its evocative power reaching far beyond the horizons of the written. Of all the surrealist poets, and the poets who were at one time surrealists, Desnos seems most often to turn away from his writing and from us. But he was no doubt aware that he would always do so: according to this perspective, perhaps the "mysterious one" of his poems of 1926 and the shadows of 1927 are meant to represent mystery and total darkness only for the readers, the "deuils anonymes" of "Le Poème à Florence" to be griefs unnamed only for us, and the doors of dream never to be open for us at all. "Les verrous sont poussés au pays des merveilles" (*DP,* p. 189). The doors of wonderland are bolted,[8] says Desnos, predicting future shadows and incommunicability:

Voici venir les jours où les œuvres sont vaines
Où nul bientôt ne comprendra ces mots écrits[9]
(*DP,* p. 188)

(Behold the time coming when works are in vain
Soon no one will understand these written words)

Myth Constructed and Myth Deflated

Elaboration

Corresponding to the epic journey of the hero as poet or as pirate, contributing to the frequent tone of exaltation in both surrealist novels of Desnos, certain points of focus are stressed in repetitions and modifications until they acquire an intensity and an emotive value far exceeding that of the less frequent images passing on the novel's surface (or on that of the poem, since the same procedure applies there). It is to these linguistic and imaginative accretions, these deliberate constructions of literary energy, that we are here giving the name of "myth," with the qualifying reminder that the myth in this sense is a voluntary creation of the poet of the elements of these constructions, which he builds and then destroys.

As preliminary examples, we might cite the round objects in the scenario "Minuit à quatorze heures" which gradually become an obsessive fixation, and, in *La Liberté ou l'amour!,* the attractive cadavers and skeletons of mermaids found on the streets and in the water. If the former exemplify the surrealist identification of the seer with the thing perceived, the latter exemplify the identification of love with death, a union which offers, according to Desnos, the perfect occasion for man to assume a semblance of dignity. But both these macabre images can be seen as denials of the poet's specific hope that some day liberty and love might be reconciled by the image of a miraculous swimmer, and of the general possibility of wandering without limit, whether on land or sea. They appear as the extreme products of the arresting of time and motion, fixations in that literal sense of the term. Similarly, in a scene of love-making, the hero notices the calendar stopped at one page: like the series of picture postcards in this same scene, this relic of time passing and arrested haunts the entire space of the book,[10] itself a motion captured. But in the perpetually paradoxical nature of surrealist thought, all these images insofar as they are repeatedly stressed, serve as repositories of concentrated energy as well as mockeries of the scenery of apparent motion. One of the most pervasive examples is the leopard-skin coat of Louise Lame, brought to her by the leopard, who drags it behind him to her doorstep, only to die there. Thereafter each new mention of her coat carries all the implication of motion and of tragedy, of his bleeding and painful pilgrimage and his death: "Processions d'enseignes et de licteurs, processions de lucioles, ascensions miraculeuses! rien

n'égala jamais en surprise la marche du fauve sanglant . . ." (*LA,* p. 24). (Processions of flags and of lictors, processions of fireflies, miraculous ascensions! nothing was ever more surprising than the advance of the bleeding animal. . . .) The sacrificial act of the leopard contributes greatly to the stature of the heroine, who takes on the miraculous quality of her coat, under which she is naked—of its elevation to the level of legend. The high points are often marked by the erotic.

In another form of myth construction, a group of static objects, any of which considered alone would be only trivial, can in a recurring series of juxtapositions accumulate a momentum sufficient to create a new focus or regenerate an old one.[11] Perhaps the most extraordinary and fullest example of this kind of intensification in these pages starts with three ordinary objects loosely connected to the major love scene of *La Liberté ou l'amour!,* during which the Corsair sees the outdated calendar page and at the end of which he pushes the heroine aside so as to continue his adventures. First, the noise of the hotel boy polishing the shoes in the corridor outside their room reminds the Corsair of Father Christmas, an image which reminds him in turn of the voyage of the Magi and of the star. Secondly, he compares the star to the pink soap he is using to wash himself, calling the soap star a better guide than the Guide Michelin. Thirdly, on a billboard outside the hotel appears, as an advertisement for Cadum soap, Bébé Cadum, a figure who is to be seen frequently as an observer of adventures, a guardian of the streets and a personal guide to the action (a benevolent parallel to the seductive mermaid). Now Bébé Cadum (or the soap-star) absorbs the religious qualities of the first steps of this mental evocation (Christmas, the Magi) and the combining of eroticism and mysticism yields the following passage:

> La nuit de son incarnation approche où, ruisselant de neige et de lumière, il signifiera à ses premiers fidèles que le temps est venu de saluer le tranquille prodige des lavandières qui bleuissent l'eau des rivières et celui d'un dieu visible sous les espèces de la mousse de savon, modelant le corps d'une femme admirable, debout dans sa baignoire, et reine et déesse des glaciers de la passion rayonnant d'un soleil torride, mille fois réfléchi, et propices à la mort par insolation. Ah! si je meurs, moi, nouveau Baptiste, qu'on me fasse un linceul de mousse savonneuse évocatrice de l'amour et par la consistance et par l'odeur. (LA, p. 32)

> (The night of his incarnation approaches, on which, streaming

with snow and light, he will show his first disciples that the time has come to salute the tranquil miracle of the washerwomen who turn the rivers blue and the miracle of a god visible as soap lather as it clings to the body of a handsome woman standing in her bath, queen and goddess of the glaciers of passion radiating with a torrid sun a thousand times reflected, and favoring death by sunstroke. Ah! if I die, a second John the Baptist, let me have a winding sheet of soapy lather evocative of love in its texture and its smell.)

In the next stage of the myth as it develops, Bébé Cadum is said to be incarnate. At twenty-one he engages in epic battle with another signboard figure, the giant Bibendum Michelin. Thus the cliché emblem of Michelin tires on French signboards and guidebooks serves as the banal origin of an extended elaboration in a poetic vein; the instantly understandable reference to the places in which the thirsty voyager is refreshed (Bibendum: to be drunk, a fat and bouncy figure) is the literal *source* of the verbal profusion.[12] This play of names permits lengthy linguistic spoofs and farcical nonsense, as the Bébé becomes a baby who drinks, the bastard son of Bibendum, as Bibendum himself gives birth to an army of tires, and so on.

Finally, the force of all the preceding passage has built up to a peak. The tires roll along in one more desertlike plain until they reach Bébé Cadum, or rather "le Cristi" (now thirty-three years old), and completely immobilize him. The chapter ends with a scene entitled "Le Golgotha," where the static picture of the cross, a church steeple, three oxen in a field, and a few poppies contrast with a catalogue of activity: a tourney of windmills, a race of red and white cars, circling carousels, shooting matches, the metallic rolling of lotteries, various oscillations and vibrations, toboggans, steam shovels, ships, trains, and an airplane. The lack of movement in the landscape and the corresponding paralysis of the Christ figure are immediately balanced by the images of extreme motion, but then the scene turns to tragedy and the mockery of tragedy. The sentences, each isolated from the others, reflect a presumed solitude and despair as the evening falls, neon signs glare in an artificial and empty contradiction of the earlier setting of full images, Christ dies in time with the orchestra's rhythm, and the flags draping the cross flap in the wind. In the space of a very few pages, a scene of eroticism has developed, through an elaborate series of verbal play of images, into a farce and then into a legendary drama. Half buffoonery and half pathos, the text still maintains the unmistakable rhythms and incantatory lyricism

of a prose poem. Often the passages most complex in texture are pro-
duced from such a meeting of the mystic, the erotic and the common-
place: already in the first chapter, the brilliance of Desnos' description
of the Magi's journey depends on a similar junction of three striking
adjectives: the Magi's love is at once exclusive, fatal and murderous
(*LA*, p. 22).

In particular, the group of images associated with the basic theme
demonstrates an unexpected complexity, like the group of objects gen-
erating the myth: lost / guide, shipwreck / navigation, and desert /
sea. Though Corsair Sanglot spends much of his time moving through a
desert of his own imagining, with the most trivial objects for guides,
just as Desnos spends much of his making "stigmata" on the arid plain
of a manuscript, their tale begins and ends with ships and water, mer-
maids and sharks. In fact, the desert in which the hero's genius always
directs him "vers une révélation qui se contredit sans cesse et qui l'égare
de sa propre image méconnaissable . . . à l'image chaotique des cieux,
des autres êtres, des objets inanimés et des incarnations fantomatiques
de ses pensées" (*LA*, p. 101) (toward a revelation which ceaselessly
contradicts itself and which causes him to stray from his own unrecog-
nizable image . . . toward the chaotic image of the skies, of other beings,
of inanimate objects and of the incarnate phantoms of his thoughts), is
as favorable to the atmosphere of mental metamorphosis as is the open
sea. Desnos, while acknowledging his own passion for the absurd wind,
thinks he has created only a cemetery of words; but his readers may
judge him to be, like Corsair Sanglot, a great adventurer of mental
shipwreck and of surrealist myth.

Contrasts

As we have seen, Desnos excels in the techniques of mocking his own
rhetoric and our expectations. The play is double, since the reader,
gradually alerted to the process, is forced not only to recognize the
marks of an approaching deflation or letdown but also to mistrust any
emotional build-up, since he knows its eventual end. Let us take, for
example, a passage already mentioned in the discussion about the con-
structing of myth. During the violent love scene between Louise Lame
and Corsair Sanglot, the calendar on the wall, stopped as it is at a date
the hero remembers for having paid particular attention to it every year,
plunges him into an adventure of fifty years ago. Thus the build-up of
time by the implicit chronological continuity and the possible repetition

of adventure at a temporal distance develop an expectancy of happenings on which the author will place high value. A series of melodramas take place rapidly in the Corsair's mind, ending with his admission into an English boardinghouse where he watches little girls bathing. The mental scene of approaching sensuality is brutally interrupted:

> ... leurs seins étaient de charmantes merveilles non déformées encore par ...
> — Dis-moi que tu m'aimes! râla Louise Lame éperdue.
> — Saloperie, râle le héros. Je t'aime, ah! ah! vieille ordure, loufoque, sacré nom de plusieurs cochonneries.
> Puis, se relevant:
> — Quel poème peut t'émouvoir d'avantage?
> (*LA*, pp. 30–31)

> (... their breasts were charming wonders not yet deformed by ...
> — Tell me you love me! gasped Louise Lame in a frenzy.
> —Slut, gasps the hero. I love you, heap of garbage, ridiculous old hag, blessed name of filth on filth.
> Then, getting up:
> —What poem could move you more than that?)

The contrasts between imagination and physical gesture, between little girls and Louise Lame, are paralleled by the contrasts, both in posture (the prone and passive position assumed by the dreamer is connected with the action of rising, "se relevant") and in language ("charmantes merveilles / vieille ordure ... cochonneries"). The comparison of the efficacy of this latter language to that of a poem complicates to a further degree the rhetorical irony of the entire novel seen as a prose poem.

The pattern of these oppositions prepares three related, but more general ones—that of love as opposed to adventure (again, one of the senses of the title), of the distance between experience and language, and finally, of the necessary gulf between desire and reality:

> Ah! ce n'etait pas *l'amour*, seule raison valable d'un esclavage passager, mais *l'aventure* avec tous ses obstacles de *chair* et l'odieuse hostilité de la *matière*.

> (Ah! it wasn't *love*, the only valid reason for a passing enslavement, but *adventure* with all its obstacles of *flesh* and the odious hostility of *matter*.)

The exclamation "Ah!" signals the placing apart of the text, and the deliberate juxtaposition of opposites in the leading theme.

> Amour *magnifique,* pourquoi faut-il que mon langage, à t'évoquer, devienne *emphatique.* Corsaire Sanglot l'avait prise par *la taille* et jetée sur le lit. Il *la* frappait. *La croupe* sonore avait été cinglée par le plat de la main et *les muscles* seraient bleus le lendemain. Il l'étranglait presque. *Les cuisses* étaient brutalement écartées.
>
> Ce n'était pas vrai. (*LA,* 31)
>
> (*Magnificence* of love, why must my language when I evoke you become so *emphatic.* Corsair Sanglot had seized *her* about *the waist* and thrown her down on the bed. He beat *her.* The sonorous *rump* had been lashed by the flat of his hand and *the muscles* would be blue the next day. He was almost choking *her. The thighs* were brutally spread apart.)
>
> (*That wasn't so.*)
>
> [My italics]

The text signals the introduction of the narrator, who mistrusts his own rhetoric, that is, the spontaneous emphasis in tone shown in the passage quoted above, however appropriate it may be to the love he genuinely considers magnificent.

The lines mark a deliberate change of tone, from the lyric to the openly sadistic. The woman, now becoming an object, is not named, unlike the hero who *acts.* The moral distance between them is marked by a brief and colorless pronoun ("l'avait prise") and a total anatomical reduction by detail ("la croupe . . . les muscles . . . les cuisses").

Corsair Sanglot goes to the mirror to put his appearance in order (after all the action denied). This step on the first level of the book's action is again countered by the colored postcards (at one remove from that level, they are only the witnesses to distant scenes) from which Louise Lame has taken all her knowledge of love, and by the further allusions to fantasy: "La mousse, le masque et les mains furent des mains de fantômes." (Moss, mask, and hands were the hands of ghosts.) Closing off the scene, marking both the letdown and the circular form assumed by the imaginative fixations, the departing steps of the Corsair on the stairs are compared to a *descending scale* like that of a little girl, whose

fingers are red from the marks of her piano teacher's ruler. This latter image leads in its turn to a scene where the headmistress whips the girls, leaving red blotches on a more sensitive place, referred to at the beginning of the passage. Desnos' own experiences with a sadistic young teacher are perhaps not wholly irrelevant to the linking of cruelty and love, and to the techniques of self-consciousness and self-reference.[13]

Another text set apart by the author's self-conscious invocations to himself treats in greater detail the contrasts between the possibility of the marvelous adventure and the banality of language recording it or celebrating it. "Qu'elle vienne, celle que j'aimerai, au lieu de vous raconter des histoires merveilleuses (j'allais dire à dormir debout)" (LA, p. 44). (Let her come, the one I shall love, instead of telling you wonderful stories [I was about to say boring stories].) The sudden switch (the marvelous / boredom), which can be read in either direction, stresses the exaggeration of the text, from which we are then removed by the author's lack of interest in us: "Vous lirez ou vous ne lirez pas, vous y prendrez de l'intérêt ou vous y trouverez de l'ennui, mais il faut que dans le moule d'une prose sensuelle j'exprime l'amour pour celle que j'aime" (LA, p. 44). (You will read it or you won't, you will be interested or find it tedious, but I have to express my love for my beloved, in the mold of a sensual prose.) We have neither a function nor a value for the author, as Desnos admits, after condemning his own sensual style which he has chosen, by the same criterion with which he began: the mention of boredom leads directly to the lament "Banalité! Banalité!" But this time the procedure is reversed, for the final paragraph of this particular text states the credo—"Je crois encore au merveilleux en amour, je crois encore à la réalité des rêves"—and the necessarily accompanying vow to slavery, the "esclavage passager" he had mentioned in the preceding paragraphs, where the word "passager" implies the notion of a ship's passenger as well as that of time, the one deriving from the other: "Jeune bagnard, il est temps de mettre un numéro sur ta bure . . ." (LA, p. 45). (Young convict, it is time to put a number on your rough shirt. . . .) The victim of love is the contemporary equivalent of the chevalier courtois or the crusader in his coat of mail.

Deception

In the familiar pattern of crescendo and rapid decrescendo, of augmentation or intensification and letdown either gradual or sudden, the

legends of love, of adventuring heroes, of saviors and leaders, once they have been constructed by the techniques mentioned above, are then mocked by rhetoric, which in its turn makes a final mockery of itself.

The beginning of the eighth chapter, "Corsaire Sanglot s'ennuyait!" (Corsair Sanglot was bored!) links it to the previous lamentations of boredom and banality, but here the exclamation point (no less ironic than emphatic) sets apart the passage to come, like the exclamations "Ah!" and "Qu'elle vienne!" in the lines previously examined. The boredom alone becomes the Corsair's motivation, and that motivation is intensified to the level of heroism, as in the following lines: "C'est à cette époque de sa vie qu'il advint à Corsaire Sanglot une étrange aventure. Elle ne l'émut pas outre mesure" (LA, p. 88). (It is at this period of his life that Corsair Sanglot had a strange adventure. He was not overly impressed.) Others would be surprised, amazed, even astounded, the author implies; not so the hero of boredom. "A peine prêtait-il une méprisante attention au paysage romantique dans lequel son corps se déplaçait . . ." (LA, p. 89). (Scarcely did he deign to pay the slightest attention to the romantic landscape in which his body was moving. . . .) All the most extraordinary spectacles pass the bored hero by: "Soudain, et ceci le Corsaire Sanglot ne le vit pas, les trente mille pierres tombales du cimetière se dressèrent et trente mille cadavres dans des chemises de toile paysanne à carreaux apparurent rangés comme pour une parade" (Suddenly, and the Corsair Sanglot did not see this, the thirty thousand tombstones of the cemetery rose up and thirty thousand cadavers in nightshirts of checked peasant linen appeared lined up as if for a parade); he feels only vaguely oppressed. The marvelous of the surrealist vision is clearly of little importance when it is not even visible to the hero; the scene becomes simply a private joke between the author and the reader.

There is an often parallel minimization of classical heroes, after the initial allusion to them gives a particular density to a passage such as the following one, where the trivial mixes with the legendary. In the scene under discussion, wounds made on the hands by table knives remind us that we should break bread and not cut it, "ceci en souvenir de N.S." (do this in remembrance of our Lord)—this between parentheses. Continuing the heroic context, a comparison is then drawn between parsley and the circumstances of Socrates' death; parsley resembles hemlock, "ce qui permit à ce héros cher aux pédérastes de faire preuve d'un grand courage" (which enabled that hero dear to pederasts to display great courage). Suddenly a peaceful bourgeois living room is trans-

formed into a place of violence, a sort of elegant slaughterhouse: "le sang jaillissant des caryatides tranchées, souillant tour à tour la soupière en porcelaine de Limoges, la suspension à gaz et le buffet imitation de la Renaissance . . ." (LA, p. 91) (the blood spurting forth from the severed caryatids, splattering one after the other the soup tureen of Limoges china, the chandelier, and the imitation Renaissance buffet . . .). When, at the end of this very long scene, we learn that all these objects were only theatre props—"paysages, vous n'êtes que du carton-pâte et des portants de décors" (landscapes, you are only cardboard and stage sets)—we are not surprised. The letdown was to have been expected: the same actor, as Desnos is careful to point out, always plays the role of ennui, which was alone responsible for the most lyric passages until now, and he simply costumes himself in the corridors, an ironic replacement for the visionary "Paysages" which began the sentence. Thus, creation and legend turn to simple play-making, lyric crescendo to self-deprecatory rhetoric.

It is true that in the space of the novel all the material for poetic expansion is provided: Jack the Ripper, invisible archangels, lost ships, mermaids and dying explorers; that is, the personal iconography of which literary myths are made—but it is used here in a complex and often contrary sense. For instance, the explorer, far from being certain of his role or natural in his attitudes, must figure out for himself how heroes are supposed to die: "si c'est les bras en croix ou face dans le sable, s'il doit creuser une tombe fugitive en raison du vent et des hyènes, ou se recroqueviller dans la position dite chien de fusil . . ." (LA, p. 99) (if it is with arms outstretched and face down in the sand, if he should dig a fugitive tomb because of wind and hyenas, or just curl up in the so-called broken-gun position). Even the positions he might take are named already, have already become clichés. And over the speaking pavement of the Place de la Concorde pass adventurers, and a procession of vehicles as diverse as the various vessels of adventure, but accompanied also by the more ordinary feminine undergarments and the drearily anonymous so and sos (Un tel, Une telle). Once more, "l'ennui s'éprend de tous les esprits" (boredom overcomes all minds), those within the text and those of the author and the readers. As the necessary counterpart of Desnos' surrealist voyage seems to be the image of shipwreck, so the myth's necessary double is apparently that of tedium.

It is precisely the intense complexity of this double motion, whether spontaneous or crafted, which distinguishes Desnos from the other

surrealists. To a limited extent, the analyses made here of his stylistic system can be paralleled in the study of other poets and novelists,[14] but it is certain that in this period Desnos is the severest critic and the most subtle destroyer of his own elaborate poetic legends.

Verbal Play

Many of the surrealist texts to which we attribute the greatest importance are generated by verbal and metaphoric play, the text reproducing itself by means of its own momentum. In the case of poetry, these verbal determinants may be more obvious and need, therefore, less commentary, whereas in the novel such analysis may meet with an initial scepticism and a subsequent accusation of formalistic triviality.

Desnos himself furnishes a justification for the concentration on the word, here considered in its generating action. Since he plainly expects to have no subject in mind, he recommends that in order to begin the "automatic" unrolling of the text—or the drawing—one should simply start moving the pen in some direction: it is his own practice in both his drawing and his writing. For the initial "scratching" or the randomly moving line on the drawing-paper, see the attached drawings, where the procedure is clearly visible. The process as regards writing is often noticeable at the beginning of chapters or poems, where the poet, in order to get under way in his text, embroiders on the sounds of one or a few words.

In the prose poetry of both the novels of this period, the range of examples resulting from the process could be extended to cover the analysis of the major part of the novels. They stretch from simple puns leading to single images or a whole passage, to the elements of an interdependent series determining a certain unfolding of action. Many examples, examined elsewhere, in the section on poetic play, seem to be self-signaling. At this point the complicity between reader and text is great: the process of play balances the other alienating procedures referred to in this chapter.

The only linguistic build-up resistant to subsequent self-parody, because it already contains within it its own *play,* is the construction of a language more important in its form than its meaning. In the following example, one word finally emerges as the link between all the images on which the story is based:

avec les salles de classes où les *chiffres blancs* sympathisent du fond du *tableau noir* avec les mystérieux graphiques dessinés dans le ciel par les étoiles, mais tandis que tu restais immobile dans un paysage de leçon de choses, l'orage de toute éternité montait derrière ton toit d'ardoise pour *éclater, lueur d'éclair,* à l'instant précis où le martinet de la correctrice rayerait d'un *sillon rouge* les fesses d'une pensionnaire de seize ans et *éclairerait* douloureusement, tel un *éclair,* les mystérieuses arcanes de mon érotique imagination. N'ai-je écrit que pour évoquer votre ressemblance, *éclair,* coup de fouet! (*LA,* p. 104)

(with the classrooms where the *white figures* at the depth of the *blackboard* sympathise with the mysterious signs sketched in the sky by the stars, but while you remained immobile in a landscape of the lesson of things, the storm of all eternity rose behind your slate roof to *break forth,* with the *brilliance of lightning,* at the precise instant when the proctor's stick marked with a *red furrow* the buttocks of a sixteen-year-old boarder and painfully *illuminated,* like a *bolt of lightning,* the mysterious arcana of my erotic imagination. Have I not written only in order to evoke your relationship, *lightning,* whiplash!) [my italics]

The passage is based on the simplest of contrasts and on its extension: the white signs play against the black, evoking more mysterious and more elevated contrasts, such as those stressed by Mallarmé: stars against the black background of the sky as a reversal of black ink against a white page, for instance. But this play is seen against a support of frozen phenomena, evidently of as little importance as the stage props just encountered; they are thus intensely opposed to the natural phenomena, whose importance is magnified by the opposition. Of primary visibility, the lyric accretion or accumulation of the entire passage is announced by the forceful expression "éclater," leading to the luminous series of images, "éclair . . . éclairerait . . . éclair . . . éclair . . . ," where the central crescendo throws light on the hidden eroticism. Here the meeting of bright and veiled, of the lyric and the erotic creates a verbal climax occurring precisely at the same moment as the whiplash, the whole set off by the typographical accent in the form of an exclamation.

In summary, if one were to sketch an abbreviated system of the techniques used by Desnos, two contrary currents would be clear, that of

progression and that of negation. The former would include various forms of intensification and fusion, of metamorphosis and modulation, of expansion and aggrandizement— by complication, by mythical allusion and contextual creation, and by a number of other means. The negative current would include various forms of separation and paralysis—by shattering, retardation, halting, diffusion—and various forms of discomfort inflicted on the reader—by deflection, incompletion, and deflation, and by a series of distancing techniques, all of which work against the positive current. Finally, as the content is self-denying and our involvement is refused, it is the form of the language itself which holds us. Finally, as the content is self-denying and our involvement is refused, it is the form of the laguage itself which holds us.

L'époque qui s'éloigne à la vitesse d'un rêve, s'isole et prend dans notre mémoire des contours fabuleux où s'inscrit, où résonne la voix de Robert Desnos, cette voix soufflante, soutenue et martelée qui, même alors, semblait toujours nous héler de très loin.

(Georges Neveux, "Robert Desnos," *Confluences*, no. 7 (Sept. 1945), p. 680)

(The epoch departing with the swiftness of dream singles itself out, shaping in our memory fabulous contours where there is inscribed, where there resounds the voice of Robert Desnos, this breathy, sustained and staccato voice which, even then, always seemed to hail us from a great distance.)

5 Poetic Structures

In the development of Desnos' greatest poetry, there is a noticeable change from the early linguistic experiments and poetic jokes, such as *L'Aumonyme and Langage cuit* of 1923, to the serious and often tragic love poems of *A la mystérieuse* of 1926, where meditations on the real and the illusory, and on the presence and absence of the woman loved, are found side by side with presentations of a vague menace in the natural world or of a startling landscape.

Each of the poems in the latter volume has an unmistakable inner coherence and certain of them have an exterior brilliance, although the collection as a whole has not the accumulated intensity of *Les Ténèbres* (1927), where the themes of adventure, love, and presence, of the waking and the nocturnal dream in its relation to reality merge with the greater theme of poetic language itself. In every poem of *Les Ténèbres* one is acutely aware of the self-critical poet already seen in the poetic novels, where the cause of linguistic adventure was paradoxically treated alongside that of surrealist love, sometimes as identical with it, and then again as its irreconcilable opposite—the two senses, contrary but joined, of *La Liberté ou l'amour!* In these poems, Desnos tests his own poetry for its fidelity to his dream and to a wider actuality beyond. This time, however, the adventure of the poet's dreaming is clearly separate from that of his love, and the latter is frequently sacrificed to

57

make way for the former; in fact, the very value of love is denied when-
ever the two are compared. Intensity of experience and expression seem
finally to depend on the poet's isolation. To what extent this psycho-
logical reality may be dependent on the tragedy of Desnos' love for
Yvonne George is finally not the major question for us. That the famous
poem "J'ai tant rêvé de toi" (I Have So Often Dreamed of You) keeps
its own profile even when, after Theresienstadt, it is recited in Czech
by Joseph Stuna and retranslated into French as "The Last Poem
of Desnos," is indicative, even symbolic, of the continuity of his per-
sonality. For it is then addressed to Youki as surely as if it had been
written for her, and the isolation which penetrates the poem finds its
concomitant reality in the life of Desnos with its tragic conclusion but
transcends it also. What we finally are attached to in our own memory
of the poet is not the specific biographical facts so much as the intensity
of certain texts, marked by a loneliness which no extrinsic knowledge
can reduce by explaining it. This is, it seems to us, the incontrovertible
and inner poetic reality.

Games and Grammar

The surrealist attitude toward language takes as its primary basis the
deliberate cultivation of ambiguities for their own sake, for their power
to liberate the mental processes from the traditional mold of logic, and
for their role in the expansion and the rendering flexible of both the
poetic framework and the word, which now takes on as many senses
as possible. Breton's famous essay "Les Mots sans rides" (Unwrinkled
Words) declares the extreme seriousness of word play: "Words have
finished playing. They are making love." This game is neither trivial nor
superficial. It is not to be considered exterior to the real business of
poetry: a certain kind of poetic depth depends in fact upon the fullest
use of linguistic potentiality.

In *Rrose Sélavy* (*Eros It's Life*) (1922–23), a majority of the one hun-
dred and fifty statements are based on a horizontal mirror image, where
the end more or less reflects the beginning; the deformation, insofar as
it yields a different perception from the original one, occasionally re-
veals a serious concern beyond the anagrams, the interior rhymes, and
the homonymic play.[1] Even in these poems, the themes and images of

crystalline language, of the diamond, the myth, desire, and chance familiar to us from other surrealist works, recur alongside the themes and images peculiar to Desnos such as the star, mother-of-pearl, the enigma, and the parallel, love = death.

Since it is scarcely worthwhile to comment at any length on puns in any language other than that in which they originate—and here I refer not only to the problem of translation as such but also to that of the translation from spontaneous wit, such as Desnos apparently had, to academic meta-wit—the selections from *Rrose Sélavy* and from *L'Au-monyme* (itself a homonym for "the homonym") stand unanalyzed in the selection of texts accompanying this essay. Beside the parodies of such poets as Mallarmé (the peacocks stuck in the shellac of lakes is an obvious, but no less funny, takeoff on the swans imprisoned in the lake of the page or the poem), all the visual-verbal ingenuities are instantly readable.

Only such self-referential expressions as the FORMES-PRISONS bear any commentary; for imprisonment in any "Forme-Prison," whether traditional or experimental in kind, would have seemed unacceptable to both Desnos, surrealist and to Desnos, ex-surrealist. However, as stated at the outset, Desnos was always fascinated by the most regular of forms, the most regular of meters, taking as a proof of his poetic free-dom the unlimited choice of form, fixed or open; none of the surrealist strictures against the forms of the past ever prevented him from quot-ing the alexandrines of others or even from composing his own, with as much enthusiasm as his experiments in syntactic transgression against the ordinary verbal code. The original title of *Corps et biens* (roughly, Goods and Chattels), which includes most of the poems he published while associated with the surrealist group, was "Désordre formel," a title appropriate in either sense of the word "formel": clearly stated, as in "clear disorder," or applying to the form, as in "formal disorder." And Desnos finally claims that only the poet can be free, never the form.

By far his most original poems on language are those of *Langage cuit* (Cooked Language), 1923. The simpler forms include a poem formed almost entirely of the musical indications "la, sol, fa, mi, ré, do": "Là! L'Asie." "Sol miré, phare d'haut . . ." ("L'Asile ami") and a poem of anatomically and literally accurate reference in the simplest mathemati-cal fashion: two of this, five of that ("j'ai de de beaux beaux bobos bobos beaux beaux yeux yeux . . . / j'ai nez / j'ai doigt doigt doigt doigt doigt à à chaque main main," followed by thirty-two teeth in their verbal

form placed one after the other). More complex, and of greater importance, a few of these poems demonstrate the effective suppression of linking words. In "Idéal maîtresse," for instance, the "escalier qui bibliothèque" (a stair that libraries) is a compression, based on the rows of steps like the rows of books; the neutral connective "which is like" is suppressed—as Breton called for the suppression of the word "comme." Or again, a chameleon as it changes colors says simply: "Je mauve" for the action of assuming a mauve tint, which, expressed in its entire and unnecessary length, would have been: "I have now become like the color mauve." The transformative action is summed up in a verb of energetic brevity, leading the poet, by a syntactic balance deliberately chosen, to an equally compressed self-identification with the preferred image of Dada-surrealist illumination: "tandis que moi-même je cristal" (while I myself crystal).

By this frequent use of nouns and adjectives as verbs, Desnos condenses the poem and intensifies the perception. "Un Jour qu'il faisait nuit" and "Au mocassin le verbe," two of the poems from *Langage cuit,* can be taken as examples of the success of the linguistic experimentation, half trick, but half serious, which Desnos undertakes with such gusto.

Un jour qu'il faisait nuit

Il s'envola au fond de la rivière. Les pierres en bois
 d'ébène les fils de fer en or et la croix sans branche.
Tout rien.
Je la hais d'amour comme tout un chacun.
Le mort respirait de grandes bouffées de vide.
Le compas traçait des carrés et des triangles à cinq côtés.
Après cela il descendit au grenier.
Les étoiles de midi resplendissaient.
Le chasseur revenait carnassière pleine de poissons sur la rive
 au milieu de la Seine.
Un ver de terre marque le centre du cercle sur la circonférence.
En silence mes yeux prononcèrent un bruyant discours.
Alors nous avancions dans une allée déserte où se pressait la foule.
Quand la marche nous eût bien reposés nous eûmes le courage de
 nous asseoir puis au réveil nos yeux se fermèrent et l'aube
 versa sur nous les réservoirs de la nuit.
La pluie nous sécha.

(One day when it was night)

(He flew off to the bottom of the river. The stones in ebony wood
 the iron wires of gold and the branchless cross.
All nothing.
I hate her with love like everyone.
The dead man breathed in great mouthfuls of emptiness.
The compass traced squares and five-sided triangles.
Then he went down to the attic.
The noontime stars shone brilliantly.
The hunter returned with his game-bag full of fish on the riverbank
 in the middle of the Seine.
An earthworm marks the center of the circle on its circumference.
In silence my eyes pronounced a noisy speech.
Then we went on in a deserted path where the crowd was surging.
When the walk had rested us we found the courage to sit down
 then at waking our eyes closed and the dawn poured over us
 the reservoirs of the night.
The rain dried us off.)

 The title, more than paradoxical, indicates the general movement of
the poem toward what would more properly be called a simple game
of paradox than the perception of the marvelous. Instead of thematic
progression, the grammatical structure shows a purely exterior pro-
gression in time (after that . . . then . . . when), serving as a parody of
any reassuring temporality, just as the basic outline of an anecdote
serves to mock the ordinary expectation of plot and happening. This is
the standard framework of much surrealist poetry, grammatically sure
and capable of infinite expansion (for instance, in the poems of Ben-
jamin Péret). Instead of a clearly marked sufferer and object of desire,
the poet offers us changing pronouns of uncertain reference ("Il": who
is he? or it? "Je la hais": who is she? or it? "nous": who are we?). In-
stead of a close-textured canvas of emotion there is a series of sentences,
deliberately uneven, blatantly "non-poetic" in any ordinary sense of the
word, which appear to us to be linked by no obvious mood or theme
whatsoever. That first reaction is superseded on a closer reading, where
the linguistic and formal subtleties are revealed. This is the basic in-
terest of the verbal games in *Langage cuit,* in *P'oasis,* and in other such
writings, their real reason for being. The coherence lies somewhere on
the other side of the instantly noticeable "quirkiness."

In each sentence, the first half clashes with the second, which is often the case in traditional poetic patterns. However, the distance between surrealist form-play and more standard forms is readily apparent. Here, nouns contradict verbs (lines 1, 5, 6, 10, 12, 13), and adjectival phrases contradict the very qualities by which their subjects are defined (1, 5, 7, 8, 11). The interest lies mainly in the rapidly sketched details outside the basic frame of contradiction—in the irony of "comme tout un chacun" of line 3, the comic / macabre picture of the "grandes bouffées de vide" of line 4, and the choice of an earthworm to put at the center which is also the circumference of the circle in line 9; in the fact that the silent speech is noisy and in the choice of the verb "se pressait" to describe the action of the crowd in the totally deserted alley; in the slight reinforcement made by the cliché-type use of "bien" and "le courage" in line 12. The implied image of the dew magnified into the image of the reservoir, here an augmentation rather than a contradiction of the sort seen before, directly precedes the understated conclusion on whose essential lightness of tone it has no effect.

In the same collection we find a poem far more experimental in its form, which can be read however as a poem of love at once succinct and moving.

Au mocassin le verbe

Tu me suicides, si docilement,
Je te mourrai pourtant un jour.
Je connaîtrons cette femme idéale
et lentement je neigerai sur sa bouche.
Et je pleuvrai sans doute même si je fais tard,
 meme si je fais beau temps
Nous aimez si peu nos yeux et s'écroulerai cette larme
 sans raison bien entendu et sans tristesse.
Sans.

(Put the Verb to the Mocassin)

(You suicide me, so docilely,
I shall die you nevertheless one day.
I we shall know this ideal woman
and slowly I shall snow upon her mouth.
And I shall doubtless rain even if I am getting late,
 even if I am a nice day.

We you love us so little our eyes and I this tear will fall in ruin
 without reason of course and without sadness.
Without.)

The title, in all its peculiarity, bears the possible sense of a threat to normal linguistic expectations: "Let's give the verb a kick." The ungrammatical character of the lines (such as that discussed above: "Je mauve") enlarges the meanings of the verbs and their applications. Non-predictable in every sense, swinging wildly about the compass of pronouns and verbs, of cliché statement and genuine sentiment, its last line an illogical *coup de théâtre* instead of a résumé of the whole, this poem is a condensed and perfect example of verbal play and, depending on one's reading, of implied emotion.

The structure follows the model of regular sentence structure: at the end of every line of thought, a period. Each departure from the "norm" not just of grammar, not just of prose, but from traditional poetic language,[2] extends the sense and complicates the tonality. If, for instance, one compares the beginning of the first two lines, the transfers ("tu me" for "je me," or for "tu te," "mourrai" for "tuerai") readily suggest the highly charged atmosphere of surrealist love. Since he so willingly accepts the grief the woman inflicts, it is the agent of suicide rather than of murder, just as his emotional sharing in her death will cause his own: "Je connaîtrons" partakes in the perception of *dédoublement* seen in the romantic tradition, in Rimbaud's "Je est un autre" as in a number of subsequent poets, although it is not the separate which is emphasized here, but the collective. Each verbal transformation so far has been occasioned by the unusual implicit sharing of two persons in an identical action.

The advent of the verb "neiger" has been prepared (or determined) by the adverbs "docilement" and "lentement," suggesting the softness of the snow's falling. The snow is now made to become a personal verb, by the poet's continued participation in its action, and it leads directly to the images of rain and of good weather. On the basis of this personalization of a neutral verb, the striking similarity of "pleuvrai" to "pleurerai" (I shall weep) lends all the strength of the unsaid to the said, as if implicit human emotion colored the most natural phenomena. "Nous aimez" is related not only by sound, but also by a sort of process of wishful thinking to the regular expression "Nous aimer," which can be true only if she consents—therefore the form of imperative "aimez"

(you must, in order for this to be realized). It is at the same time a doubling, a conjunction and telescoping of noun and verb, as the suppressed grammatical distance parallels the closeness willed by the poet. By the same process, the image of her mouth is now transferred to that of our eyes, since once she consents, the gaze will be shared. But it is not yet true, and the falling tear does not simply run down ("couler") or run off ("écouler"), but it takes with it all the fortifications of the person who loves, inflicting the final catastrophe. ("S'écrouler" = to fall in ruins, determined in sound by the unspoken word "écouler.") The poet stresses his disaster, to such a degree that the verb ending ("-erai" = I shall crumble) applies not just to that lone tear, but to his whole being. In each of these lines his presence absorbs all the other subjects by a series of varying techniques, as the verbs are actually altered by his attitude toward them. The entire experiment is one in which emotion takes precedence over grammar, as does the poet's perception over the normal course of things.

Of course the experiment is, like the tear crumbling the defenses of the poet, "sans raison." The final line, whose incomplete form is perfectly identified with its meaning, being without an end, has now attached to it all the weight of desire, inevitable sadness, and the realization of the absurdity of the entire statement and experiment as seen from anywhere but the mind of the poet, in whose attitude we may endeavor to participate, to the best of our ability. Finally, we might show how two of these poems work together, as they are juxtaposed in a harmonic resonance, to demonstrate effective suppressions of linking words as well as deformations of syntax under the obsessive participation of the poet, or then the reader, in the text.

A présent

J'aimai avec passion ces longues fleurs qui éclatai-je à mon entrée. Chaque lampe se transfigurai-je en œil crevé d'où coulai-je des vins plus précieux que la nacre et les soupirs des femmes assassinées.

Avec frénésie, avec frénésie nos passions naquis-je et le fleuve Amazone lui-même ne bondis-je pas mieux.

Ecouté-je moi bien! Du coffret jaillis-je des océans et non des vins et le ciel s'entr'ouvris-je quand il parus-je.

Le nom du seigneur n'eus-je rien à faire ici.

Les belles mourus-je d'amour et les glands, tous les glands tombai-je dans les ruisseaux.

La grande cathédrale se dressai-je jusqu'au bel œil. L'œil de ma bien-aimée.

Il connus-je des couloirs de chair. Quant aux murs ils se liqué-fiai-je et le dernier coup de tonnerre fis-je disparaître de la terre tous les tombeaux.

(*DP*, p. 78)

(At Present)

(I passionately loved those long flowers which exploded-I at my entrance. Each lamp was transfigured-I in an eye burst open from which ran-I wines more precious than mother-of-pearl and the sighs of assassinated women.

With frenzy, with frenzy our passions was I born and the Amazon River itself did not leap-I better.

Listen-I to me carefully! From the coffer surged-I forth oceans and not wines and the sky rent-I open when it appeared-I.

The lord's name had-I nothing to do with this.

The damsels died-I with love and the acorns, all the acorns fell-I in the streams.

The great cathedral rose-I as far as the lovely eye could see. The eye of my beloved.

It knew-I certain corridors of flesh. As for the walls they were liquified-I and the last thunderclap made-I disappear from the earth all the graves.)

In "A présent," the vision is deliberately transferred to the object seen, the passionate involvement of the observer fuses him with the observed—precisely what Breton's essays on art demand from the onlooker—so that the linguistic trace of that involvement is left everywhere in the poem. (Again here, as in *Le Grand Jeu* of René Daumal, and in *Le Grand Jeu* of Benjamin Péret, the "jeu" is doubled by the "je.") Now the title indicates a tense quite unlike that in the body of the poem. "At present," it reads, whereas the action and the description unfold in the past: this dichotomy contributes to the tension created in the setting of the poem. For the present, participation of the observer is

imposed on the fairytale events of a past scene replete with flowers and lamps, with all the ornaments of love, a scene including oceans spilling like diamonds from a chest of plenty, beautiful damsels perishing of passion, and acorns plummeting into peaceful streams flowing by a majestic cathedral. But the style battles against the description as I have rendered it so far, by its inner violence of contraries characteristic of an obsessive outlook. Frenzied terms, such as "éclater," "crever," "frénésie," "passion" (explode, burst, frenzy, passion), clash with calmer and more liquid ones: "longues," "couler," "vins," "soupirs," "fleuve" (long, flow, wine, sighs, river).

Introduced into this setting and revealed only in the extraordinary syntax is the obsession of the speaker, whose declared passion causes the flowers (long, but far from languid) to spring forth at his entry, causes the light-filled bulbs to burst in what can only be an erotic explosion: here the eye of the desirous beholder spills its precious milky liquid, in which there mingle the blood of murder and the fluid whose imbibing is celebrated years later in the Sperm-Drinkers' Club of *La Liberté ou l'amour!* The sighs of the victimized or / and willing females, the frenzy of shared passions, advancing by leaps and bounds ("ne bondis-je pas mieux") precipitate the gushing forth of oceans far more vigorous in their stream than the mild flowing of precious wine from the eye, or the object for which the eye stands, in an implied exhibitionism, by transference. At the center of the poem thus obsessed, as at the center of that eye bursting with its own passionate vision, there suddenly appears not God but the larger-than-life narrator. Not to put too fine a point upon it, the last lines now reflect his Zeus-like amorous adventures, with the same syntactic shift visible in "les belles mourus-je d'amour" as in the poem "Au mocassin le verbe": "tu me suicides, si docilement. / Je te mourrai pourtant un jour" (*DP*, p. 83). (You suicide me, so gently. / I shall die you nevertheless some day.) The implied object rises and falls under the vision of another. So the look of passion is now answered, at least in its own terms, as the eye of the not-I observes the second liquefaction and the final explosion, concluding in the optimism of a past act which is also meant to carry over into the present. This obsessive text is shaped in a tripartite crescendo, whose elements increase in size, from the passion to the birth of frenzy, to the death-destroying thunder. The "je" never ceases its intrusion into the text, of which it marks each part with a sort of obscene vigor.

In "Idéal maîtresse," under the verbal force granted by the obsessed participation, nouns change to verbs, every sense of the static being

lost as the entire text serves for the gesture of the I or the eye verbalized.

Idéal maîtresse

Je m'étais attardé ce matin-là à brosser les dents d'un joli animal que, patiemment, j'apprivoise. C'est un caméléon. Cette aimable bête fuma, comme à l'ordinaire, quelques cigarettes puis je partis.

Dans l'escalier je la rencontrai. "Je mauve" me dit-elle et tandis que moi-même je cristal à plein ciel-je à son regard qui fleuve vers moi.

. . .

L'escalier, toujours l'escalier qui bibliothèque et la foule au bas plus abîme que le soleil ne cloche.

Remontons! mais en vain, les souvenirs se sardine! à peine, à peine un bouton tirelire-t-il. Tombez, tombez!

. . .

Eh quoi, déjà je miroir. Maîtresse tu carré noir et si les nuages de tout à l'heure myosotis, ils moulins dans la toujours présente éternité.

(*DP*, p. 79)

(Ideal Mistress)

(I had delayed that morning in brushing the teeth of a lovely animal that, patiently, I am taming. It's a chameleon. The amiable beast smoked, as was its habit, some cigarettes, and then I left.

On the stairs I met it. "I mauve," it said to me and while I myself crystal in the open heaven-I at its look streaming toward me.

. . .

The stairs, still the stairs, librarying and the crowd below more abyss than the sun rings.

Let's go back up! but uselessly, the memories sardine itself! scarcely, scarcely does a button tiralira. Fall, Fall!

. . .

What, already I mirror. Mistress you black square and if the clouds of just now forget-me-not, they, mills in the eternity always present.)

Boundaries no longer hold between place and place, and the collective suffix "je" makes one statement cohere with another, one element of the text with its neighbor, beyond the bounds of simple contiguity. "Je

cristal" thus replies to "je mauve" as a defining opposition, where the dull copula of an *être* (I am mauve-colored, I am crystalline) would never find its place. The process depends on ellipsis and compression. A look seen as rivering toward the onlooker already signifies a certain imposition of inscape on outlook. A crystal chain is evident just under the textual surface: a color-changing chameleon might well be mauve, a crystalline object might well suggest the transparency of a look, or the transparency of a river water, thus a look which rivers, as the water mirrors the lady looking in the mirror or at her locks undulating as a river ripples ("Mes tresses! / Maîtresse!"); in another series of suggested images, the staircase "libraries" like graduated stacks of books, seen from the side again like the accordion of Breton unfolded; or in a third set of suggestions, sardines are pressed together like so many memories, or indeed like the multiple suggestions with which these two juxtaposed texts are replete.

From Language to Silence

The following three sections represent an attempt to look at the same topic from three different angles: psychological, structural, and finally, thematic. They can be taken as the successive experiments of one reading, circling about identical texts.

The Flasks of Night

Il déjeune tous les jours dans cette
 famille
Il y boit tous les jours la même
 camomille
Il y mange tous les jours de la CUISINE
 BOURGEOISE[3]

Although these lines could scarcely be said to apply to Desnos, who preferred headier liquids (see *Le Voyage en Bourgogne*, for example, in large part consecrated to the joys of traveling from one well-stocked table and—mostly—cellar to another, the orgiastic sequence of the pseudonymous *La Papesse du diable,* or of the Sperm-Drinkers' Club in *La Liberté ou l'amour!*), the appeal of repetitive structures was always a strong one. Of all the works he published between the years of 1926 and 1930, a great majority bear, in this respect, a striking similarity to

each other. Their architecture depends heavily on the exact or approxi-mate repetition of certain key images and key phrases. Although this is true of much surrealist poetry, where a word or phrase once under-lined is repeated at the beginning or end of a line and thus becomes a *formula*—at once verbal incantation, imagistic ritual, and structuring element—in no other poet is there a similar indication of the possible complexity of repetition. The most striking device in the poetry and the poetic prose of Desnos is the play of the repeated element against its own variants.

This procedure, which conveys some of the primitive appeal of folk-tale and myth on all the writings sustained by the *continuo* of the background, is of course connected to various techniques of automatic writing: the hypnotic effect on the reader—and, if one might be allowed to make that supposition, on the writer—is not unlike a mild form of trance in which the limited focus permits a certain stylistic intensity and exalted vision. From the reader's point of view, it matters little whether the initial production takes place with the eyes closed or open, in a lucid choice of repetitive technique or through a consciousness clouded by hypnosis, drugs, or drink. But the poetic strength of Desnos' early writings (based on the obsessive sources of inspiration about which we know only from external evidence) seems quite absent from the works of the later poet of "realism," who openly claims to have left be-hind him the forms and structures of the surrealist dream. It is not im-possible that our own fascination with his early writings is only another obsession, acceptable solely as a subjective (or surrealist) poetic involvement.

For the worst possible manifestation of the later and non-repetitive work, paradoxically at its most static when it is least obsessed, see *Le Vin est tiré,* an unreadable novel about the advantages of the "real world." But here that world is strongly lyricized: birds peep at dawn, the smell of coffee permeates the daybreak, and so on, this lyric and natural "reality" only perceptible after the hero has sloughed off human vice by abandoning the intricate rites and artificial décor of opium smoking. Even if we share the attitude, this style either prosaically flat or blatantly overwritten is disappointing. Nevertheless, obvious signals of the earlier attitude abound, and they will be my major concern. Most obvious and, therefore, least interesting, are the frequent references to the joys of drunken daydream and the necessity for shutting out a banal sobriety. Under this heading come the allusions to the shadowy forms of a clouded mind (*Les Ténèbres*) and the uncritical intermingling of

images both in the experiments with hypnotic sleep and in alcoholic-
ally or drug-induced mental adventure, referred to in the passages
already quoted: "Dormons, dormons / . . . / Lampes, éteignez-vous /
. . . / Et meure le chant du coq" (*DP*, p. 212). (Let us sleep, let us sleep
/ . . . / Lamps, be extinguished / . . . / Let the cockcrow die.")

Of particular interest in the context of this chapter are the following
lines:

> Je conte et je décris le sommeil
> Je recueille les flacons de la nuit
> et je les range sur une étagère.
>
> (I count and I describe sleep
> I gather the flasks of night and
> arrange them on a shelf.)

These bottles should be associated with the vessels of imagined voyage
and projected messages constant in Desnos' poetry until 1931, the
positive origin for the recurring image of those shards of broken bottles,
representing the negative side of a dream shattered.

But it is my contention that beyond these clear metaphoric allusions
to bottles and beverages, to drugs and poetic signals of vision and vision
denied, a major part of the stylistic interest itself centers about a specific-
ally chosen liquid source for the word play. Furthermore, certain repeti-
tive and recurring structures can be seen as characteristic of intoxicated
sight or speech: whether this structuring is considered a deliberate
process or an unintentional one, the effect is the same.

The liquid source One of the sequences in *Deuil pour deuil* of
1924 will provide an initial example. A classic still life of a glass and a
bottle is laid out to evoke the memory of a blonde virgin. Implicit in
this scene is the possibility of the bottle having contained light beer,
"bière blonde," whereas had it contained dark beer or "bière brune,"
she might very likely have been said to be a brunette. Here the referent
is suppressed, whereas in the bold statement "à côté du verre à côtés"
(beside a sided glass), the verbal assimilation of the adjectival phrase
to the prepositional phrase or vice versa works, as is often the case in
Desnos, toward a kind of self-satire. (Compare, in *Le Rouge et le noir*,
"le verre vert" Julien raises at one point.) Later, the same drinking scene
and its toasting prepare the image of a watering can:

[arroser: to drink to something] → arrosoir.

The catalogue of examples can be extended now by all the series of puns on the sound of the word for water, for by oral implication "eau" includes the letter "o," which in turn leads to this sequence:

> *L'eau* terrible coule. . . . *Eau, Eau!* ne coule plus, je suis propre, ne coule plus. *Mes yeux* pleurent. . . . *Eau, tu roules trop d'yeux* pour que *j'ose* te contempler. J'ai peur de tes *multiples sphères où* sont visibles tes souvenirs comme le SACRE-COEUR dans un porte-plume d'os. (*DPD,* in *LA,* p. 143) (My italics)

> (The terrible water flows. . . . Water, Water (oh, oh!) don't run any more, I am clean, don't run any more. My eyes are weeping. . . . Water (oh!), you are rolling your eyes too much for me to dare to contemplate you. I am afraid of your multiple spheres where your memories are visible like Sacré-Cœur in a bone pen-holder.)

Here, the shape of the suggested letter, with the circumflex over it like an arched eyebrow, leads phonetically to the image of "eyes," those "multiple spheres" by appropriately visual suggestion, to the exclamation "oh!" by phonetic suggestion, and to the words "ose" and "os" by a lateral / literal suggestion:

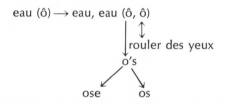

(The play on these particular words is not infrequent in surrealism: compare Breton's "L'Air de l'eau," whose title may just as well be "L' R de l'o," and René Char's "Eaux-mères" as "(H)omer" or "ô mères," "aux mères," and so on.)

In *La Liberté ou l'amour!,* the important sequence of the Sperm-Drinkers (censored in 1927, so that the early edition, full of blank pages, looks like an unintentional and exaggerated Tristram Shandy) shows another set of images associated with a quite different type of intoxication. The concierge of the club is a mermaid, the club members are said to love the sea, and they drink from flasks or bottles: these are already

indications of the importance of this cluster or constellation of images:

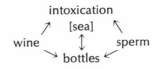

The sequence of the Sperm-Drinkers is also an example of the best sustained and explicit passage of word deformation, semi-untranslatable but instantly perceptible, based on the sounds of the letters *n* and *l* ("haine" and "aile," hate and the wing, respectively). The deforming effect of water and of all liquids is extolled at length by the surrealists, for whom the dissolving of any solid contour is the basic principle of the transformative power of poetry, the latter taken as a serious attitude and not a genre.

—Femme Sperle?
—Plutôt semelle.
—Semelle? Semaine? le temps et l'espace.
Tout rapport entre eux est celui de la haine et des ailes.
—L'oseille est en effet un mets de choix, un mets de roi.
—Moi, déchet.
—Mot à mot, tome à tome, motte à motte, ainsi va la vie.
—Enfin voici que l'heure sonne.
—Que sœur l'aune.
—La soeur de qui?...
—Le cœur décis, décor ce lit.
—Feux intellectuels vulgaires.

The ending, with its deflective consequence, shows again the self-satirical mode. And of course the game is as delightfully vulgar as it is intellectual. If Desnos usually conceals the game under the surface where a plot is supposed to be taking place, that is not particularly flattering to the reader's imagination. But here we have the indications that the passages having to do with liquids of all kinds and with their absorption can often be penetrated to discover the generating source of the verbal, which in its turn determines the so-called "plot" itself.

For sheer stylistic variation, three separate passages of the long poem "Siramour" (1930), each revolving about the image of the bottle and its message—which we can read as the text with its intoxicating source —will be quoted. Taken together, they repesent the constellation of images recurring with the greatest constancy in Desnos' work:

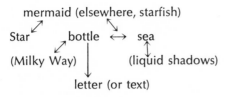

In the first passage, the bottle, we are assured, is a real bottle, no figment of the imagination, and the remnants of wax sticking to it may be read as implying the past candle-flame, an illumination which has taken place already but whose light endures: "C'était pourtant une bouteille comme les autres et elle ne devait pas contenir plus de 80 centilitres et, pourtant, voilà que l'océan tout entier jaillit de son goulot où adhèrent encore des fragments de cire" (*DP*, p. 200). (It was however a bottle like other bottles, and it wasn't supposed to hold more than 80 centilitres, and yet here was the whole ocean pouring forth from its mouth to which some fragments of wax still adhered.) This is one of the clearest affirmations of the *merveilleux* contained in this ordinary vessel, communicating as it does with the totality of the universe.

In the second passage, the chain of transforming and transformed images is openly stated in a paradoxical presence and absence, this contrast present in many of the early poems of the poet. The star rises:

> ... au-delà de l'écume éclatée comme un orage bas dans les ténèbres liquides. A ses rayons, la bouteille abandonnée dans l'herbe et les ajoncs s'illumine des voies lactées qu'elle paraît contenir et ne contient pas car, bien bouchée, elle recèle en ses flancs la sirène marquée, la captive et redoutable sirène masquée. ... Pour l'instant captive elle attend la délivrance dans sa prison bien bouchée par une main amoureuse, tandis qu'une lettre, non remise à son destinataire, moisit sur le sol. (*DP*, p. 198)

> (... beyond the foam burst open like a deep storm in the liquid shadows. In its rays, the bottle abandoned in the grass and the rushes is illuminated by the milky way that it seems to contain and does not, for it is firmly corked and contains in its depths the masked mermaid, the captive and awesome mermaid. ... Captive for the moment, she awaits her deliverance in her prison tightly closed by a loving hand, while a letter, undelivered to its addressee, lies moldy on the ground.)

The corked bottle here can be associated with another possible reading

of the wax remnants in the preceding quotation—thus, the closing of the bottle related to the eventual illumination it may provide. The "liquid shadows" are at once the source of Desnos' surrealist vision and of the darkness distinguishing that vision from everyday sight. The milk bottle seeming (falsely) to contain the Milky Way, by a series of suggestions, first homonymic, and then conceptual (mother's milk):

mer (sea) ⟶ mère (mother) ⟶ voies lactées (*Milky* Way)

and the simultaneous blocking of the bottle's mouth, combine to give this text its particular density. Whether or not its message reaches us or rots upon the ground seems never to have been the particular concern of the poet. The extent to which any surrealist text demands to be, or can be, shared is a very moot point indeed.

The third passage pours out in one lengthy sentence like a drunken song, spilling forth not from the mouth of the poetic drunkard but from the bottle itself, overturned. It is from the few objects recurring again and again in these texts that all the illumination comes, if we know how to look at them:

> Que le buveur, *ivre de la chanson,* parte sur un chemin biscornu bordé d'arbres effrayants au bruit de la mer hurlant et *gueulant* et montant la plus formidable marée de tous les temps, non hors de son *lit* géographique, mais *coulant d'un flux rapide* hors de la bouteille renversée tandis que, libre, la sirène *étendue* sur le sol non loin de cette *cataracte,* considère l'étoile, la tantôt noire, la tantôt bleue, et s'imagine la reconnaître et la reconnaît en *effet.* (*DP,* p. 200)

> (Let the drinker, *drunk on the song,* set out on a misshapen path bordered with frightening trees with the sound of the sea roaring and *bellowing* and swelling in the most astonishing tide of all time, not outside of its geographic *bed,* but *flowing rapidly* from the bottle overturned while the mermaid free and *stretched out* on the ground not far from this *rushing water,* stares at the star, now black, now blue, and thinks she recognizes her, and recognizes her in *fact.*) (My italics)

I have italicized here the references—certainly ambiguous, stressed because of this reader's own obsession—to the textual production in its own spreading out ("étendue") in a rapid course ("cataracte," "flux")

across the page, dependent on the oral impact ("gueulant," "chanson")
and on the reaction of the reader ("lit," "effet"). It is clear that this is
no ordinary drinker, since he is drunk on his song rather than singing
because he is drunk: at this point the intoxication can be seen as struc-
turing the poem.[4]

The fixed gaze Rather than an overall perspective, Desnos frequently
forces our attention to the minute detail or an unexpected angle of
vision, not as a passing variation from the large to the small but rather
as if his obsession must become ours. The recurrence of certain objects,
which gradually take on all the resonances of myth, the narrowing of
focus as if in a dazed state, is at once curious and effective, linking as it
does the apparently disconnected parts of discourse or vision each to
the other by a rapid transfer of close attention. There is a parallel
breaking-down of the logical patterns and habits of looking, so that, as
we saw above, even the shapes of letters can take on a profile of primary
importance regardless of content.

In one of his scenarios, as was mentioned, Desnos endlessly repeats
the injunction, implicit and explicit, to focus on an eye, a coin, a hoop,
a ball, a circle in the water—the accumulation of circular elements as
the center of our gaze, controlled as it is by his own, is as obsessive as
it is cohesive. In both his early novels, certain figures repeatedly attract
the writer's attention and thus ours. Nor can they be said to have any
predictable place in the text; rather, they appear and reappear, fixing
our gaze, their presence unpremeditated and seemingly unmotivated:
thus the billboards and calendars are not seen from different angles but
always from the same one, their iteration hypnotic and obsessive.

In the poems of *A la mystérieuse,* the repetition is often present in its
simplest form of exact restatement or alternation. In contrast to the
axiom of information theory, according to which the message weakens
in communicative content as it is repeated—unless the context changes
—this particular process of poetic obsession acquires an accumulated
value, enhanced by the number of instances in which the obsession is
recognized and verbally accounted for. Consider, for example, the
recurring expression:

O douleurs de l'amour

. . .

O douleurs de l'amour.

(*DP,* p. 193)

(O pangs of love

. . .

O pangs of love.)* Poems translated in the section marked Texts in Translation.

And in the celebrated poem wherein the "mysterious one" assumes her mysterious nature only by the repetition of the pronoun "toi" and the balance of contrasting pronouns "je / toi / je / toi," in a sequence whose exaggeration is precisely the determining factor in its poetic effectiveness, the lines

J'ai tant rêvé de toi

. . .

J'ai tant rêvé de toi
(*DP*, p. 95)

(I have dreamed of you so often

. . .

I have dreamed of you so often)*

take on an overtone of myth, an assurance of import greater than the simple number of accumulated recurrences. In the poems of *Les Ténè-bres*, the poet points to the arrangement of a woman's hair, calling it an "idée fixe," or an obsession:

Mais tes cheveux si bien nattés

. . .

Mais tes cheveux si bien nattés ont la
 forme d'une main.
(*DP*, p. 115)

(But your hair so neatly braided

. . .

But your hair so neatly braided has
 the form of a hand.)*

Even the initial "but" calls our immediate attention to the unprepared quality of the image. Although it has no logical place in the poem, it surges forth from the flow of words to control the subsequent direction, arresting the vision and concluding the poem, which it turns into an avowal of obsession. Or again, the obsession can be hidden as is the image of a mermaid within the poem "Identité des images," where it

nonetheless controls the poem, each of its images, and its final path, as if the poet were staring into space, absent from the surface or the sober covering of the poem.

Repetitive structures Parallel to the obsessed staring at an object, absent or present, or the fixation on a particular angle, is the series of structures caused by the repetition of phrases—exact or altered—almost as if the poet were stammering. These repetitions and accumulations which serve as a focus here on several occasions take different forms: sometimes a repeated series of lines or images serves as a warming-up exercise, as in Desnos' recommendation for automatic texts and automatic drawings started by any random lines scratched on the surface. For example, one might consider "De la fleur d'amour et des chevaux migrateurs" (About the Flower of Love and the Migrating Horses),* discussed in the next section.

Within this poem presumably focused on a flower, all the interest built up about this object of obsession is finally turned away, as the last four lines show, in their exact repetition, a band of migrating horses capturing the spectacle and galloping on beyond the space of the poem. We might call this a *deflective* process, for the initial direction is changed, suddenly and drastically. The poet stares out at the horses just as he is about to speak of himself, or so he has said; is he no more in control of his text than is the reader? Or again, in the same collection, "La Voix de Robert Desnos" (The Voice of Robert Desnos),* which begins its meditation on metaphoric discourse in a halting manner: "Si semblable à .../ et au .../ au .../ ... aux .../ au .../ si semblable à .../ et à la ..." (so like ... like ... like). The elements are here of less importance than their combined weight; this momentum becomes, then, the source of the poem's "flux" or progression or of its final self-destruction. The poet, drunk on his own poem, betrays his intoxication with his words. And ironically, the successive phrases built up about the woman loved—as elements of the universe effectively summoned—are shown at last to be useless: she neither listens nor responds. The tragic end can be read as plaintive, the poet having lost control of his voice, his poetic power, and of the text itself.

As opposed to straight-line patterns, where the poem is clearly directed toward an end prepared by its development, the texts of Desnos are prone to sudden veerings, swerves, and deviations. The pathetic lament in "En Sursaut" (Startled)* is symptomatic of the tone of many of these poems: "Je ne sais pas où je vais..." (*DP*, p. 150). (I

don't know where I'm going. . . .) For instance, "Vieille clameur" (Old Clamor), still in *Les Ténèbres,* is built on the repeated and jovial toast, "Here's to you!" But it is suddenly transformed into a poem of lamentation, as the joviality turns to the negation of possible continuity, a negation stressed by the number of preceding affirmations:

Salut de bon matin quand l'ivresse est commune. . .
 . . .
Salut de bon matin à la fleur du charbon la vierge au grand
 cœur qui m'endormira ce soir
Salut de bon matin aux yeux de cristal aux yeux de lavande aux
 yeux de gypse aux yeux de calme plat aux yeux de sanglot
 aux yeux de tempête
Salut de bon matin salut
La flamme est dans mon cœur et le soleil dans le verre
Mais jamais plus hélas ne pourrons-nous dire encore
Salut de bon matin tous! crocodiles yeux de cristal
 orties vierge fleur du charbon vierge au grand cœur.
(*DP,* p. 127)

(Early morning greetings when drunkenness is shared. . .
 . . .
Early morning greetings to the flower of coal the generous
 virgin who will put me to sleep tonight
Early morning greetings to the eyes of crystal to the
 eyes of lavender to the eyes of gypsum to the eyes
 of dead calm to the eyes of sobs to the
 eyes of storm
Greetings early morning greetings
The flame is in my heart and the sun in the glass
But never again alas! will we be able to say again
Early morning greetings everyone! crocodiles crystal eyes
 thistles virgin flower of coal generous virgin.)

The accumulation thus denied, and noticeably, by the repetition of the identical phrase used originally to build up the effect, has the effect of canceling out the text itself, here only a drunken song.

In certain cases, the cessation of poetic power appears to come from without, from some universal menace. But on occasion, and more characteristically, Desnos testily denies what he himself has said, as if one had challenged him. In "Passé le pont" (Past the Bridge) after

proffering a menace, he takes it back hurriedly, acknowledging that he was out of control:

> Je n'ai pas dit cela.
> Je n'ai rien dit
> Qu'est-ce que j'ai dit?
> (*DP*, p. 149)

> (I did not say that.
> I said nothing
> What did I say?)*

Now, for a surrealist to be out of control suggests, one would have thought, an ideal situation, as if here the automatic power of the poem itself were at last to overrule the conscious hand. But the denial of speech itself entails in every case the denial of the poem: for it is in the mouth that the latter originates, as an oral text coming forth from the unconscious.

Later, when Desnos goes beyond the early intoxication with speech to a more prosaic landscape of sober realism, obsession and obsessive repetition are consciously absent, as is his unique and complicated lyricism, in its statement and its self-denials. The irony of this progression is implicit: with the disappearance of the poet's own symptoms of verbal intoxication there disappears also one of the most valuable sources for his most engaging poetic technique.

Forms

This discussion, dealing as it does wholly with the recognition and analysis of the sorts of repetition just discussed—now seen in the abstract—will precede the further discussion of the substance of the poems, so that the structural elements can be seen as detached. Finally, a later section will attempt to reconstitute the form and the effect.

In the poems of *A la mystérieuse* the repetition is often present in its simplest form, the transmission of an obsessive idea, such as in the lines we have already seen: "O douleurs de l'amour . . . O douleurs de l'amour"; or again, "J'ai tant rêvé de toi . . . J'ai tant rêvé de toi." And nevertheless they may yield a slightly more complex expression, such as that of an intense alternation between two elements, so that the ground for the poem seems to be composed of the space stretched taut between those elements. As examples of the latter, the poems "Les

Espaces du sommeil" (Sleep Spaces)* and "Si tu savais" (If You Knew)* are both sufficiently long (thirty and thirty-one lines, respectively) to give full play to the working-out of the repetitions: the two poems can be seen as mirror images of each other. In the former poem the two elements "Dans la nuit" and "Il y a toi" (In the night and You are there) begin in rapid alternation *ABAB* and are given a gradual amplitude as the poem slows down and expands on each element.

$$
A \begin{cases}
\text{Il y a toi sans doute que} \ldots \\
\text{Mais qui} \ldots \\
\text{Toi qui} \ldots \\
\text{Toi qui} \ldots \\
\text{Toi qu'en} \ldots \\
\text{Toi qui} \ldots
\end{cases}
$$

$$
B \begin{cases}
\text{Dans la nuit} \ldots \\
\text{Dans la nuit} \ldots \\
\text{Dans la nuit} \ldots
\end{cases}
$$

$$
BA \begin{cases} \text{Dans la nuit il y a toi} \end{cases}
$$

until the final line of ambiguous intent:

$$
C \begin{cases} \text{Dans le jour aussi} \end{cases}
$$

Does the daytime presence undercut or underline the marvelous (mysterious, as in the title) nature of the woman? The ambiguity of meaning depends completely upon the complex structure.

On the other hand, the famous poem "Si tu savais" begins the alternation of its two elements slowly, in an expanded form:

$$
A \begin{cases}
\text{Loin de moi} \ldots \\
\text{Loin de moi} \ldots \\
\text{Loin de moi} \ldots \\
\text{Loin de moi} \ldots
\end{cases}
$$

$$
B \begin{cases} \text{Si tu savais} \ldots \end{cases}
$$

$$
A \begin{cases}
\text{Loin de moi} \ldots \\
\text{Loin de moi} \ldots \\
\text{Loin de moi} \ldots \\
\text{Loin de moi} \ldots
\end{cases}
$$

$$
B \begin{cases} \text{Si tu savais} \ldots \end{cases}
$$

only to end with a more rapid alternation, *AABBBAB*. The poems are thus examples of opposed rhythms, or, one might say, of opposed dynamic structures

It is only in *Les Ténèbres* that the structure of the refrains or repetitions is worked out in its complexity. Again, it is the use of the fixed element which stresses the outline of the poem, making the *architexture* visible.

a. *Repeated unifying image/phrase*

i. In this category the position of the phrase seems to be of little importance. In the examples "L'Identité des images" (analyzed elsewhere) and "Désespoir du soleil," the fixed elements of "coal-master-of-the-dream" and "poem-of-the-day-beginning" are not placed in a rigid framework, but serve simply as incantations and focus within the body of the poem. The recurrence of the statement itself (of the dream, or of the poem) assures the continuity of the poem.

ii. Or again, the one unifying image is carefully positioned, that is, it has no longer an arbitrary situation as in the poem discussed above. For instance, in "Le vendredi du crime" (The Friday of the Crime) the phrase-theme "passez cascades" occurs at regular intervals, in lines 5, 10, and 14; and in the tragic "Personne d'autre que toi", the transformation of a seemingly banal statement of love into a striking admission of loneliness is brought about through the positioning of the repeated line which gives the poem its title: it begins the poem as it is read, acts as its center, and ends it. Furthermore, both the initial and the concluding lines are stressed in a musical third, so that the transformation, like the transposition of mode from major to minor cannot be overlooked here. Thus the phrase occurs in lines 1 and 3, lines 5–9, and lines 14 and 16.

"Trois Etoiles" (Three Stars)* provides an interesting case where the repetitions serve originally as a matter for illusion; that is, the image first presented seems to change its direction during the course of the poem and yet does not. As one reads quickly the opening lines:

A
{
J'ai perdu . . . (I have lost)
(J'ai gagné) . . . (I have won)
J'ai perdu . . . (I have lost)
J'ai tout perdu . . . (I have lost everything)
}

they may seem, all but the second, to stand in direct contradiction to the middle section of the poem:

$$B \begin{cases} \text{Maître du seul vent (Master of the wind alone)} \\ \text{Maître des cailloux (Master of the pebbles)} \\ \text{Maître de tout enfin . . . (Master finally of everything)} \\ \text{Maître de tout . . . (Master of everything)} \end{cases}$$

that is, "j'ai perdu" seems to be the opposite of "Maître": ordinarily, then, $A = \sim B$. But in fact, the loss is first of regret, then of a glory despised, so that there is an implied negation of this negation. He has finally lost all *except* his love, with the result that this losing is seen as equated with winning, and on the same side of the fence, as it were, with mastery. ($A = B$.) So, in this next reading, the line carries through from the beginning positive (under the guise of negative) to the next positive element, or the mastery. But in fact at the center, the preceding refrain—"De tout hormis l'amour de sa belle" (All except the love of his lady)—is picked up and, this time, reversed in implication:

Maître de tout enfin hormis l'amour de sa belle

If, in the beginning, one read "losing negated by keeping":

$$- \overset{\sim}{\leftarrow} +$$

then here one must read "mastery negated by losing":

$$+ \overset{\sim}{\leftarrow} -$$

The triple repetition of this now tragic refrain stresses the beginning irony of the three seemingly negative or "losing" terms against the seemingly positive term "winning": now master of the wind and the pebbles only, he has lost what he most cared about.

b. *The suspension of an image by its awaited recurrence* In the poem entitled "Infinitif" (Infinitive)* because of its form, the entire ten-line sequence depends on the expectancy created by the initial negation, "to die" and "not to die yet":

y *mourir* ô belle flammêche y *mourir*
. . .
ne pas mourir encore . . .
naître avec le feu et *ne pas mourir*
(my italics)

(to die there oh most beautiful flame to die there

. . .

not to die yet . . .

to be born with the fire and not to die)

The poem, made only of infinitive forms ("étreindre," "embrasser," "gagner," "découvrir," "omettre de transmettre," "rire") is sustained and suspended—as the infinitive is precisely a verbal suspension of situation—until the final line:

et mourir ce que j'aime au bord des flammes.

(and die what I love at the edge of the flames.)

c. *Compression, dispersion, canceling out* By the massing together of repeated elements, a structure can be created wherein enough energy is accumulated so that the later occurrences of those same elements or parts of them in isolation from each other act still as carriers of the energy thus built up: one might call this a metonymic reference. For example, in the epic poem "De la fleur d'amour et des chevaux migrateurs," the initial appearance of the flower is strengthened by the amassed comparatives ("more radiant than," "paler than," "sadder than"):

$$A = \begin{array}{l} \text{plus que} \ldots \\ \text{plus pâle que} \ldots \\ \text{plus triste que} \ldots \end{array}$$

so that the poet's abandoning all else in the universe including his own love to speak only of her is formally justified:

Je parle de la fleur de la forêt et non des tours
Je parle de la fleur de la forêt et non de mon amour

The above repetition might be called a doublet and diagrammed like this for convenience, the latter term in each case standing for what the poet does not speak of:

$$A \cdot \sim B$$
$$A \cdot \sim C$$

Later, having built up this paradigm, he can repeat it in a more diffuse version (thus a dispersed doublet), where x stands for an unmarked or neutral line:

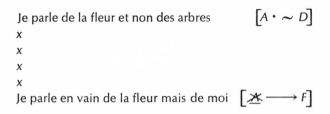

Je parle de la fleur et non des arbres $\quad\quad \left[A \cdot \sim D \right]$

x

x

x

x

Je parle en vain de la fleur mais de moi $\quad \left[\maltese \longrightarrow F \right]$

But the "moi" is more or less equivalent to "mes amours," so that

$$F = C$$

That is, a slight reversal is visible; this object he has built up by comparison and by speech is now left aside and the poet returns to his own concerns, which he was not to speak of before. Finally, however, the entire scene, flower, poet, and the poet's love or recounting of it is swept away by the exterior (migrating) element, a physical interruption then repeated four times for stress; so that the poem might read in the following fashion:

A
$A. \sim B$
$A. \sim C$
$A. \sim D$
$\maltese \rightarrow E \ (= C)$
$\maltese \rightarrow \maltese \ (= C) \rightarrow F$
$\quad\quad\quad\quad F$
$\quad\quad\quad\quad F$
$\quad\quad\quad\quad F$

d. Crescendo and denial The most characteristic process in all the poems of Desnos dependent on the technique of repetition, is the concentration of sentiment or energy about a central focus, and then its undoing. (For instance, as in section 3 above, where the momentum built up about the flower is then denied so that the energy for speech is transferred to the poet, and that energy is then in its turn transferred to the migrating horses as the poet is in his turn denied by the passing spectacle, the poem itself being finally canceled out in favor of the surrounding scene.) The most famous poems of the cycle *Les Ténèbres* show this structure. For example, the first poem, the source of the title for the present study, "La Voix de Robert Desnos"* begins with a formal stressing of metaphor ("So like . . .") as the basis of poetry:

$$A \atop 1\text{--}4 \left\{ \begin{array}{l} \text{Si semblable à} \ldots \\ \text{au} \ldots \\ \text{au} \ldots \\ \text{si semblable à} \ldots . \end{array} \right.$$

It then continues with the metaphoric task, extended here in fifteen lines of quantitative accumulation:

$$B \atop 1\text{--}15 \left\{ \text{j'appelle} \ldots \right.$$

and lastly, widens the scope of poetic summons to the woman loved, a task different from *B*, and marked as different by the exact repetition of the lines unchanged ("I call the one I love"):

$$3C \left\{ \begin{array}{l} \text{j'appelle celle que j'aime} \\ \text{j'appelle celle que j'aime} \\ \text{j'appelle celle que j'aime} \end{array} \right.$$

Then the effort of *B* is proved efficacious in another long stretch of related lines—thirty-four separate but connected answers to his summons, and yet the effort of C, more important than all the rest, is found invalid, in a set of three parallel negations:

$$\sim \text{C1--3}$$

The accumulations in "Avec le cœur de chêne" (With Oaken Heart)* are of a different sort altogether, not massive and quantitatively important; rather one unit is added at a time, as in children's songs. The tone is therefore light, in spite of the underlying negation ("I love another") —as always, it is the structure of the repetitions which controls the tone. The pattern is simple: after the initial question, How much *A* and *B* does it take to produce *CDE?*, the alternating responses add one element each time to the refrain. When this number of additions is present, and in such a controlled fashion, the form is plainly meant to be accented over the words themselves:

$AB \longrightarrow CDE?$
AB
 $+ C$
ABC
 $+ D$
$ABCD$
 $+ E$
$ABCDE$

In the middle of the poem, the mention of death and varnished leaves (thus, nature denatured) turns the direction of the poem, so that the accumulation is negated and the poem begins afresh; this time, however, the accumulation is not prepared by the help of an intervening refrain. The final explanation, "J'en aime une autre qu'Isabelle la vague" (I love another than Isabelle the Vague), takes place before the final summing up, which is therefore determined only by form, certainly not by any cumulative optimism as was the case in the first part:

AB
—
ABC
—
ABCD
—
ABCDE

"De la rose de marbre à la rose de fer" (From the Marble Rose to the Iron Rose)* is again simple in structure like a child's poem. The seven roses, each placed in a long verse according to their different material (marble, glass, coal, etc.) have accreted around them a series of appropriate descriptive phrases so that the accumulation in each line is self-contained, all the linguistic energy being absorbed by the initial element. Then all these elements, assured of eventual rebirth, are negated, their petals strewn on the rug like so many adjectival phrases dispersed, the whole series of descriptions reduced to the prime element:

$$(A_1 \ldots A_7)$$
$$\sim (A_1 \ldots _7)$$

And this negation is the mysterious definition of the one who negates the preceding elements:

$$x = ?$$
$$x = \sim (A_1 \ldots A_7)$$

e. *Accumulation and reversal* A ten-line stanza of the same light tone as "Avec le cœur de chêne" and, like it, interesting mainly for its form, "Chant du ciel" (Sky Song)* demonstrates the technique of advancing and receding elements, toward and away from the center,

which remains alone. Each element (the sky, the waves, etc.) speaks to the second element of its virtues, then the second speaks to a third until the poet at the center is addressed; he, of course, speaks only of his love (F:G!) The other speakers, after speaking of her also, then withdraw, and he is left to speak of her alone. One might read this:

$$
\begin{aligned}
A \rightarrow B \quad &: \quad B! \\
B \rightarrow C \quad &: \quad C! \\
C \rightarrow D \quad &: \quad D! \\
D \rightarrow E \quad &: \quad E! \\
E \rightarrow F \quad &: \quad G! \\
D \longleftarrow F \quad &: \quad G! \\
C \longleftarrow F \quad &: \quad G! \\
B \longleftarrow F \quad &: \quad G! \\
A \longleftarrow F \quad &: \quad G! \\
? \leftarrow F \quad &: \quad G!
\end{aligned}
$$

Here, all the weight of the preceding conversation is absorbed in the final exclamation, as the poet speaks either to himself or to us.

f. *Denial of speech* Typical of Desnos, the denial of the substance of the poem and of its structure is brought about by the denial of speech itself when the speaking may refer by implication to the poem. Thus in "Vieille clameur" (Ancient Clamor)* the concluding section, based on the repeated greeting "Salut de bon matin" (four times) is suddenly cut off by the next to the last line, "Mais hélas ne pourrons-nous dire encore" (But alas shall we never again be able to say), placed before the final repetition. Where \diamondsuit indicates possibility,

$$A_{1-4}$$
$$\sim \diamondsuit A$$
$$A$$

In "Passé le pont" (Past the Bridge), the entire structure, built upon the closing of the door and the plea for quiet, with its implied menace ("Taisez-vous. . . . Laissez-la dormir ou bien j'affirme que des abîmes se creuseront" [Be still. . . . Let it sleep or else I say that abysses will be dug]), is challenged by a middle section in which speech or the act of speech just performed by the poet is canceled out. The end, which repeats the beginning, is placed in an ambiguous situation. Was the menace denied or just the plea?

A

$B \vee C$

$\sim (B \vee C?)$

B

In all cases, the repetition underlines and stresses the structure as well as the theme of a love lost and haunting. The techniques of accumulation, deflection, reversal, denial, dispersion can all be seen as relating to that love, to those shadows, or seen alone, on the surface of the text itself, in their profundity and textural complexity.

A Poetry of Shadows

Les Ténèbres contains some of the most complex surrealist poetry ever written. The twenty-four poems demonstrate a wide range of forms, from the several dense circular poems of ten or eleven lines in which the end joins on to the beginning, to far longer poems where the brief conclusion is occasionally set apart from the main body of the poem in a formal echo to the isolation felt within the poem itself. The length of the lines ranges from a single word (for example, "Crie") to an uninterrupted flow of a hundred words; there are prose poems with as many as six sentences included in the space of one indentation, others with shorter and evenly spaced divisions and of a repetitive form, while a few poems show an extremely various and complex texture, where for instance among sixteen short lines there suddenly appears a very long one, completely distinct in tone. Within these poems of description, of statement, of lamentation, an extensive series of questions ("Eh quoi?" [What then?]), threats ("Mort à la voile blanche" [Death to the white sail]), exclamations ("Quelle évasion!" [What an escape!]), break up the interior rhythm. Yet the latter may be balanced by an equally extensive series of appositions whose links are assured, if not made explicit, so that the surface jerkiness overlies a genuine continuity:

> L'infini profond douleur désir poésie amour révélation miracle révolution amour l'infini profond m'enveloppe de ténèbres bavardes (DP, p. 143)

> (The profound infinite sorrow desire poetry love revelation miracle revolution love the profound infinite surrounds me with talkative shadows)

The strength of the passage is such that the elements in apposition tend to fuse with one another, without the daylight banality of connectives which would, ironically, weaken the sense of enveloping shadows and the unmarked interior cohesion they surround.

Now Desnos, like the baroque poet he partly is, chooses images of light to play against dark, of flowering and fire to play against the depths. In particular, the star, the crystal bottle, and the sea are paralleled by and opposed to coal, anemone, abyss within the imaginative focus of his writings, which he considered to be the individual and visible parts of one long poem "elaborated from birth to death." These images and the works containing them are all closely linked, as around the central focus of a star various ideas spread partial illuminations. Now the star suggests to Desnos the starfish—that is the mermaid also, the captivating singer of sailor songs or Yvonne George—and thus the starfish of the "anti-poem" La Place de l'étoile, written in 1927 and revised in 1944, is at once connected with the sky and the sea: she reappears in Man Ray's film L'Etoile de mer, based on Desnos' poem or anti-poem. In the long poems "Sirène-Anémone" and "Siramour," the mermaid and the star are sisters and rivals, the star vies with coal too as a giver of equal light, thus the fire and the sea are joined, and opposed to the shadows, darkness, and ashes which are their doubles. Just so, desert and town, sea and sand, voyage and shipwreck, forest and road are seen as inseparable complementaries, each leading to the other, so that the notion of crossroads or conjunction remains primary in the imagination for the reader as for the poet. A theoretical and metaphoric basis for this reliance on opposites juxtaposed can be found in all the images of communicating vessels and conducting wires common to the theories of surrealism. The violence of the illumination depends often on the unexpectedness of the opposed elements, but in Desnos it depends rather on the repetitions of a small number of images in their interconnections.

Desnos makes a frequent and complex use of interpenetrations of images and of their mutual definition. In a typical poem of these years, the convergence of imagery is so marked as to make possible the suppression of one central image, all the while pointing implicitly to that image as the location of the original impulse for the poetic statement. If the image said to be suppressed in one poem appears frequently as the clearly predominant element of other texts, the initial perception of its centrality receives additional support.

Often within a particular poetic universe of great cohesiveness, constructed about a constantly recurring small number of images each of

equal importance, a central poem can be found whose elements and their interrelations may serve as paradigms for all the other poems, whatever their date. Each poem of the given set may point in some way, explicitly or implicitly, to this particular key poem. Rather than discussing abstracted components of the poet's sensibility, style or his images, the reader may choose (usually through a series of experiments) the text which appears central to him, distinguish in that text the salient factors, explaining how they are marked as high points (set off from the others by the poet), and what other elements in the text justify or determine them. Then those stressed elements should be matched to those same elements stressed elsewhere in order to sketch a precise or post-text profile of the particular poetic imagination in question. Any poem and any series of poems can be read in both directions, so that an image may be justified by one following it, and vice versa. A text written before another can be retrospectively clarified by the later one; these parallel readings stress the continuity of a particular language, of the chain of obsessive imagery over the discontinuity of chronological points taken as separate texts.

It is within *Les Ténèbres* that the most significant clues to Desnos' evolution are to be found. This collection contains twenty-four connected aspects of tenebral vision, corresponding, perhaps, to the hours of the night and day seen as the temporal space of the continuing surrealist dream (as in Breton's *Vases communicants*). The alternations of night / day, language / silence, faith / doubt, or love / loneliness often perceived in the other surrealist poets are arranged in more difficult patterns than is customary in the poetry of Tzara, Eluard, Péret, or even Breton. Sometimes apparent, and sometimes hidden within the poem, are various complicated and disturbing oppositions of involvement and separation between the poet and the poem, between the poet and the language or vision, between the poet and the reader. The overall force of the poems seems to deny the power of poetic language and the marvelous vision by the disintegration of elements within the poem, while the poet seems to pursue his adventure beyond the space of the poem, thus denying us any participation in it. At least three possible interpretations can be given of this poetic attitude: first, that Desnos' experience necessarily bars any observer. This might be true, but no more so for him than for any of the other surrealists; consequently, it would not be sufficient to explain the peculiar nature of his poetry. Second, that Desnos is here predicting, implicitly, his final journey beyond the surrealist experience of the shadows to the more open poem of

the day ("poème du jour") which he mentions in two of these texts. Finally, that these poems are a confirmation of Desnos' own statement that beyond all free poetry there is the free poet; the two latter explanations form the basis for the present study.

Even if the experiments with language and with dream had proved to be endlessly rewarding, even if he had felt no constriction within their framework, Desnos would have chosen to move beyond them. Since he always maintained, and to a far greater extent than any of his companions, the absolute separation of every second from the next, it is probably his constant rejection, in principle and in fact, of all the experiments already undertaken which finally determines his evolution beyond the limits of the shadows. *The Night of Loveless Nights,* published three years later than *Les Ténèbres,* begins with an invocation of night (closely resembling Tzara's texts of darkness in *L'Antitête* called "Avant que la nuit"):

Nuit putride et glaciale, épouvantable nuit
Nuit du fantôme infirme et des plantes pourries,
Incandescente nuit, flamme et feu dans les puits
Ténèbres sans éclairs, mensonges et roueries.
(*DP,* p. 215)

Putrid and glacial night, terrifying night
Night of the sick phantom and of rotted plants,
Incandescent night, flames and fire in the wells,
Shadows, without flashes, lies and knaveries.

and ends by another simple evocation calling for the overthrow even of the realm of poetic darkness just created: "Tais-toi, pose la plume / . . . / O Révolte! Quiet! put down your pen / . . . / O Revolt!" (*DP,* p. 235)

This whole realm of shadows is itself an exploration of the language and the goal of the poetic adventure, centered about the themes of love and dream, alternating with recurrent strains of loneliness and suffering, as well as more violent references to suicide, strangling, and murder. The poems of speech and poetic metamorphosis are countered by those of silence and despair, the images of the marvelous by those of bareness, negation, and destruction. Now, according to surrealist theory, this negation of language and love can be considered an exemplification of the necessary contraries and their resolution. For each element is always juxtaposed with its polar opposite, the resulting and marvelous union approximating, on the metaphysical level, a *point sublime,* and on the

human level, poetry. In this light, such a collection represents, even at the point where it denies its own language, an unsurpassed creation of polarity and ambiguity.

Day and Night

Dawn: "Désespoir du soleil" Even in the period of *Les Ténèbres*, Desnos writes a few poems of relative simplicity, and some of them read like exact poetic transcriptions of certain theoretical attitudes already discussed. In the poem entitled "Désespoir du soleil" (Despair of the Sun)* which appears in a series directly after four titles alluding to day and night, "Le Suicidé de nuit," "Pour un rêve du jour," "Il fait nuit," and "Nuit d'ébène" (Night Suicide, For a Day Dream, It is Night, Ebony Night), the two poles of optimism and pessimism meet. However, the general tone seems to deny the despairing element, in keeping with the positive direction of surrealism.

> Quel bruit étrange glissait le long de la rampe d'escalier au
> bas de laquelle rêvait la pomme transparente.
> . . .
> L'escalier s'enfoncera-t-il toujours plus avant?
> montera-t-il toujours plus haut?
> Rêvons acceptons de rêver c'est le poème du jour qui
> commence.
>
> (What strange noise was gliding along the banister at whose
> base the transparent apple dreamed?
> . . .
> Will the staircase always sink lower?
> will it always mount higher?
> Let us dream be willing to dream it's the poem of day
> beginning.)

The theme is thus as simple as the implied dualities: a sphinx who leaves the desert to investigate the mysterious sound is contrasted with a man totally devoid of mystery, calmly cleaning the steps in a banal routine gesture. The invocation of dream coincides oddly with the beginning of daytime reality, and the central image of the staircase obviously suggests both upward and downward motion, made explicit in the verbs "s'enfoncer" and "monter." The entire mood is optimistic, with the accent falling on the question of widened range: "L'escalier

s'enfoncera-t-il . . ." and on the indirect but definitely positive answer about the fresh beginning of the dream and of the day. The smaller elements are also positive, such as the transparent apple (or round banister knob)[5] at the bottom of the staircase; of course, in the surrealist universe, temptation is the greatest good, and the highest compliment the poet can address to an object is to see it as crystalline. This poem is of a simple clarity consonant with the subject.

As one would expect, however, it is not the poem of the day which forms the center of this or any surrealist collection of texts. Although Breton alludes, at the conclusion of *Les Vases communicants*, to the eventual possibility of carrying on the poetic or alchemical work in daylight, our attention is usually focused on the irrational and inexplicable. The image of the communicating vessels of day and night or of reality and dream—an image which we perceive as transparent because of Breton's many references to the crystal and the diamantine clarity he desires in his life and work—is, like the crystal itself, an image typical of the 1930 decade of surrealism. In the early years of the movement, when obscurity was valued for its ambiguous power to illumine, Desnos' favorite image of coal was perhaps more appropriate, as he describes it in the passages from "Sirène-Anémone" already quoted, and in the litanic and impressively monotonous central poem "Identité des images." As the mentor of his dreams and of his solitude, coal or the nocturnal fire it represents serves as the basic image for all the texts from this period. Since they can best be seen from his particular starting point, it is essential to study that image / source as it is simultaneously revealed and suppressed, in order to show the ambiguous character of a typical Desnos text, marked by multiple signals pointing only to an absence strongly felt.

Dream and dreamer: "Identité des images," "La Chambre close" As a paradigmatic indicator of Desnos' poetic universe of 1926–27 and of the great series of testimonials to mystery and to the power of shadow, to which the titles *A la mystérieuse* and *Les Ténèbres* bear witness, I shall briefly consider the central or key poem called "Identité des images," from the latter collection. As the title already indicates, the poet here refuses—as, in fact, he always does—to make traditional categorical separations between elements, real or imaginary. All the elements mentioned within this poem are equivalent to each other; they are also equivalent paths leading finally to the center of the labyrinth hidden inside the obvious fabric of the text.

In this poem, itself the center of the poems clustered about it, the central image, implicit but suppressed, the real underlying support for a series of other images and developments of thought, is that of the mermaid.

> Ma sirène est bleue comme les veines où elle nage
> Pour l'instant elle dort sur la nacre
>
> . . .
>
> Mais le ciel de ma sirène n'est pas un ciel ordinaire
> (DA, p. 97)

> (My mermaid is blue as the veins in which she swims
> For the moment she is asleep on mother-of-pearl
>
> . . .
>
> But my mermaid's sky isn't an ordinary sky)

As the heroine of Desnos' novels and of his poems, the mythical incarnation of the "mystérieuse" herself, and the sole permanent resident of Les Ténèbres, the mermaid, who is also and simultaneously the star, Melusina, and the soror of the alchemists, serves both as guide and as temptress. Her presence is here so strongly felt that any specific mention, however trivial, of her noble and awful role is a metonymic indication of the whole series of forces with which she is associated; thus, the mention of a "belle nageuse" is already, for the initiated, an incantation of the power of dream.

But without a preliminary understanding of this role and these forces, of the substitution or suppression of the central idea and its open acknowledgement by the reader, the poem feels hollow, its deliberate incantatory quality seems an exaggerated formal play, undertaken to no emotional end. Once the hidden center is exposed in its formal absence, the true identity of bottle and fragments—form a whole of which the single identity is finally apparent, as well as the identification of each image with every other. "Identité des images" (Identity of Images) then, stands out among the other poems as an enigma capable of resolution, as a clue to the lyric labyrinth, a clue which has at its own center another labyrinth, whose Minotaur is a mermaid.

Identité des images

> Je me bats avec fureur contre des animaux et des bouteilles
> Depuis peu de temps peut-être dix heures sont passées l'une après
> l'autre

La belle nageuse qui avait peur du corail ce matin s'éveille
Le corail couronné de houx frappe à sa porte
Ah! encore le charbon toujours le charbon
Je t'en conjure charbon génie tutélaire du rêve et de ma solitude
 laisse-moi laisse-moi parler encore de la belle nageuse qui
 avait peur du corail
Ne tyrannise plus ce séduisant sujet de mes rêves
La belle nageuse reposait dans un lit de dentelles et d'oiseaux
Les vêtements sur une chaise au pied du lit étaient illuminés par
 les lueurs les dernières lueurs du charbon
Celui-ci venu des profondeurs du ciel de la terre et de la mer était
 fier de son bec de corail et de ses grandes ailes de crêpe
Il avait toute la nuit suivi des enterrements divergents vers des
 cimetières suburbains
Il avait assisté à des bals dans les ambassades marqué de son
 empreinte une feuille de fougère des robes de satin blanc
Il s'était dressé terrible à l'avant des navires et les navires n'étaient
 pas revenus
Maintenant tapi dans la cheminée il guettait le réveil de l'écume
 et le chant des bouilloires
Son pas retentissant avait troublé le silence des nuits dans les rues
 aux pavés sonores
Charbon sonore charbon maître du rêve charbon
Ah dis-moi où est-elle cette belle nageuse cette nageuse qui avait
 peur du corail?
Mais la nageuse elle-même s'est rendormie
Et je reste face à face avec le feu et je resterai la nuit durant à
 interroger le charbon aux ailes de ténèbres qui persiste à pro-
 jeter sur mon chemin monotone l'ombre de ses fumées et le
 reflet terrible de ses braises
Charbon sonore charbon impitoyable charbon

(Identity of Images)

(Furiously I fight with animals and bottles
In a short space of time perhaps ten hours have passed one after
 the other
The lovely swimmer who feared the coral this morning awakes
The coral crowned with holly knocks at her door
Ah, the coal again always the coal

I beg you coal tutelary genius of the dream and of my solitude let
me let me speak again of the lovely swimmer who feared the
coal

Tyrannize this seductive subject of my dreams no longer

The lovely swimmer rested in a bed of lace and birds

Her clothes on a chair at the foot of the bed were lit by the glim-
mers the last glimmers of coal

Come from the depths of the sky and of the earth and of the sea
the coal took pride in its coral beak and in its great crepe
wings

All night long it had followed divergent funerals toward suburban
cemeteries

Attended balls in embassies marked with its fern imprint white
satin dresses

Had risen terrible before the ships and the ships had not returned

Now crouched in the chimney it awaited the awakening of foam
and the song of teakettles

Its reverberating step had troubled the silence of nights in the
streets with resounding paving stones

Coal resounding coal master of the dream coal

Ah tell me where is she this lovely swimmer this swimmer who
feared the coral?

But the swimmer herself has gone back to sleep

And I remain face to face with the fire and I shall remain the night
long questioning the coal with shadow wings who persists in
casting over my monotonous path the shade of its smoke and
the terrible reflection of its embers

Coal resounding coal merciless coal)

The world of fire and shadow, the flickering opposite of the static
and seemingly certain daytime world, does not require or even permit
the fixed categorical relations essential to the formal and descriptive
balance of "normal" linguistic construction. In the latter, for example,
following the initial fight with "animals" in the first line, one would
have expected a general balancing expression such as "men" or "things"
or "myths." But here both a linguistic and a thematic emphasis are
placed on the unbalancing of the terms, as in this juxtaposition of the
animate with the inanimate. Furthermore, the specific and banal term
"bottles" might seem only realistic to the reader unaware of the pro-

fusion of crystalline images in this period, of the crystal mountains and glass corridors in the essays of Tristan Tzara, of Breton's salt cubes in his "éloge du cristal" (praise of the crystal), of Benjamin Péret's images of fountains and windows, of the mirrors of Aragon and Eluard. When this bottle shatters into glass splinters, these "tessons" haunting all the early work of Desnos, it is a signal that the darkest moments of consciousness are at hand, that the disintegration of the brilliant dream is an imminent reality. When, on the other hand, it contains a message, we may read that as the opposite signal, as the definite indication of the possible link between the world of adventure and the world of the poet's écriture.

The legendary marvelous power of the mermaid who enchants is here altered in direction. The swimmer, beautiful as ever but less powerful, is herself afraid: the knock on the door and the verbal suggestion of a funeral wreath threatening even in the world of dream are faintly menacing, although the menace seems to originate in the apparently neutral image of coal. Why should this "guiding genius of dream and solitude" be considered tyrannical ("encore ... toujours ... je t'en conjure ... ne tyrannise plus") unless it be that the poet has precisely no control over his dream, neither in regard to its subject ("ce séduisant sujet") nor in regard to its outcome?

The seduction is double. As the mermaid seduces the poet, albeit in the guise of a simple swimmer, she is in turn seduced by the image of coal which casts light upon her discarded clothing and is seen, retrospectively, to have furnished the luxurious elements for the bed where she reposes. The latter is made of lace and also of feathers or down, these latter images only hinted at by the actual term "oiseaux" in the line which is thus literally unbalanced as was the first one, according to a surrealist technique recommended by Breton. The coral-red protruding beak of the coal is the visual support for the image of the bird with its black crepe wings: as the substance of the coal burns away, the charred and paper-thin shell which remains flutters in the hot air. The tissue suggested, crepe-like, is seen as the possible determination of the lace on the bed, the latter now doubly connected to the image of the bird and, by extension, to its flight. Crepe and lace, feathers, beak, and wings, nighttime repose and fire, the red of coral and of burning coal, in glaring contrast to the black of mourning—all these interconnections tie the fire to the dream. The elements of water ("la belle nageuse") and fire ("charbon sonore") meet in a rarefied atmosphere of sonority and

silence, hope and threat: it is this "bec de corail" and these mourning wings of black crepe which predetermine, in the context of the poem, the mermaid's fear.

After this preliminary warning of the risk incurred in dream, the poet elaborates on the images of mourning ("enterrements divergents"), the signs of death even in the midst of splendor ("marque de son empreinte . . . des robes de satin blanc")—the latter image of luxury corresponding to the lace and feathers of the bed—and of shipwreck, where the coal takes upon itself the traditional role of the mermaid, enchanting the sailors whose ships will never return.

This development of imagery should be compared with two other passages on shipwreck which are as stationary in form as the trapped vessels. In the first example, static spectacle and certain knowledge ("je sais," "je connais") replace action; in the second, memory and uncertainty interrupt a statement which technically affirms, in its lengthened form and retarded rhythm, its own non-moving character.

> Navire en bois d'ébène parti pour le pôle Nord voici que la mort se présente sous la forme d'une baie circulaire et glaciale, sans pingouins, sans phoques, sans ours. Je sais quelle est l'agonie d'un navire pris dans la banquise, je connais le râle froid et la mort pharaonique des explorateurs arctique et antarctiques. . . . (LA, p. 49)

> (Ebony ship departed for the North Pole, now death appears in the form of a glacial bay of circular form, without penguins, without seals, without bears. I know the agony of a ship caught in the ice-floes, I recognize the cold death rattle, the pharaoh's death met by Arctic and Antarctic explorers. . . .)

> La carcasse du navire naufragé que tu connais—tu te rappelles cette nuit de tempête et de baisers? — était-ce un navire naufragé ou un délicat chapeau de femme roulé par le vent dans la pluie du printemps? — était à la même place. (DP, p. 144)[6]

> (The carcass of the shipwrecked vessel which you know—do you remember that night of storm and embraces? Was it a shipwrecked vessel or a woman's delicate hat tossed along by the wind in the spring rain? Was in the same place.)

Elsewhere the poet says plainly that he longs for this shipwreck, that it has been the object of all his surrealist adventure. He does not say that a hidden mermaid lures him to the shipwreck: the song is hidden

within the poem's more apparent language. Here menace and adoration are identified, forming the parallel leitmotifs of the voyage. The sailor trapped and consciously immobile is one in the poetic imagination with the dreamer as he wakes from an unmoving position, physically still in spite of his nocturnal adventures now evaporated. They are seen to have led nowhere, except back once more to the fireplace beside which he dreams.

For a poet so devoted to mental adventure as Desnos, the penetrating irony of the line

> Maintenant tapi dans la cheminée il guettait le réveil de l'écume et le chant des bouilloires

> (Now crouched in the fireplace it awaited the waking of foam and the song of kettles)

could scarcely be more noticeable, introducing as it does the recollection of the resounding steps on the cobblestones as they hold sway over the silence of the night outside the room, beyond the place of the poem.[7]

But again, in the rhythm of elation and deception characteristic of Desnos, the coal is suddenly placed in a humble position of discrete watchfulness—no longer guide, genius, tyrant, but spy—as it hides, watches, awaits the sad contrast of the waking sea foam, an image of freedom, with the kettle it causes to sing, pathetic image of a sedentary existence of comfort at the close of adventure.

And yet the coal keeps within itself the memory of those footsteps ("pavés sonores / charbon sonore") and, by implication, of the mermaid's song, a combination sufficiently strong to reply to, even to override the banal singing of a teakettle. Here the dominating image of the seductive mermaid, suppressed as it is in the written texts, makes itself known through the echo of song.

The explicit image of the sleeping swimmer replaces the implicit image of the mermaid, as the poet's ideal companion for his dream; she eventually abandons the poet to his lonely vigil by the fire whose double spectacle of flickering illumination and fearful blackness, of terrible brightness (thus the fear of coral expressed by the mermaid) and equally terrible shadows (its songs of darkness, the shadow of its smoke), absorbs within it the singing of the mermaid together with her own pitiless nature. The intricate transferrals and shiftings of imagery reflect the flickering form of the light here illuminating the dream.

This poem in its desperate and understated loneliness prefigures the final and complete desertion of the poet by the mermaid, described most vividly in the long poem "Sirène-Anémone," where her presence is plainly announced in the title. This central preoccupation appears as clearly in the tone of the text, written in the year of the poet's actual separation from surrealism, as in any of his invocations to shipwreck. The farewell here is at once a farewell to the guiding image of his work, and to a particular form of that work over which the mermaid as muse presided, explicitly or implicitly. Here the former understatement gives way to open regret, as the hidden source becomes apparent at the very moment of departure.

> Adieu déjà parmi les heures de porcelaine
> Regardez le jour noircit au feu qui s'allume dans l'âtre
> Regardez encore s'éloigner les herbes vivantes
> Et les femmes effeuillant la marguerite du silence
> Adieu dans la boue noire des gares
> Dans les empreintes des mains sur les murs
> . . .
> Adieu dans le claquement des voiles
> Adieu dans le bruit monotone des moteurs
> Adieu ô papillons écrasés dans les portes
> Adieu vêtements souillés par les jours à trotte-menu
> Perdus à jamais dans les ombres des corridors
> Nous t'appelons du fond des échos de la terre
> Sinistre bienfaiteur anémone de lumière et d'or
> Et que brisé en mille volutes de mercure
> Eclaté en braises nouvelles à jamais incandescentes
> L'amour miroir qui sept ans fleurit dans ses fêlures
> Et cire l'escalier de la sinistre descente
> . . .
> Tandis qu'au large avec de grands gestes virils
> La sirène chantant vers un ciel de carbone
> Au milieu des récifs éventreurs de barils
> Au cœur des tourbillons fait surgir l'anémone.

> (Farewell already among the porcelain hours
> See how the day darkens at the fire lit in the hearth
> See how the living grasses depart
> And how the women pluck the petals from the daisy of silence
> Farewell in the black mud of stations
> In the imprints of hands on the walls

. . .
Farewell in the snapping of sails
Farewell in the monotone roar of motors
Farewell butterflies crushed in the doors
Farewell garments soiled by scampering days
Lost forever in the shadows of corridors
We summon you from the bottom of earthly echoes
Sinister benefactor anemone of light and gold
And broken into a thousand twirls of mercury
May it shine forth in new embers forever incandescent
This love this mirror which for seven years flowered in its cracks
And polishes the staircase of the sinister descent
. . .
While on the deep with great virile gestures
The mermaid departs singing toward a carbon sky
Who at the center of the murderous reefs
In the heart of whirlwinds makes the anemone flower.)

The mark first made by the coal of death on the majestic white ball dresses is made now by human hands on simple walls. All the once noble images of bird flight and sailing and shipwreck are transformed now into the more banal and less legendary snapping of sails or the monotonous roar of motorboats. No longer is the door of beauty decorated with a wreath; rather the most delicate and fragile insect is crushed in the closing door. The clothing is no longer illuminated by the firelight or placed in implicit correspondence with the luxurious covering of a bed; it is only soiled by daily and trivial cares. And the poet who once dreamed of adventure by the fireside is now lost with his fellow poets in a subterranean labyrinth.

But the fire itself, taking its source in the depths of the earth like the poem drawing its strength from its hidden center, sings the way toward a sinister fall which is now adventure enough.

Maîtresse généreuse de la lumière de l'or et de la chute
. . .
Maîtresse sinistre et bienfaisante de la chute éternelle

(Generous mistress of light of gold and of the fall
. . .
Sinister and beneficent mistress of the eternal fall)

At last the coral of fire, the anemone of light, and the mermaid of

poetry merge in a final luminous identification of all the guiding images of the unified and difficult universe of Desnos. As the mermaid swims out to sea, beyond the reach of the poet's voice or vision, as the living images in their turn depart or are destroyed, all the texts converge in this integral, central, and ultimately tragic perception.

Separation and Loneliness: "Il fait nuit," "Paroles des rochers"

Unlike the preceding collection, A la mystérieuse, where the dreams included the presence, however illusory, of a woman—"J'ai tant rêvé de toi," (I Have So Often Dreamed of You) "Dans la nuit il y a toi," (In the Night You Are There)—in Les Ténèbres, the dreams of both the waking and the sleeping hours of night seem to be associated with the poet's inevitable solitude, with his "monotonous path" along which he moves alone. When the subject of his dreaming is a beautiful swimmer, whose clothes cast aside on the chair are illuminated by the last glow of the embers, only she sleeps, while the poet remains awake by the pitiless coal of the fire. He was her companion neither in the water, for him the supreme image of adventure, nor in her dream, which he cannot make his. And the poem "Il fait nuit" (It Is Night), at the end of which the poet goes to sleep beside the extinguished lamp, begins with his acceptance of solitude, as if it were the necessary prior condition for the advent of the marvelous dream. A certain closure or isolation from the outside precedes the possibility of grace:

> Tu t'en iras quand tu voudras
> Le lit se ferme . . .
>
> (You will go away when you wish to
> The bed closes up . . .)

Elsewhere, however, Desnos warns that one should choose the tragic atmosphere of love over the "pays fabuleux de cauchemar et du rêve" (the fabulous country of nightmare and dream), as if there were never any possibility of choosing both.[8]

All these poems having the bed of the dreamer for their scene are illuminated, from another perspective, by the poem "La Chambre close," included in the recently published Destinée arbitraire. In particular, "L'Identité des images" is reflected in it like a mirror image so that many of the basic elements are reversed. In place of the firelight flickering over the clothes by the bed, as in the nocturnal scene of the

poem previously discussed, the sunlight comes here to play on the bedclothes and the pillow, while a dress on the chair alongside the bed is agitated "by the breath of a strange breeze." The single hair said to be trembling on the sheet folded back seems, in the context of this accentuated emptiness, the discarded dress, and the mysterious draft, less absurd than touching, a possible indication of the memory of past love, or then a mocking of present beauty soon to be reduced. (It is in all probability identified by the reader as a metonymic representation of the one who would be resting there, and is thus the counterpart of the mermaid in the former poem.) The feeling of desertion is stressed by the desolate ticking of a clock, "about to stop." The room, closed and empty, "quite empty," is a convincing scene of life almost arrested, of diminished action until the arrival of a humming-bird, whose wings beat feverishly and in vivid colors on the pillow, like a lively corresponding image to contrast with the very slight motion of the single hair: this technique of doubling by contraries is typical of the surrealists in general, and of Desnos in particular. But in a characteristic evolution from drama to tragedy, the poet imagines the bird to strike its head against its double in the mirror where the silver is flaking off, dying in a series of one-word lines, so that in the empty room the sun may move finally about the corpse:

> Afin que dans la chambre vide le soleil déplace sa ligne autour de
> ton cadavre
> Où la fenêtre se reflète dans le sang qui poisse ton duvet
> (DA, p. 126)

> (So that in the empty room the sun moves its line about your corpse
> Where the window is reflected in the blood gumming your downy
> feathers)

Yet from the static if remarkable reflection of the window in the blood comes an assurance of renewal, for the image of openness gives a new breathing space to the room. The humming-bird rises once more like a phoenix, resurrected this time from the red color of blood by analogy with fire:

> Pour un chant identique, pour un vol égal,
> Paré des mêmes couleurs,
> Colibri du soir, colibri du matin,
> Tu renaîtras.
> Et dans la chambre vide, l'horloge à nouveau chantera

Colibri, colibri,
Colibri du soir, colibri du matin.
(*DA*, p. 126)

(For an identical song, an equal flight,
Bedecked with the same colors,
Humming-bird of evening, humming-bird of morn,
You will be reborn.
And in the empty room, the clock will sound once more
Humming-bird, humming-bird,
Humming-bird of evening, humming-bird of morn.)

Thus the expression "colibri" leads to the refrain of the same moving and repetitive sort as the "charbon" in the first poem, and summons—as did the image of coal in the other poem—the images of wing and flight, and the presence of song simultaneous with the renascence of love. In the second section of the long tripartite poem, the bird is seen flying toward the coast, and then lost at sea, setting the scene once more for sailors and for figureheads, for the event taking place in the "country of mermaids and typhoons, / in the country of thunderclaps" (*DA*, p. 127).

"All this takes place where I wish it to," claims the poet, and as in his novels and his poems, the marvelous convergence and the doubt as to eventual separation prevail:

Et jamais la femme ne verra le vol de cet oiseau, jamais, de son
 ombre, le vol de cet oiseau ne rayera
Le chemin suivi par cette femme.
Jamais? Est-ce bien sûr?
ô, rencontres—
ô, fontaines gémissantes au coeur des villes
ô, coeurs gémissants par le monde.
(*DA*, p. 128)

(And never will the woman see the flight of this bird, never, by its
 shadow, will the flight of the bird trace out
The path taken by this woman.
Never? Is that certain?
oh, encounters—
oh, fountains sighing at the heart of towns
oh, hearts sighing throughout the world.)

We are reminded of the poems which end by questioning their own

vision, of the loneliness echoing throughout the early writing of Desnos —but in the second part of this poem, after the doubt as to the renascence of the phoenix of love, the exclamation is undeniably vital and positive:

Vive la vie!
(Long live life!)

The bird, whose corpse and renewal we saw and then whose flight ruled the second part of the poem, is described in the final section of the poem as terrible, menacing, as perched on a branch of a terrifying tree, juxtaposed with death "hidden in a knife." The tree is aflame but no phoenix arises. Rather, death is inscribed in capital letters, hanging from the hair of the woman addressed and linked to her glances, while images of insult, abyss, and subterranean fear conclude the poem. Furthermore, the reader may see the knife's cutting as implicit in the poet's own tongue ("Ma langue dans ma bouche / My tongue in my mouth") so that even at the source of poetry there lies the cruelty of the drama.

The final line of the poem denies explicitly the possibility of love, of encounter and renewal, of imagination and of future: we are familiar with the desperate conclusions of Desnos and each contributes to the intensity of all:

Je sais qu'il n'est jamais plus temps.
(DA, p. 129)

(I know that it is never again to be the moment.)

So the three acts of the poem close on negation, as if this text were itself the dark double of that former "Identité des image," the mirror whose surface reflects—imperfectly, for the mirroring capacity is flaking away—not just that poem but all the others included in it.

In the subtle and tragic poem whose title "Paroles des rochers" (Words of the Rocks) is a further indication of Desnos' fascination with language, the solitude of the poet dreaming is intensified. From a beginning of apparent luxury, both qualitative (taxis, silk, mother-of-pearl, diamonds) and quantitative (at every window a mass of hair), and an abundance of trivial social communication to match ("A bientôt!" "A bientôt!" "A bientôt!" [See you soon!]), the all-inclusive landscape of night ("Une nuit de tous les littorals et de toutes les forêts / Une nuit de tout amour et de toute éternité," [A night of all the littorals and all the forests / A night of all love and all eternity]) suddenly draws back to

reveal catastrophe, loneliness, a desperate emptiness, and death. That the night predicted should be without exterior illumination of any kind —"A bientôt une nuit des nuits sans lune et sans étoile" / Soon [there will be seen] a night of moonless and starless nights)—might have seemed positive, since it could have created a more propitious background for the more profound mental illumination of dream; but it turns out to be only a darkness filled with artificial light and death, "une nuit de lustre et de funérailles," where the poet is alone amid the debris of all the former signs of value:

> Une vitre se fend à la fenêtre guettée
> Une étoffe claque sur la campagne tragique
> Tu seras seul[9]
> Parmi les débris de nacre et les diamants carbonisés
> Les perles mortes[10]
> Seul parmi les soies qui auront été des robes vidées à ton approche
> Parmi les sillages de méduses enfuies quand ton regard s'est levé

> (A pane breaks at the watched window
> A cloth clacks over the tragic field
> You will be alone
> Among the pieces of mother-of-pearl and the carbonized diamonds
> The dead pearls
> Alone among the silk dresses emptied suddenly at your approach
> Among the tracks of jellyfish fled before your glance.)

The use of tenses intensifies the loneliness: the windowpane which shatters as it is watched, and the rag which flaps desolate in the wind of the "tragic countryside" prefigure the future separations and unhappiness; but at the presence of the poet even the action changes to the past, as if it were putting itself at a distance from his approach and removing itself as an object of his gaze. Immediately after this, the poem switches to an uncertain future, as if only the actions whose implications are positive had to be prefaced by the sign of doubt: "Seules peut-être les chevelures ne fuiront pas / T'obéiront" (Only the manes of hair will perhaps not flee from you / Will obey you), once more to a tragic, or at least separate past: "Chevelures longues des femmes qui m'aimèrent / Et que je n'aimai pas" (Long hair of women who loved me / And whom I did not love) and then to a present of absolute absence, darkness, and self-doubt. At this point the staircase, once the path toward surrealist undertakings, is transformed into the place of misfortune; and the sea,

usually the privileged place for heroic adventure, now abandons even the cork of the bottle, the only remnant of the poet's chosen image of surrealist vision. This poem is at the opposite pole from the poem ruled by the mermaid, obeying only an inner tragic structure:

> Un escalier se déroule sous mes pas et la nuit et le jour
> ne révèlent à mon destin que ténèbres et échecs
> L'immense colonne de marbre le doute soutient seule le ciel
> sur ma tête
> Les bouteilles vidées dont j'écrase le verre en tessons
> éclatants
> Le parfum du liège abandonné par la mer . . .

> (A staircase winds under my feet and night and day reveal to my
> fortune only shadows and failure
> Doubt alone an immense marble column sustains the sky above
> my head
> The empty bottles whose glass I shatter to shining bits
> The smell of cork abandoned by the sea . . .)

The debris of mother-of-pearl further decomposes into a dull powdery substance, the infinite hope which Desnos had placed in the action of dream and in the world of shadows splinters like the windowpanes and the bottles, images of a crystalline faith deceived:

> Les infinis éternels se brisent en tessons ô chevelure!
> (Eternal infinites shatter to glass splinters o mane of hair!)

And in the final lines, as the night is banished from the present completely, and exiled either to the past or to the future, it is suddenly deprived not only of the images of light and luxury but even of those which show a potentiality destroyed:

> C'était ce sera une nuit des nuits sans lune ni perle
> Sans même de bouteilles brisées.

> (It was it will be a night of nights without moon or pearl
> Without even broken bottles.)

Poetic momentum comes to a halt. Now the poet's encounters have apparently no privileged place, his adventures have no apparent importance.

Deflection, Repetition, and Absence:
"De la Fleur d'amour et des chevaux migrateurs,"
"Avec le cœur de chêne," "Ténèbres! O Ténèbres!"
"Passé le pont."

Within the sleeping state, which Desnos regards as a part of surrealist research, like a scientific experiment: "Je conte et décris le sommeil / Je recueille les flacons de la nuit et je les range sur une étagère" (I count and describe sleep / I gather the flasks of night and arrange them on a shelf), adventures are to be pushed to their extreme limit, a ground for further ambiguity. His most significant observation on this point is at once a prideful statement of poetic risk, and a lament of poetic impotence:

> Le naufrage s'accentue sous la paupière.
> (Shipwreck is intensified under closed eyelids.)

One might imagine the poet always present in his adventures, participating entirely in whatever drama of metamorphosis they provoke. Parallel, however, to the personal separations occasioned by sleep or imagining is the distance between the adventures dreamed of by the poet and the poet's own "monotonous" path, which is only the shadow of the dream state. He is privileged to enter the world of dream and absolute shadow ("les ténèbres absolues"), but never to possess that world.

In a similar fashion, much of the action is deflected out beyond the poem, out of the reach of the poet as well as that of the reader. The longest and most complex poem of the collection, "De la fleur d'amour et des chevaux migrateurs," which I have examined here in another setting, contrasts a splendid and flourishing chrysanthemum without spot or weakness to the yellowed and rotting fern of the poet's heart, to the stagnant waters and swamps which surround it, and to the other flowers losing their petals which are future predictions for the fate of even the most splendid flower. Going beyond, in a formal and literally spatial *dépassement* of all the other elements, the final image of migrating horses, which has recurred several times and then is repeated in four lines of unadorned and rapid succession at the end ("les chevaux migrateurs, les chevaux migrateurs," etc.), deflects attention away from the simple descriptions within the poem, forcing the reader's gaze toward a place beyond the specific and limited formal boundaries. For these lines dominate all the preceding ones, in which they were predicted by fragmentary allusions. The initial pathos, the action develop-

ing gradually to the lyric summit where all the images of ripeness and loss, sharpness and softness contrast and mingle, all of this is swept away by the violence of the conclusion and the insistence on immediate departure. The verbal and visual subtleties of the color yellow played against the icy white of the ground, the hints of death juxtaposed with a natural luxury, the promises of openness sensed (of the sky, of doors) and then cut off, this series of oppositions and parallel statements is finally reduced to the immobility of a flower,[11] which is then in turn left behind when the attention is finally drawn to the road and the "real" adventure:

Je parle en vain de la fleur mais de moi
Les fougères ont jauni sur le sol devenu pareil à la lune
Semblable le temps précis à l'agonie d'une abeille perdue
 entre un bleuet et une rose et encore une perle
Le ciel n'est pas si clos
. . .
C'est de la fleur immobile que je parle et non des ports
 de l'aventure et de la solitude
Les arbres un à un moururent autour de la fleur
. . .
Et le givre craquant les fruits mûrs
 les fleurs effeuillées l'eau croupissante le terrain
 mou des marécages qui se modèlent lentement
Voient passer les chevaux migrateurs

Les chevaux migrateurs
Les chevaux migrateurs
Les chevaux migrateurs
Les chevaux migrateurs.

(I speak in vain of the flower but of myself
The ferns have yellowed on the earth become moon-like
Resembling to the exact moment the agony of a bee lost between
 a cornflower and a rose and still again a pearl
The sky is not so closed
. . .
It's of the immobile flower that I speak and not of the ports
 of adventure and solitude
The trees died one by one around the flower
. . .

And the frost splitting open the ripe fruits the depetaled flowers
 the stagnant water the spongy land of marshes slowly forming
See the migrating horses passing

The migrating horses
The migrating horses
The migrating horses
The migrating horses.)

An especially oblique poem of the same final elusiveness, "Avec le cœur de chêne," also already discussed, has as its apparent subject a lady called "Isabelle the Vague," whose name is repeated in each refrain with traditional accumulation of emphasis. Yet in the center of the poem Isabelle is suddenly described as unimportant for the poet, as if her vagueness were in fact a reflection of his genuine attitude toward her, of which the formal framework was a betrayal. She is, he says, only an image of dream; now one would have thought that alone sufficient to guarantee her permanent merit, considering the usual surrealist evaluation of dream and of the imaginative adventure. But here, on the contrary, this image of dream is scorned, in favor of the world beyond the dream. The poet claims that whatever approach Isabelle the Vague might make—whether to speak to him, kiss him, strip herself naked before him, kill him, walk on him, or die at his feet—will make no difference to him in reality:

Car j'en aime une autre plus touchante qu'Isabelle la vague.
Avec le cœur du chêne et l'écorce du bouleau, avec le ciel,
 avec les océans, avec les pantoufles.

(For I love another more touching than Isabelle the vague.
With oaken heart and birchbark, with the sky,
 with oceans, with slippers.)

All the attributes of the poem which have been successively repeated in a form typical of much surrealist love poetry are suddenly moved out of the poem to the space of the "real," as the poet's other sentiment is acknowledged; the poem itself counts no longer, nor does its heroine, nor does the dream of which she is nothing else but the embodiment.

Each individual reading of the poems will depend on the reader's prior understanding of the connections between Desnos and surrealism. If he has already been convinced, apart from the evidence of these particular texts, that Desnos was at this point disillusioned with the dream

experiments, then he is likely to interpret certain passages as negative statements or at least as indications of Desnos' gradual loss of interest in this period of the surrealist adventure. If the reverse is the case, he may interpret them as positive suggestions as to what the dream, or the mingling of dream with reality, might be. And the case becomes not less complicated, but more so, as one reads the work of Desnos more closely.

For instance, to the reader who remembers that at the end of the title poem "Ténèbres! O Ténèbres!," there is a specific image or group of images seemingly referring to the marvelous possibilities of the dream—". . . un homard de lentille microscopique évoluant dans un ciel sans nuage ne rencontrera-t-il jamais une comète ni un corbeau?" (will a lobster of microscopic lens evolving in a cloudless sky never meet a comet or a crow?)—that image is likely to add its own weight to another poem, whose title, "En sursaut" (With a Start), is more indicative of a daytime awakening than of a nighttime invocation such as "Ténèbres! O Ténèbres!" The opening line of this second poem reads, "'Sur la route en revenant des sommets rencontré par les corbeaux et les châtaignes . . .'" (On the road returning from the summits met by crows and chestnuts): we do not know if the poet is here returning from the heights of dream with the hope of going there again, or if it is considered a unique venture. The poem then acknowledges the presence of disaster ("Le désastre enfin le désastre annoncé"), admitting to an ignorance of the particulars of his dream and of their significance, and to a doubt of his own success as a wanderer:

Mais où sont partis les arbres solitaires du théâtre
Je ne sais où je vais j'ai des feuilles dans les mains
 j'ai des feuilles dans la bouche
Je ne sais si mes yeux se sont clos cette nuit sur les
 ténèbres précieuses ou sur un fleuve d'or et de flamme

(But where have they gone those solitary trees of the theatre
I don't know where I'm going I have leaves in my hands I have
 leaves in my mouth
I don't know if my eyes closed last night on the precious shadows
 or on a river of gold and flame . . .)

Here Desnos seems to value the shadows above the heat and brightness, as one would expect of him at this period, but that appearance may be as ambiguous as the night with neither moon nor pearl. Was that dark-

ness precious, or was its value illusory, empty as the bottles seem to become at the poet's approach? Are the leaves which remain from the spectacle, preventing him from action and from speech, simply disordered remnants akin to the debris and the *tessons*, or are they natural reminders, valuable within the system of recalls and echoes, of the green branches, the sycamores, the willows, oaks, and birches in at least five other poems of this collection as well as the solitary trees of this poem? Do all the trees of dream finally turn into the inconsequential images of themselves as the mother-of-pearl is finally transformed into just another dust? And, still within this one short poem, the poet says that he has never spoken of his "rêve de paille." In what sense can the "ténèbres précieuses" or a "fleuve d'or et de flamme" conceivably be compared to the aridity and brittleness of a dream of straw? Or was that particular vision, of which he cannot speak, opposed to his usual visions of growing, if solitary, trees? In this case, at least the living spectacle, even in its fragmentation, leaves the poet with at least some matter for speech, whether the speech be comprehensible or not. Only the remnants of the dream crowd other language out of the mouth, and as in the poem of Isabelle, the vagueness of dream may be finally rejected for the world of the present.

In another instance, he entitles a poem "Passé le pont" (Past the Bridge), a title which forces the reader to acknowledge that, in a formal sense, the poem has gone past a boundary he knew nothing about, that the spectacle has changed its location before he was even permitted to enter its frame. Furthermore, since the text commences with a door closing, the reader, familiar with all the surrealist images of doors left swinging and vessels communicating with each other, will feel especially shut out from the text. The feeling is intensified by the poet's sudden demand for our silence to equal his own: "Taisez-vous, ah taisez-vous," threatening natural catastrophes and personal schisms unless his demands are met.

Subsequently, he refuses to us and to himself even the certainty of what he has said, when in a passage already quoted, he manifests a self-doubt touching on language and going past it, to the possibility of believing as of expressing:

Je n'ai pas dit cela
Je n'ai rien dit
Qu'ai-je dit?

(I didn't say that
I didn't say anything
What did I say?)

Shipwreck, Passion, and Irony:
"Dans bien longtemps," "De la rose de marbre à la rose de fer"

These self-critical elements are more frequent in Desnos than in any other surrealist of his time or after. It might be tempting to speculate that they reflect a repressed scepticism as to the surrealist adventure, as to his part in it, and so on, or his innate preference for other sorts of poetry already mentioned. In any case they give to all his early writing, poetry and prose, a complex and ambiguous texture that coincides with the equally ambiguous texture of fragmentary dream material, and its related images.

In the strange poem concerning time which is entitled "Dans bien longtemps" (For a Long Time Since), an image of a woman's transparent presence, appropriate to all the other crystalline images of surrealism and the preceding ones of Dada poetry makes a sharp contrast with a juxtaposed lament on the simultaneous aging of the poet's own body and of the universe. Desnos then breaks the sentimental flow of the poem by a sarcastic attack on the banal character of his own poetic language: "N'aimez-vous pas ce lieu commun? laissez-moi laissez-moi c'est si rare cette ironique satisfaction" (Don't you like this common-place? leave me alone leave me alone, this ironic satisfaction is so rare). For the reader familiar with Desnos, there is a double irony, since the case is not rare at all. And, to such a reader, the following lines, already quoted, have a double sense beneath the already openly ambiguous subject:

Les flots étaient toujours illusoires
La carcasse du navire naufragé que tu connais—
 tu te rappelles cette nuit de tempête et de baisers?—

(The waters were always illusory
The hulk of that wrecked ship that you know—
 do you remember that night of tempest and of kisses?—)

These are not two neutral images happened upon at random, since, as we have seen, ships and shipwreck and the associated images of mer-

maids and deserts pervade all the work of Desnos, and especially the novel *La Liberté ou l'amour!*, which appeared in the same year as these poems. So that the passage can be read as another instance of self-doubt; the ideal and mysterious image of the wrecked vessel, which was once the agent of adventure, with all its suggestions of adventure condemned and its aura of nostalgia for the faith and passion of the days of adventure is no more in reality than an everyday object, a commonplace used to procure for the author one more ironic satisfaction. The non-literary world of the present becomes the "real" opposite of the illusory passion, and of the purely literary images allied with it.

The way out from all the irony and doubt of language and of dreaming might have been the heroine of the dream. But the central poem, "Ténèbres! O ténèbres!" where the poet calls upon his friends to be silent with him before the great abyss of shadows ("devant les grands abîmes") and where he states with pride that they have been the first to know their white sheets (both the abyss and the sheets being apparent eulogies of the dream), ends with an invocation of woman as a broken bottle, her beauty only parasitic, always absorbing more than it offers, and herself bringing nothing to the poet or the dream: "Tes yeux tes yeux si beaux sont les voraces de l'obscurité du silence et de l'oubli." (Your eyes your beautiful eyes are hungry for darkness silence and forgetfulness.) She seems to desire not language but silence, not dream or the memory of the dream but the complete denial of the past. Either she deserts the poet at the moment of the dream ("Tu t'en iras" [You will go away]) or she refuses to mediate between its experience (seen as illusory, like the water where the shipwreck takes place) and the daytime reality; the latter exists, and really exists, outside the closed doors and on the return road from the summits. She herself is perhaps an illusion—certainly she cannot be known.

The last poem of the collection is an extraordinary and mysterious portrait written in an intensely lyric prose, combining a strong sense of desolation with a sense just as strong of exaltation and even sublimation: Desnos creates a formal atmosphere of a complexity fitting to the complexities of concept it must embody. "De la rose de marbre à la rose de fer"* is a series of separate elaborations on the rose as a traditional image of feminine beauty, the elements of the series then linked in one long sentence affirming their endless future regeneration and the negative splendor of their present destruction for the glorification of the woman on whose rug they lie scattered, by the same process as the pulverization of the preceding poems. The mystery and importance

of the possessor of the rug are amplified by the previous multiplication in quantity and species of the roses to be sacrificed and then by the restatement of the whole catalogue which is destroyed for her benefit; yet the fact that she is also herself a woman and therefore present by implication in their sacrifice is one more inversion to belie the apparent simplicity of the construction: "Qui es-tu? toi qui écrases sous tes pieds nus les débris fugitifs de la rose de marbre de la rose de verre de la rose de charbon de la rose de papier buvard de la rose de nuages de la rose de bois de la rose de fer." (Who are you? you who crush under your bare feet the fugitive debris of the marble rose the glass rose the coal rose the blotting paper rose the cloud rose the wood rose the iron rose.) The entire poem, and perhaps the entire collection of poems, has been written for her, and still she is not known to the poet. The fact that we know the name of the woman for whom these poems were written does not in the slightest alter, for us or for the poet, the sense of this final question. The absence of knowledge is felt as a more general absence in what might have been, or seemed to be, a poem of presence.

The Closed Doors: "La Voix de Robert Desnos," "Pour un rêve de jour," "Vieille clameur"

The poem just analysed is then an echo of the first poem of the series, a desperate poem on the powerlessness of poetry and of language. "La Voix de Robert Desnos"* begins with the poet summoning the world authoritatively and surely—powerful over tornadoes, tempests, storms, cyclones, tidal waves, earthquakes as well as over the more humble elements of the universe:

> j'appelle à moi la fumée des volcans et celle
> des cigarettes

> (I summon volcano smoke and that of cigarettes)

and ends with the uselessness of the summons in the face of love, the final perception thus working a retrospective destruction on the rest of the poem and, through it, on the entirety of the poet's language:

> les pilotes se guident sur mes yeux
> les maçons ont le vertige en m'écoutant
> les architectes partent pour le désert

les assassins me bénissent
la chair palpite à mon appel

celle que j'aime ne m'écoute pas
celle que j'aime ne m'entend pas
celle que j'aime ne me répond pas.

(pilots steer according to my eyes
stone masons grow dizzy at my voice
architects leave for the desert
murderers bless me
flesh quivers at my call

the one I love does not listen to me
the one I love does not hear me
the one I love does not answer me.)

From a celebration of the poet's cosmic strength, this poem moves to an absolute denial of that strength in the one instance which counts; the closing triplet is a tragic testimony to silence and emptiness in the place of language and in the moment of love.

For the Desnos of these poems, as it is already evident, the idea of affection seems to be incompatible with that of adventure: "Il n'est plus temps il n'est plus temps d'aimer vous qui passez sur la route" (It is no longer time it is no longer time to love you who pass by on the road). The poet's language is based either on love or on dream, inspirations which are mutually exclusive, or appear to be. Within the world of the poems, the love is of uncertain duration, its object is always distant and unknown in nature, and so the love carries with it certain loneliness and deception. The dream negates the possibility of knowledge and of action, and even of speech. At least within this world, therefore, the language will cease, as the poet's enthusiasm for a certain kind of adventure subsides.

"Pour un rêve du jour"* is the ironic opposite of the first poem discussed here. Instead of "le poème du jour qui commence" (the poem of day beginning) the possibility of linguistic metamorphosis is initially announced and then abruptly canceled out by the reiteration of the word *silence:*

Un cygne se couche sur l'herbe voici le poème des métamorphoses.
Le cygne qui devient boîte d'allumettes et le phosphore en guise
de cravate. Triste fin Métamorphose du silence en silence . . .

(A swan lies down on the grass here is the poem of metamorphosis. The swan which becomes a matchbox and the phosphorus in the guise of a cravat. Sad end Metamorphosis of silence into silence . . .)

As the rose was at once a gentle mockery of the traditional image of the rose and the inheritor of its metaphoric weight, so the swan is probably a nostalgic reminder and inheritor of symbolist imagery;[12] both are at the same time literary puns and the serious bearers of all the nobility of past poetry, as the ship's deserted hulk was at once a reminder of unsuccessful poetic adventure and the vessel of double significance, bearing all the contents of past literary treasures.

But there is in any case no personal knowledge to replace the lack of language to which the poet is doomed, and which is the unspeakable end of all the surrealist hope in metamorphosis. The question at the end of the poem, "qui qui qui et qui?" (who who who and who?) has no answer, and could have none. The last admonition of the poet is in part the playful reminder of the traditional "carpe diem" juxtaposed with the genuine lesson expounded by the poet in the present. And it is also in part a sarcastic statement of the necessary replacement of the faith once founded in the adventures of language and of love by the creation of an artificial situation, the only possible source of permanence: "Cueille cueille la rose et ne t'occupe pas de ton destin cueille cueille la rose et la feuille de palmier et relève les paupières de la jeune fille pour qu'elle te regarde ETERNELLEMENT." (Pluck pluck the rose and don't worry about your fate pluck pluck the rose and the palm leaf and lift the eyelids of the girl so she will gaze at you ETERNALLY.) Perhaps Desnos realized from the beginning that the essential condition for overcoming the limits of time and the monotony of the real in the timelessness of adventure is the serious and repeated acknowledgement of genuine separation, and the acceptance of an artifice, replacing the artifice of language.

In one of the poems which ends by transcending poetry in an action removed beyond the formal place of the poem, Desnos deliberately retreats into an interior distance and offers a typically ambiguous warning, either to us or to himself:

Je pense à très loin au plus profond de moi
Les temps abolis sont pareils aux ongles brisés
 sur les portes closes . . .

(I think of distance in my inner depths
Abolished instants are like fingernails broken on closed doors.)

It all depends on which side of the doors the adventure takes place. If the meditation and the dream provide sufficient and lasting vision, then the closed doors are a simple proof that the outsiders to surrealism are limited forever to their own framework of seasons and perceptions and actions. But if they are parallel in significance to the return road from the summits and the abandoned hulk of a ship, then perhaps the voyage which Desnos eventually makes from the "closed" language of surrealism to that of journalism, and what he calls universal comprehension, is based on a prior and tragic silence or *closure*. Only he could have said whether the "ténèbres et échecs" (those shadows and failures) he envisioned for himself in the fate of his days and nights were ineluctably associated. Since Desnos closes his whole poetic system within itself, the reader cannot know if the closed doors represent only his own exclusion from knowledge and vision, or the poet's as well.

In the latter case, the escape beyond the individual poem and the individual dream was all along illusory, as the poet seems to indicate in his "Vieille clameur":

Au flanc de la montagne se flêtrit l'édelweiss
L'édelweiss qui fleurit dans mon rêve . . .

(On the side of the mountain the edelweiss withers
The edelweiss which flowers in my dream . . .)

This final closure is far more serious than the one mentioned at the beginning of this discussion. Desnos is casting a grave doubt not only on the notion of companionship in his adventure, which he had done all along, but on the notion of the voyage itself. If it is only in the dream that the flower can bloom, what possible real link can be perceived between the sleeping and the waking worlds? Perhaps, in his earlier surrealist years, Desnos might not have asked to bring a proof out beyond the universe of the marvelous as would an ordinary traveler; perhaps that universe would have seemed then a sufficient ground of faith, its importance clearly visible from any point *within* itself. At this point, however, he is already reacting against the reliance on what he sees as purely immaterial, a reaction which was to culminate in his diatribe in the *Troisième manifeste* of 1930 against what he called Breton's too limited mysticism.

Now the adventure, formerly marked as the adventure of dream, becomes itself identified with the epic voyage of language while the poems focus endlessly on the question of their own poetic essence and

poetic technique. Throughout the collection, the voyage of language is haunted by an interior misfortune: the poem of day beginning becomes finally the poem of night and separation, the poet dreaming by the fireside becomes the exhausted traveler who sees only the corpse of the mermaids, until now the companions and guides of his adventure. A desperate solitude invades the space of the dream, which is the space of the poem.

The trees against whose backdrop the poetic drama unfolded shed their leaves in the poet's mouth, which was once the source of brilliant language, and the flower he attempted to bring back in order to prove the marvelous dream withers away as he descends again from the summit. At last, the doors of the dream appear as closed, the voyage of language as useless, and the only possible metamorphosis as one of silence into silence.

Mais encore moi qui me poursuis ou
sans cesse me dépasse.
(Domaine public)

(But still myself chasing myself or go-
ing beyond.)

6 The Continuity of the Surrealist Adventure

The continuous path of Desnos the surrealist can be shown in three examples from contiguous realms, each of which illustrates a different hypothesis.

First, the minor final changes Desnos made in the early collection of poems called *C'est les bottes de sept lieues cette phrase "Je me vois"* demonstrate the poet's attention to the unbroken line of what are to all appearances his most disconnected and discontinuous poems. Second, parts of the long and pieced-together epic *The Night of Loveless Nights* cohere because of the recurrence of certain obsessive figures and themes, in spite of the most various forms; the continuity is based entirely upon feeling and imagery. Third, *La Papesse du diable,* an example of the erotic literature Desnos always defended so vigorously (signed Jehan Sylvius and Pierre de Ruynes, but clearly in the same style and inspiration as *La Liberté ou l'amour!*) proves that a work to which Desnos contributed, for whatever purposes it was written, will be recognizable from its tone, its stylistic configurations, and its most essential attitudes.

Desnos undertook repeatedly his own defense of the continuity of his surrealist spirit beyond the apparent discontinuities of his development, as seen from the outside, and this continuity is supported by internal evidence.

Manuscript Indications

A study of manuscripts is sometimes helpful in giving certain clues as to the poet's changing attitude or his work methods: here I give only the briefest sketch of some of that study, as it is relevant to this chapter.

C'est les bottes de sept lieues cette phrase "je me vois"

The poems of C'est les bottes de sept lieues cette phrase "je me vois" (It's Seven-League Boots, This Sentence "I See Myself"), written in 1926, are linked by the general concern with fate, fear, death: as in the titles "L'Air homicide," "Destinée arbitraire," "Corde," (Homicidal Air, Arbitrary Fate, Cord); in the images of skeletons, eyes ripped out, murder, funerals, coffins, tombs; and in the related theme of voyage stated in the title, for which the most frequent setting is water:[1] "Je vais être noyé!" (I am going to be drowned!)—although the poem quoted, "Corde," would seem to indicate hanging instead. Within each poem, the successive images are linked to each other, so that, for instance, "Destinée arbitraire" moves from the spectacle of the crusades[2] to a closed window through which birds are seen like fish in an aquarium and then like a pretty woman in a store window. The idea of immobility and imprisonment, suggested already in the three closed windows mentioned (including the glass of the aquarium) leads to the figure of a policeman locking handcuffs around the wrists of the poet, statues able to turn away but not to leave their pedestals, and the last immobilized image, that of a beautiful corpse, and the notion of free burial. Suddenly at the end, the poem veers toward the idea of fresh beginnings, when, as an unexpected reversal of the cliché, "I know that my end is near," Desnos writes: "Je sais que mon commencement est proche . . ."[3] (I know my beginning is near . . .).

Far more interesting is the fact that Desnos wanted particularly to emphasize the continuity of the lines in these poems; he seems to have cared most about this in the frequent cases where the images are more apt to shock.[4] That he should want to link, in the poem just discussed, the line about the smiling woman to the store window where she is smiling might not have seemed especially noteworthy; that he should bother to make such links in twenty-five cases and that thirteen of these are macabre ones is more so. Each alludes to death or to cruelty, as in the following examples:

Un beau corps de femme
Fait reculer les requins

(A beautiful woman's body
Makes the sharks turn back)
("Destinée arbitraire")

Avant peu ses deux serres
m'arracheront les yeux

(Before long her two claws
will tear our my eyes)
("Porte du second infini")

Ma belle dame mettez vos deux mains
dans le bec de gaz

(Lovely lady put both your hands
in the gas burner)
("Que voulez-vous que je vous dise?")

vous êtes perdue si vous ne m'égratignez
pas un peu

(you are lost if you don't
scratch me a little)
("Que voulez-vous que je vous dise?")

Le mystérieux concierge enfonce
avec précaution sa clef dans ton œil

(The mysterious concierge carefully
plunges her key in your eye)
("Que voulez-vous que je vous dise?")

La liberté belle noyée d'aluminium blanche et touchante
surnage sur les flots

(Freedom the beautiful drowned girl of white and touching
 aluminum
floats over the waves)
("Corde")

Et quelque tigre féroce a décalqué
sur ma poitrine le reflet de ses yeux jaunes

(and some savage tiger has transferred
to my breast the reflection of his yellow eyes)
("Tes amants et maitresses")

Midi l'heure de l'amour torture délicatement
nos oreilles malades.

(Noon the hour of love delicately tortures
our sick ears)
("Rencontres")

un docteur très savant coud les mains de la prieuse
en assurant qu'elle va dormir.

(a wise doctor sews the hands of the praying woman together
to be sure she'll sleep)
("Rencontres")

In several other cases also, Desnos makes later changes to emphasize the macabre; for example, in the poem "O Sœurs" (see the Unpublished Documents), and in *The Night of Loveless Nights*, where a neutral passage, "Toi qui vas rêvant / Espace ni temps / Et vienne le temps" (You dream along / Neither space nor time / And let time come) is dropped for the gloomier "Cœur qui va rêvant / jusqu'à ce qu'il meure" (Heart that dreams along / until it dies), and where a "lugubre escalier" becomes an "escalier ruisselant" (lugubrious staircase → dripping staircase), an image so strongly implying the image of blood that there is no need to state it.[5] During the whole period 1924–29, from *Deuil pour deuil* to "L'Aveugle," a series of images of death, blindness, and fear is stressed. In spite of the apparently disconnected and lighthearted nature of his poems ("Mais je suis inventeur d'un téléphone de verre de Bohème et de tabac anglais [But I'm the inventor of a telephone of Bohemian glass and English tobacco]) the lines joined on to these are characteristically obsessed: "en relation directe avec la peur!" (in direct relation to fear!).

The Night of Loveless Nights

The Night of Loveless Nights, written in 1928–29 and published in 1930, is an example of collage in the lyric manner. In spite of its changing tone, it is poetically unified about the themes of love and dream, of criminals and prisons, water and bottles, swans, swords, fans, plumes

and pens, about night and dawn, stars and mermaids, phantom ships and phantom heroes, flowers flourishing and withered. In its final state the poem is composed of nine or ten different shorter poems—not simply ten different types of verse forms, but ten different shorter *moments* of writing (judging by the different handwritings illustrated here, and the colors of ink making up the final collage).[6]

The longest sub-poem, in occasionally stilted alexandrines, sets the text in a cheerless atmosphere ("Nuit putride et glaciale, épouvantable nuit" [Putrid and glacial night, appalling night]): as it stands, it is divided in three parts, but it was originally a long poem, as can be judged from the form and content as well as from the physical appearance of the text, which has been altered and cut, in order to be re-formed differently. The original text is first interrupted by a faintly melancholy prose poem on the place of dream, on the shadows, the solitude, and the immobility characteristic of the most persistent landscapes of Desnos' surrealist adventure:

J'habite quand il me plaît un ravin ténébreux . . .
Le vallon était désert quand j'y vins pour la première fois.
Nul n'y était venu avant moi. Nul autre que moi ne l'a parcouru.
. . .
La saison de l'amour triste et immobile plane en cette solitude.
(*DP*, p. 220)

(I inhabit when I choose a shadowy ravine . . .
The valley was deserted when I first came there.
No one had come there before me. No other has traversed it.
. . .
The season of sad and immobile love hangs over this solitude.)

Two sub-poems, treating the theme of love with a fair degree of banality, obviously written with great rapidity and facility ("Coucher avec elle" [Sleeping with Her] and "Toujours avoir le plus grand amour pour elle" [Always To Have the Greatest Love for Her]) are divided into two fragments each and spliced together, followed by two segments of contrasting alexandrines and then an alternation of the long and short verses of Desnos at his visionary best, written in the style of *Les Ténèbres*:

Blêmes effigies fantômes de marbre dressés dans les palais
 nocturnes
Une lame de parquet craque

Une épée tombe toute seule et se fiche dans le sol
Et je marche sans arrêt à travers une succession
De grandes salles vides dont les parquets cirés ont le reflet de l'eau.
(*DP*, p. 230)

(Pallid effigies marble phantoms risen in the nocturnal palaces
The wooden floor creaks
A sword falls and sticks in the floor
And I walk without stopping through a succession
Of great empty rooms whose polished floors reflect like water.)

A long passage on a macabre hallucination of hands, conveying the rhythm and tone of the most genuine panic reminds us of the "Porte du second infini" found in *C'est les bottes de sept lieues,* a poem on the subject of writing, madness, and fear, dedicated to Antonin Artaud. An obvious breathlessness betrays the genuine emotional center of the poem, which is not only a poem on love, but also on the act of writing itself. The union of these two themes informs the poet's greatest works, and is closely related both to the violent and to the tragic. Doubt and cruelty appear on the surface of the consciousness this time; the threat is still vague but the poet's state of mind is vivid, its expression intensified by the frequent allusion to shadows. The *attente,* the state of waiting often taken as the surrealist equivalent of the state of grace, is more violent than hopeful in this case:

Les mains sont trompeuses
Je me souviens encore de mains blanches dans l'obscurité
 étendues sur une table dans l'attente

. . .

Ah! même ma main qui écrit
Un couteau! une arme! un outil!
Tout sauf écrire!
Du sang du sang!
(*DP*, p. 232)

(The hands deceive
I still remember white hands in the darkness
stretched out on a table waiting

. . .

Ah! even my hand writing
A knife! a weapon! a tool!
Anything except writing!
Blood blood!)

The association often made in *Les Ténèbres* between dream and withered flowers, dry straw, or broken glass pervades the next section of the poem:

Eglantines flétries[7] parmi les herbiers
O feuilles jaunes
. . .
Verre pilé, boiseries pourries, rêves interminables, fleurs flétries
(*DP*, p. 233)

(Sweetbriars withered among the lofts
O yellow leaves
. . .
Shattered glass, rotted wood, interminable dreams, withered
flowers)

A mysterious white hand reaching out to his forehead through the darkness poses no threat, and gives no sign of the deception one might connect with the withering of leaves and flowers; rather the hand seems linked to the promise implied in the ensuing image of an invisible bird of paradise, as if the innocence of love were able to create a world beyond shadows and death. But Desnos still consciously inflicts a certain cruelty in this poem. The wings of a bird imprisoned in the room where he lies dreaming pinion his own arm, as the nightmare becomes forever inseparable from the promise of dream. A litany of dawn and night concludes in shriveled thoughts and desires compared to withered fans ("maints éventails flétris") seen falling on the landing of a stair. The image of the stairs is a constant in the poetry of Desnos, particularly in relation to the themes of adventure and dreaming; the landing represents the cessation of reverie, the fall of the heroic flight. It is clear from these remarks that the memory of Mallarmé haunts Desnos' imagination, as is obvious also in the drawings appended here.

Finally, the initial poem starts again with a plea from the poet to himself for silence: "Tais-toi, pose la plume et ferme les oreilles" (*DP*, p. 234) (Be silent, put down your pen and stop your ears). The tone diminishes in volume, the poetic reduction matching the fading of the sky until Desnos at last invokes, in the final lines, "la sirène et l'étoile à grands cris . . . O Révolte!" (*DP*, p. 235) (the mermaid and the star with loud cries . . . O Revolt!). The rebellion against the halt of dream may or may not result in a renewal of poetry: as is the case in some of the most interesting surrealist works, neither the reader nor the poet is sure of the "real" ending of the poem. The spectacle and the drama move away from us, to a less artificial realm than that of the page.

In what must be one of the oddest collections of partial poems ever made into a conglomerate whole, Desnos gives us an autobiography of style and themes, unevenly interesting, occasionally exaggerated to the point of self-parody. *The Night of Loveless Nights* would not hold together at all, were it not for the recurring figures in this landscape: it is a tour de force, an experiment in combinations. Approximately one-fourth of the final poem is on the aesthetic level of *Les Ténèbres*, and that is the freest part; that he should have placed it alongside the often badly strained alexandrines is an indication of his attitude toward poetry as a flexible witness to changing moods.

Pseudonyms

The pseudonymous novel *La Papesse du diable* (The Devil's Popess)[8] is obscene and lyrical in exactly the exalted style of *La Liberté ou l'amour!* Compare the orgies of the Sperm-Drinkers' Club in the latter with the Sacred Orgy in *La Papesse*, which begins under the direction of and in the honor of the Queen of the World: "Les convives parlaient peu, n'osant, pour la plupart, même point lever les yeux vers elle qui incarnait, face à leur puissance d'hommes, le monde supérieur du mystère féminin" (*PD*, p. 90). (The guests spoke very little, most of them not daring even to raise their eyes to look at her, as she incarnated in the face of their virile power, the superior world of feminine mystery.) The "Archimagesse" rules this novel as Louise Lame does *La Liberté ou l'amour!*—both are, like *A la mystérieuse* and *Les Ténèbres*, written in honor of woman, as surrealism is meant to exalt the feminine principle, against a male rationality which has not made much of a success of the world.

Secondly, compare the following passage with those in *La Liberté ou l'amour!* on the timeless and motionless tedium of the deserted square, on the mermaids and the restraint of love, and with the haunting leitmotifs there of solitude and immobility.[9] The similarity is incontrovertible:

> Il n'y a plus, sur la grande place triangulaire, le calme regard des pylones posé sur mon cœur. Comment donc alors rejoindre les compagnons partis vers les terres étroites où toutes les paroles sont des palmes? Le corps de la sirène est bien tendre et nacré, mais il n'y a pas ces jambes lianes pour vous retenir. Le départ impossible se change en une stupeur immobile, tandis que passe au loin la caravane des désirs chargés d'aromates et d'angoisses. (*PD*, p. 54)

(On the great triangular plaza the calm look of pylons is no longer posed on my heart. How then can I rejoin the companions who have left for narrow lands where all words are palm trees? The mermaid's body is tender and pearly, but she has no legs to twine like creepers about you and hold you to her. Impossible departure changes into an immobile stupor, while in the distance passes the caravan of desires weighed down with aromatics and with anguish.)

The final parallelism weighing on the senses and on the feeling, the perfect similarity between the themes and the oppressive plosive sound, repeated as if to emphasize the combination of explosion and soundlessness, of desire and no progression ("plus," "place," "pylones," "pose," "-pagnons," "partis," "paroles," "palmes," "pas," "pour," "-part," "-possible," "-peur," "passe") mark this passage.

And finally, compare the evocation of the Corsair Sanglot lost in the desert (see the chapter on *La Liberté ou l'amour!*) with the following litanic evocation:

Chantez la complainte des exilés dans la terre des soifs!

. . .

Chantez la complainte des exilés dans la terre des horreurs!

. . .

Chantez la complainte des exilés dans la terre des cauchemars!

(*PD*, p. 52)

(Sing the song of exiles in the land of thirst!

. . .

Sing the song of exiles in the land of horrors!

. . .

Sing the song of exiles in the land of nightmares!)

If the sole survivor, alone and crazed, fears to become the prey of the androgynous mermaids, if he is constantly tormented by the visions of the "grands chiens attardés le soir aux coins des rues du souvenir" (*DP*, p. 54) (large dogs loitering in the evening at the street corners of memory), he is also irresistibly drawn to the shadow like Desnos himself. Just as the mermaid is appealing in her mystery, or the star, the desert and the sea in their distance from ordinary life, the hero in every poem of Desnos', in every essay, in every novel, is compellingly inscribed in the orbit of an undefined mysterious force, which governs his adventures as it might those of a romantic hero: "je ne puis résister plus longtemps à l'appel des ombres" (*DP*, p. 54) (No longer can I resist the summons of the shadows).

Qui pourrait donc me voir?
(*"Sirène-Anémone"*)

(Who then could see me?)

7. Conclusion and Question

The early Desnos considered himself above all a poet of love and of a particular love, which formed the subject of all he wrote. One of the most powerful poems in *A la mystérieuse* ends with these lines where surrealist pride and personal simplicity meet:

> . . . moi qui ne suis ni Ronsard ni Baudelaire
> Moi qui suis Robert Desnos et qui pour t'avoir connue et aimée,
> Les vaux bien.
> Moi qui suis Robert Desnos, pour t'aimer
> Et qui ne veux pas attacher d'autre réputation à ma mémoire sur
> la terre méprisable.
>
> (*DP*, p. 102)

> (. . . I who am neither Ronsard nor Baudelaire
> I who am Robert Desnos and who, for having known you and loved
> you,
> Am their equal.
> I who am Robert Desnos, in order to love you,
> Wanting to attach no other reputation to my memory on this des-
> picable earth.

What then is the relation between the actual text and the adventure

of dream, the supposedly equivalent of poetry? Do the closed doors in the early collection *Les Ténèbres* have a necessary link with the paralyzed landscape visible in the late collection of *Contrée?* Is the admitted poetic impotence within the enforced limitations of the latter "real" landscape found after the early dream has subsided, prefigured in the laments of loneliness and emptiness at the center of the surrealist theater of shadows ("les arbres solitaires du théâtre" [the solitary trees of the theater])? To what extent did Desnos finally discover himself to be a "free" poet, in spite of the paralyzed and frozen landscape about him?

The statements made by Desnos himself are questions rather than assertions. His style remains one of a chosen ambiguity; his earliest and strongest works seem to have no exterior conclusion and to suppose no interior closure. In that they fit our contemporary state of mind. But in the later poems, the framework is clear, and the landscape limited, while the poetry itself acquires the formal limitations of rhyme scheme and pattern which might seem the parallel of that landscape. We might think of the evolution of Paul Eluard and of Louis Aragon to a more formal and easier, more predictable, scheme of poetry after their first, difficult and surrealist verse, in the interest of the majority of readers and partly for political reasons. (But Desnos always wrote alexandrines on the side, for which he was greatly criticized by Breton.) One may see him writing, in these last poems, a pathetic and fixed end to his own early ambiguities, on which all the force of his surrealist summons seemed to depend.

In a voluntary contrast to his praise of the unknown, of the mysterious and the tenebrous, his static portraits of mythical personages such as the nymphs Calixto and Alcestes and his still pictures of a clear and petrified landscape (such as "Le Coteau," "Le Cimetière," "La Clairière," "La Caverne," "La Sieste," "La Ville," "La Maison" in *Contrée*) are as shocking to a surrealist-oriented sensibility as is the surrealist attitude to a non-surrealist sensibility. That the subtle critic of the cinema should forsake movement for portraiture and for still life (or more precisely, "nature morte"), is the most difficult of all desertions for the admirers of his early period.

And that he should have taken this step consciously, informing us of it, is the final stumbling block. To experience all the ambiguous potentialities of surrealism at its most mobile and most complex and then to go beyond them to a fixed form is surely as extraordinary as the choice of shipwreck which Desnos made explicitly so many times. But shipwreck is no less logical than navigation, he claims, and perhaps no

less adventurous a choice. Desnos is no more trapped in his own ship-wreck than his heroine the mermaid is trapped in the sea. On the other side of the poems of obvious adventure, Desnos claims to find another adventure; beyond all the surrealist poetry of freedom, he claims the possible existence of the free poet.

The eventual alienation of Desnos from his reader comes after we have weathered all the early insults and deliberate deceptions. For the farewell of the poet to the mermaid prefigures another and more final one, that of the poet to the reader, a farewell situated within the fragile, appealing, and often tragic temporality of the work:

Adieu déjà parmi les heures de porcelaine
(And now farewell among the porcelain hours)

But neither the poet's separation from the mermaid, nor the reader's final exclusion from the imaginative adventure place any limit upon the adventure of the text. In the last message from Desnos in the concentration camp at Theresienstadt to his wife Youki on January 7, 1945,[1] he states with complete conviction that for him, the relation of the poet to poetry is never touched by exterior circumstances, that the faith in poetic adventure can still be completely justified, in the long run and in the smallest detail, in spite of everything else. "As for the rest, I find a shelter in poetry. It is really 'the horse running on the crests of the mountains' which Rrose Sélavy mentions in one of her poems and which I have found to be justified word for word." It is as if, at last, the two terms of freedom and love (La Liberté ou l'amour!) had found their resolution—and even, perhaps, their identification—on the summits of the surrealist imagination, where finally no distinction was to be made between mermaid, star, and anemone, between open sea and ice floe, between the mountain, the desert, and the page or the poem.

For in spite of the self-doubting text, the adventure was always to be one of language, with those doubts a source of primary action and continuing complexity. Desnos made, in 1926, a "Confession d'un enfant du siècle," which at once bears perhaps the most telling witness to that active language and makes the most fitting, because most ambiguous, answer to the question of his being remembered: "The only tense of the verb is the present indicative." Of that sentence he might have said, as of his love poetry which finds its source in the same sentiment, that he wanted to be remembered by it only; like a serious gamble on presence.

un oeil fermé
une porte fermée
et pas de clef.
(Destinée arbitraire)

(an eye closed
a door closed
and no key.)

Unpublished Documents

These documents from the collection Paul Eluard–Camille Dausse of the Museum of Modern Art in New York are reproduced with the gracious permission of Doctor Michel Fraenkel, Editions Gallimard, and the Museum itself. The six drawings are found on separate sheets in the manuscript of *The Night of Loveless Nights:* certain themes of other Desnos texts are easily recognizable, such as the swans (an echo of Mallarmé, whose white page is transposed into the desert of *La Liberté ou l'amour!,* and whose frozen lake, the sign of his vain exile ["vanité"], leads to the ice floes where the ship of the same novel is trapped). The desert itself is visible within the drawings, as are its explorers (see the analysis of the verbal play in my chapter on the novels, "Perdu dans un désert de houille et d'anthracite, un explorateur vêtu de blanc . . . Dans le désert, irrémédiablement perdu, l'explorateur casqué de blanc . . ."). The cadaver (occasionally that of a mermaid) floating on the water or drifting in the sand, is the indication of the end of all the adventures of mermaids, stars, and bottles:

> Qui me regarde ainsi au fracas des rivières?
> Noyés, pêcheurs, marins? . . .

The "doigts indicateurs" can be seen pointing not only to this novel and to the long evocation of hands in *The Night of Loveless Nights* but

to many of Desnos' poems which I have called meta-poetical in their self-referential nature.

The two manuscript pages show a typical change of handwriting and of style, like a small-scale model of the composition of the entire poem, in which the frequent changes of ink color, the different letterheads and kinds of paper on which the poem is written, and its series of altered numerations are revelatory of the collage style of composition in its arrangement and rearrangement.[2]

The fragment of a poem tentatively entitled "O Sœurs,"[3] whose title reminds us of René Char's "Eaux-Mères" was found with the manuscript of the text, *C'est les bottes de sept lieues cette phrase "Je me vois,"* whose changes in punctuation are discussed elsewhere in this study as an indication of the poet's attitude to the images contained therein. It is far from being worthy of inclusion in Desnos' best poetry, but since the images are familiar to us, they stress the very distance between his ordinary poems and his great ones, on which attention is centered here.

Translation of the fragment "O Sœurs":

O Sisters

I saw, it was no dream no daydream
The daydream is of mist and the dream of lead
I saw, under a ceiling of cloud, sponges
Creeping noiselessly towards the blond-tressed light

I saw under a blue sky candles parading with a saber
 by in their fist
And their flames drifted and seemed magically
The plume of a helmet carried along by the wind

I saw under all the skies under all the oceans
Large eyes which seemed to belong to a single face
Bodies full of desires and of gaping abysses
Hearts all trembling with passions and images

Oh sisters who caressed my forehead nearby
Where the mermaid joins the star and the diamond
And the star the ice and the diamond the page
Where your names are inscribed by your former lover

Manuscript of "O Sœurs," an unpublished poem

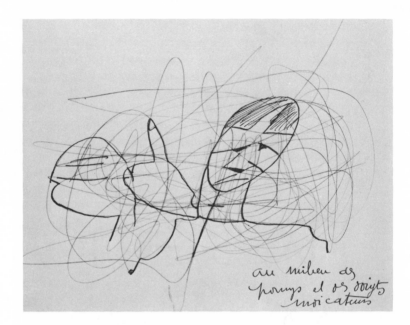

"In the center of pointing fists and hands"
This and the five following drawings are found in the
manuscript of *The Night of Loveless Nights*.

"Vanity, memory of the swan"

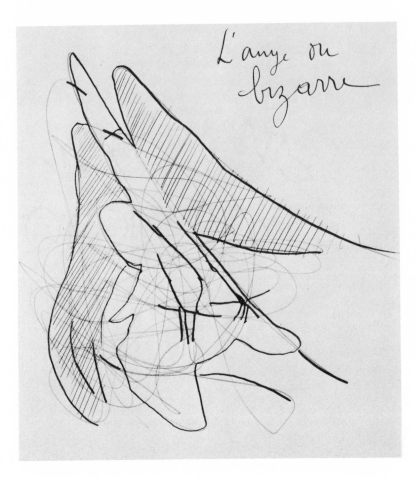

"The angel of the bizarre"

"The fish has recognized the Crusaders"

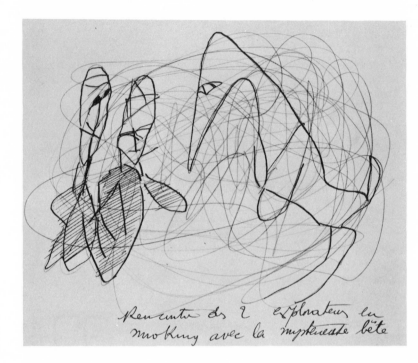

"Meeting of the explorers in evening clothes with the mysterious beast"

"Leda is present among us" and "The sailor remembers China"

Heurte les diamants froids, les lèvres sépulcrales
Sa bouche silencieuse a sa bouche et ses yeux
Ses yeux de sphinx cruels et ses mains animales
a ses yeux à ses mains, à son étoile, aux cieux.

Mais lui le cœur menti par de mortes chimères
gardant leur bec pourri planté dans les amours,
Pour un baiser vrai O beautés éphémères,
vous sauvera sans doute au seuil du dernier jour.

Le rire sur sa bouche écrasera des fraises
Les yeux seront marqués par un plus pur destin.
C'est Bacchus renaissant des cendres et des braises
Les cendres dans les dents, les braises dans les mains

Mais pour un qui renaît combien qui sans mourir
Portent au cœur Portent aux pieds de lourds chaînes
laissez laissez couler les eaux laissez les morts pourrir
Et chaque an reverdir le feuillage des chênes.

Simple interligne

Breton
42 rue Fontaine
Paris

Page from the manuscript of *The Night of Loveless Nights*

X J'habite quand il me plait un ravin,
ténébreux au dessus duquel le ciel se découpe
en un losange déchiqueté par les ombres des
sapins, des mélèzes et des rochers qui
couvrent les pentes escarpées.
Dans l'herbe du ravin poussent d'étranges
tubéreuses et, des ancolies et des colchiques
survolées par des libellules et des
mantes religieuses et si pareils sans
cesse le ciel, la flore et la
faune où succèdent aux insectes
les corneilles moroses et les rats
musqués que je ne sais quelle
immuable saison s'est abattue
sur ce toujours nocturne ravin
avec son dais en losange constellé
que ne traverse aucun nuage
Sur les troncs des arbres deux initiales
toujours les mêmes sont gravées.
Par quel couteau, par quelle main,
pour quel cœur?

Page from the manuscript of *The Night of Loveless Nights*

. . .de la naissance à la mort, un grand
poème s'élaborait dans le subcon-
scient du poète qui ne pouvait en
révéler que des fragments arbitraires.
(Postface to *Fortunes*)

(. . . from birth to death, a great poem
was being worked out in the sub-
conscious of the poet, who could only
reveal arbitrary fragments of it.)

Texts

The translations which follow are intended to give some idea of the poetic production of Desnos, particularly during the period discussed here, but ranging from the earliest poems to the last ones. My choice is necessarily subjective, but I believe it to include the greatest of Desnos' more serious poems. The lighter ones are not so well represented, primarily because they do not lend themselves to translation as will be easily visible in the few included here—and secondly because they do not seem to me to have the strength or the lasting interest of Desnos' more tragic love poems.

I have also added selections from his two early poetic novels, and an essay on Lautréamont, each of these of value for the whole body of the poetry of Desnos. It is to be hoped that the texts in their great variety furnish the necessary background material against which the preliminary essay can be seen and that, in its turn, the essay may cast some light on the texts.

Several poems are found complete in the essay itself and are not repeated here. In the essay, asterisks mark the texts complete in the following pages, for easy reference.

From Rrose Sélavy (Eros It's Life) 1922–23

O mon crâne, étoile de nacre qui s'étiole

(Oh my skull, mother of pearl which fades out)

Ne tourmentez plus Rrose Sélavy, car mon génie est énigme.

Car on ne le déchiffre pas.

(Don't torment Rrose Sélavy [Eros It's life] any more, for my genius is
enigma. For one [or Charon] cannot decipher it.)

Ah! meurs, amour!

(Oh! die, love! [or Love, love!])

Au paradis des diamants les carats sont des amants . . .

(In the paradise of diamonds carats are lovers . . .)

Mots, êtes-vous des mythes et pareils aux myrtes des morts?

(Words, are you myths and similar to the myrtles of the dead?)

Les lois de nos désirs sont des dés sans loisir.

(The laws of our desires are dice without leisure.)

[Lines indicating interior rhymes, anagrams and homonymic play in this
selection of aphorisms are my addition, M.A.C.]

From L'Aumonyme (The Homonym) 1923

"It's a tiresome undertaking: creating mystery around our loves. Not so
tiresome as all that.

 I love the great white car speeding along. From time to time, turning

the corners, the white and black chauffeur lowers, even more majestically than a frigate commander, his arm in the space rolling, rolling, rolling along so rapidly in white waves like the tires of the car I love.

But the mystery which unfolds concentrically around its breasts has captured in its asphalt labyrinth spotted with tears the great white car sailing rather than rolling along, making great invisible circles around it in space, concentric waves of mystery. The aerial target through which men pass without realizing it is slowly displaced according to the desires of lovers and the sphere, encircled with parallel lines like her breasts, pops like a balloon. Dirigibles and balloons, airplanes and mists, locomotives and automobiles, all is mystery in my immobile love for her breasts."

After having spoken, I looked:

The desert which stretched out around me was peopled with echoes which cruelty forced me into the presence of my own image reflected in the mirror of mirages. The women holding these hand mirrors were naked, except for their gloved hands, their left breasts encased in taffeta moiré black enough to set my gums screaming in pleasure, and except for their hair hidden under scarves of thin yellow wool. When these women turned around I could see their marvelous backs in entirety, all except the nape of the neck, the vertebral column, and the part where the hip begins to curve, hidden as these were by the scarf. Did this partial nudity, skillfully irritating to me, provoke my madness? Tell me that, you whose mystery is the goal.

 syllables

Prisonnier des et non des sens

 mots

Pris au nier?

 ser

des cils à bai

 ssés

 haï

Oh! hais non des sens
 mais des FORMES-PRISONS
 (DP, p. 58)

 syllables

(Prisoner of and not of meanings

 words

Taken in the denying [prisoner]?
 kiss
 of lashes to [Syllables ABC]
 be lowered

 (hated [not by]
Oh! Do not hate meanings
 but THE PRISONS OF FORMS)

S.E.
E.C.

(Essay
S.A.)

Je vois les pensées odorer les mots
. . .
Je vois les Pan C

(I see thoughts perfuming words
. . .
I see the Thaw TS)

From Langage cuit (Cooked Language) 1923

Vent Nocturne

Sur la mer maritime se perdent les perdus
Les morts meurent en chassant des chasseurs
dansent en rond une ronde
Dieux divins! Hommes humains!
de mes doigts digitaux je déchire une cervelle cérébrale.
 Quelle angoissante angoisse
Mais les maîtresses maîtrisées ont des cheveux chevelus
 Cieux célestes
 terre terrestre
mais où est la terre céleste?

(Night Wind)

(On the seasome sea the lost are lost
The dead die chasing the chasers
dancing a round around
Godly gods! Human humans!
with my digital fingers I tear apart a cerebral brain.
 What anguishing anguish
But the mastered mistresses have hairy hair
 Heavenly heavens
 earthly earth
but where is heavenly earth?)

Mouth-Shaped Heart

Her coat was dragging like a sinking sun
and the pearls of her necklace were as lovely as teeth.
A snow of breasts that the house surrounded
and a fire of kisses in the hearth.
And the diamonds of her rings shone brighter than any eyes.
"Night visitor, God believe in me!
—I hail you gracious with fullness
blessed be the womb of your fruit.
Outside the reeds of delicate proportions curve gently.
The cats screech louder than weathercocks.
Tomorrow at daybreak, breathe roses with dawn's fingers
and the shining cloud will transform softest down to a star."

In the night it was the swearing of rails at the nonchalant trains
near the gardens where the forgotten roses
are uprooted love affairs.
"Night visitor, one day I shall lie down in a winding sheet as in a sea.
Your looks are star beams
the streamers on your dress roads to the infinite.
Come in a balloon light as a heart
in spite of the magnet, an arch of triumph in its form.
The flowers of the orchestra pit become the liveliest hands of Haarlem.
The centuries of our life last scarcely seconds.
Scarcely do seconds last loves.

At each bend in the road a right angle like an old man.
The night quiet as a wolf climbs into my bed.
Visitor! Visitor! your shields are breasts!
In the studio vipers rear up as mean as tongues.
And the flower-like iron vices have become hands.
With whose foreheads will you lapidate the peoples?
What lion follows you roaring louder than a storm?
Here come the nightmares of phantoms."
And the roof of the palate slammed as loudly as the doors of the tomb.
They nailed me with nails as thin as the dead
in a death of silence.
Now you will pay no more attention
to the birds of the comic song.
The sponge I wash myself with is only a dripping brain
and knives pierce me with the sharpness of your looks.

[This poem is based largely on the reversals and deformations of certain clichés: for instance, "le cœur en bouche" is the twisting of "la bouche en cœur," or a heart-shaped mouth, and so on, for the list: teeth like pearls, breasts like snow, rosy-fingered dawn, hands like flowers, and old man bent at right angles, a tongue as mean as a viper's, a deathly silence, the spongy matter of the brain, and looks as sharp and cutting as knives. Compare with the poems analyzed in the section on "Games and Grammar," where deformations of terms and tenses abound.]

From Peine perdue (In vain)
[1923, published in *Destineé arbitraire* (Arbitrary Fate), 1975]

On the Other Shore

The blind man held out his hand toward the queen
The queen held out her mouth for him
Miracles you shrivel up along my path!
My girl friends are gagged
what is the good of speaking the language of looks
and of hands
I go through a dictionary of an unknown tongue
an alphabet similar to the gas lights the whole length of the avenue
I am the slave of certain distinguished letters,

Letters of hate, I was still writing all of them
it was in August
I wondered if I was capable of love
or of hate
my pen-holder wrote as I dictated
whether it wished to or not
In a labor camp of women in the tropics
My beloved was to be found
The cutting edge was nicked on her broad neck
The trees defoliate and become hands
When I have feet
and hands no longer
I shall still have wings
Oh crimes what difference between you
and the death of reeds?
One day I shall be a surprising lover
All women will love me
but I am so afraid of not understanding.

From Deuil pour deuil
(Mourning for Mourning) 1924

These ruins are situated on the banks of a winding river. The town must have had some importance long ago. Monumental buildings still remain, and a network of tunnels, as well as towers of a bizarre and varied architecture. In these deserted and sunny squares we have been overtaken by fear. In spite of our anxiety, no one, no one at all came to meet us. These ruins are uninhabited. To the southwest there rises a tall metallic construction with apertures, whose use we have not been able to determine. It seems ready to crumble into ruins, for it is leaning at a sharp angle and hangs over the river:

"Strange sicknesses, curious customs, bell-clapper love, how far astray are you leading me? I find in these stones no vestige of what I seek. The impassive mirror, always new, reveals only myself. Is it in an abandoned town, a desert, that this magnificent meeting should logically take place? From afar, I have seen the beautiful millionairesses advancing with their caravan of decorated and gold-bearing camels. Impassive and tormented, I have awaited them. Even before reaching me, they were transformed into dusty little old ladies, and the camel drivers

into beasts. I have developed the habit of laughing uproariously at funerals which serve as my landscape. I have lived infinite existences in dark corridors at the heart of mines . . .

Love! Love! I shall no longer use in describing you the warring epithets of airplane motors. I shall speak of you in banal terms, for banality may yield me the extraordinary adventure I have been preparing since my first words, and whose gender I do not know. . . . Love, do you condemn me to become the tutelary demon of these ruins, and shall I live from now on an eternal youth. . . ?

I do not believe in God, but I have the sense of the infinite. No one has a spirit more religious than mine. Ceaselessly I strike against insoluble questions. The only questions I admit willingly are all insoluble. The others could only be asked by unimaginative beings and hold no interest for me.

These ruins are situated on the banks of a winding river. The climate is nondescript. To the southwest there rises a tall metallic construction with openings, whose use we have not been able to determine. . . ."

But, oh granite, do not regret your terrifying majesty at the foot of the cliff. Now that you are resting in this cemetery, shaped into a paperweight on a deadman perhaps turned to paper thanks to the rot used to make that matter and perhaps even the paper on which I write this eulogy, you take on the most serene majesty, thanks to that dead man who tried to carry into the silence even his name and to confide to the modest echoes of his surroundings the sound of a terrible and satanic burst of laughter.

Paris, April 1924

A La Mystérieuse (To the Mysterious One) 1925

Oh Pangs of Love!

Oh pangs of love!
How necessary you are to me and how precious.
My eyes closing on imaginary tears, my hands stretching
 out ceaselessly toward nothingness.
I dreamed last night of crazed landscapes and of adventures
 as dangerous from the perspective of death as from the
 perspective of life which are both also the perspective of love.

At my waking you were present, oh anguish of love, oh desert
 muses, oh exigent muses.
My laugh and my joy crystallize about you. Your
 makeup, your powder, your rouge, your alligator bag, your
 silk stockings . . . and also that little fold between the ear
 and the nape of your neck, near its base, your
 silk pants and your delicate shirt and your fur coat, your
 round belly is my laughter and your feet my joys and
 all your jewels.
Really, how good-looking and well dressed you are.
Oh pangs of love, exigent angels, here I am imagining you
 in the very likeness of my love, confusing you with it . . .
Oh pangs of love, you whom I create and clothe, you
 are confused with my love whose clothing only I know
 and also her eyes, voice, face, hands, hair, teeth, eyes . . .

I Have So Often Dreamed of You

I have so often dreamed of you that you become unreal.
Is it still time enough to reach that living body and to kiss
 on that mouth the birth of the voice so dear to me?
I have so often dreamed of you that my arms used as they are
 to meet on my breast in embracing your shadow would
 perhaps not fit the contour of your body.
And, before the real appearance of what has haunted and ruled
 me for days and years, I might become only a shadow.
Oh the weighing of sentiment.
I have so often dreamed of you that there is probably no time
 now to waken. I sleep standing, my body exposed to all the
 appearances of life and love and you, who alone still
 matter to me, I could less easily touch your forehead and
 your lips than the first lips and the first forehead I
 might meet by chance.
I have so often dreamed of you, walked, spoken, slept with your
 phantom that perhaps I can be nothing any longer than a
 phantom among phantoms and a hundred times more shadow
 than the shadow which walks and will walk joyously over
 the sundial of your life.

Sleep Spaces

In the night there are naturally the seven marvels of the world
 and greatness and the tragic and enchantment.
Confusedly, forests mingle with legendary creatures hidden in the
 thickets.
You are there.
In the night there is the nightwalker's step and the
 murderer's and the policeman's and the streetlight and the
 ragman's lantern.
You are there.
In the night pass trains and ships and the mirage of
 countries where it is daylight. The last breaths of twilight
 and the first shivers of dawn.
You are there.
A tune on the piano, an exclamation.
A door slams,
A clock.
And not just beings and things and material noises.
But still myself chasing myself or going on beyond.
You are there, immolated one, you for whom I wait.
Sometimes strange figures are born at the instant of sleep
 and disappear.
When I close my eyes, phosphorescent blooms appear and
 fade and are reborn like fleshy fireworks.
Unknown countries I traverse with creatures for company.
You are there most probably, oh beautiful discreet spy.
And the palpable soul of the reaches.
And the perfumes of the sky and the stars and the cock's
 crow from two thousand years ago and the peacock's scream
 in the parks aflame and kisses.
Handshakes sinister in a sickly light and
 axles screeching on hypnotic roads.
You are most probably there, whom I do not know, whom
 on the contrary I know.
But who, present in my dreams, insist on being sensed there
 without appearing.
You who remain out of reach in reality and in dream.
You who belong to me by my will to possess you in illusion

but whose face approaches mine only if my eyes are
 closed to dream as well as to reality.
You in spite of an easy rhetoric where the waves die on
 the beaches, where the crow flies in ruined factories, where
 wood rots cracking under a leaden sun.
You who are at the depths of my dreams, arousing my mind
 full of metamorphoses and leaving me your glove when
 I kiss your hand.
In the night there are stars and the tenebral motion of
 the sea, rivers, forests, towns, grass, the lungs
 of millions and millions of beings.
In the night there are the marvels of the world.
In the night there are no guardian angels but there is sleep.
In the night you are there.
In the day also.

If You Knew

Far from me and like the stars, the sea, and all the
 props of poetic legend,
Far from me and present all the same without your knowledge,
Far from me and still more silent because I imagine you
 endlessly,
Far from me, my beautiful mirage and my eternal dream,
 you cannot know.
If you knew.
Far from me and perhaps still farther from being unaware of
 me and still unaware.
Far from me because you doubtless do not love me or,
 not so different, I doubt your love.
Far from me because you cleverly ignore my passionate
 desires.
Far from me for you are cruel.
If you knew.
Far from me, oh joyous as the flower dancing in the river
 on its watery stem, oh sad as seven in the evening in
 the mushroom fields.
Far from me still silent as in my presence and still joyous

as the stork-shaped hour falling from on high.
Far from me at the moment when the alembics sing, when
the silent and noisy sea curls up on the white pillows.
If you knew.
Far from me, oh my present present torment, far from
me with the splendid sound of oyster shells crunched under
the nightwalker's step, at dawn, when he passes by the
door of restaurants.
If you knew.
Far from me, willed and material mirage.
Far from me an island turns aside at the passing of ships.
Far from me a calm herd of cattle mistakes the path, stops
stubbornly at the brink of a steep precipice, far from
me, oh cruel one.
Far from me, a falling star falls in the night bottle of
the poet. He corks it instantly to watch the star en-
closed within the glass, the constellations come
to life against the sides, far from me, you are far from me.
If you knew.
Far from me a house is built just now.
A white-clothed worker atop the structure sings a sad
brief song and suddenly, in the hod of mortar there appears
the future of the house: lovers' kisses and double suicides
and nakedness in the rooms of lovely unknown girls and
their midnight dreams, and the voluptuous secrets surprised
by the parquet floors.
Far from me,
If you knew.
If you knew how I love you and though you do not love
me, how I am happy, how I am strong and proud,
with your image in my mind, to leave the universe.
How I am happy enough to perish from it.
If you knew how the world submits to me.
And you, oh beautiful unsubmissive one, how you are also
my prisoner.
Oh far-from-me to whom I submit.
If you knew.

No, Love is Not Dead

No, love is not dead in this heart and these eyes and this
 mouth which announced the beginning of its burial.
Listen, I have had enough of the picturesque and the
 colorful and the charming.
I love love, its tenderness and cruelty.
My love has but one name, but one form.
All passes. Mouths press against this mouth.
My love has but one name, but one form.
And if some day you remember
O form and name of my love,
One day on the ocean between America and Europe,
At the hour when the last sunbeam reverberates on the
 undulating surface of waves, or else a stormy night
 beneath a tree in the countryside or in a speeding car,
A spring morning on the boulevard Malesherbes,
A rainy day,
At dawn before sleeping,
Tell yourself, I command your familiar spirit, that I alone
 loved you more and that it is sad you should not have
 known it.
Tell yourself one must not regret things: Ronsard before me and
 Baudelaire have sung the regrets of ladies old or
 dead who despised the purest love.
When you are dead
You will be beautiful and still an object of desire.
I will be already gone, enclosed forever complete within your
 immortal body, in your astonishing image present forever
 among the constant marvels of life and of eternity, but
 if I live
Your voice and its tone, your look and its radiance,
Your fragrance and the scent of your hair and many other
 things beside will still live in me,
Who am neither Ronsard nor Baudelaire,
I who am Robert Desnos and who for having known and loved you,
Am easily their equal.
I who am Robert Desnos, to love you
Wanting no other reputation to be remembered by on the
 despicable earth.

From Les Ténèbres (The Shadows) 1927

The Voice of Robert Desnos

So like the flower and the breeze
like the water's flowing with its passing shadows
like the smile glimpsed that famous midnight
so like everything like joy and sadness
it's past midnight its naked torso rising above belfreys and
 poplars
I summon to me all those lost in the countryside
old corpses young felled oaks
the threads of cloth rotting on the ground and the linen drying
 near the farms
I summon to me tornadoes and hurricanes
tempests typhoons cyclones
tidal waves
earthquakes
I summon to me volcano smoke and that of cigarettes
smoke rings from luxury cigars
I summon to me loves and lovers
I summon to me the living and the dead
I summon to me gravediggers I summon murderers
I summon executioners I summon pilots builders and
 architects
murderers
I summon flesh
I summon the one I love
I summon the one I love
I summon the one I love
triumphant midnight unfolds its satin wings and alights on my bed
belfreys and poplars bend to my desire
the former fall in ruin the latter fade
those lost in the countryside find their way in finding me
the old cadavers resuscitate at my voice
the young felled oaks become green
the shreds of cloth rotting in the ground and on the ground
clack at my voice like the banner of rebellion
the linen drying around the farms dresses adorable women whom

 I do not adore
who come to me
obey my voice and adore me
tornadoes twist in my mouth
hurricanes redden my lips even more
tempests growl at my feet
typhoons rumple my hair even more
I receive the drunken kisses of cyclones
tidal waves rush forward to die at my feet
earthquakes destroy only at my command
volcano smoke clothes me in its vapors
and cigarette smoke perfumes me
and smoke rings from cigars crown me
loves and love so long pursued take refuge in me
lovers listen to my voice
the living and the dead submit to me the former greeting
 me coldly the latter in friendship
gravediggers leave graves half dug declaring that I
 alone can order their nightly labor
murderers salute me
executioners invoke the revolution
invoke my voice
invoke my name
pilots steer according to my eyes
builders grow dizzy listening to me
architects leave for the desert
murderers bless me
flesh quivers at my call

the one I love does not listen to me
the one I love does not hear me
the one I love does not answer me.

 (December 14, 1926)

Infinitive

To die there oh lovely spark to die there
to see clouds melting like snow and echo
origins of the sun of white poor as Job's turkey
not yet to die and see the shadow lasting still
to be born with the fire and not to die
to embrace and kiss fleeting love the unpolished sky
to attain the heights abandon ship
and who knows discover what I love
omit to transmit my name to future years
to laugh in the stormy hours to sleep at the foot of a pine
thanks to the stars like a spectacle
and to die what I love at the edge of flames.

Obsession

I bring you a bit of seaweed which was tangled with the sea
 foam and this comb
But your hair is more neatly fixed than the clouds with the
 wind with celestial crimson glowing in them and are such that
 with quiverings of life and sobs twisting sometimes between my
 hands they die with the waves and the reefs of the strand
 so abundantly that we shall not soon again despair
 of perfumes and their flight at evening when this comb
 marks motionless the stars buried in their rapid and
 silky flow traversed by my hands seeking still at their root
 the humid caress of a sea more dangerous than the
 one where this seaweed was gathered with the froth scattered
 by a tempest
A star dying is like your lips
They turn blue as the wine spilled on the tablecloth
An instant passes with a mine's profundity
With a muffled complaint the anthracite falls in
 flakes on the town
How cold it is in the impasse where I knew you
A forgotten number on a house in ruins
The number 4 I think
Before too long I'll find you again near these china-asters

The mines make a muffled snoring
The roofs are strewn with anthracite
This comb in your hair like the end of the world
The smoke the old bird and the jay
There the roses and the emeralds are finished
The precious stones and the flowers
The earth crumbles and stars screeching like
 an iron across mother-of-pearl
But your neatly fixed hair has the shape of a hand.

Three Stars

I have lost regretfulness of evil with the years gone by.
I have won the sympathy of fish.
Full of seaweed, the palace sheltering my dreams is a shoal and
 also a territory of the stormy sky and not of the too-pale
 sky of melancholy divinity.
I have lost all the same the glory I despise.
I have lost everything save for love, love of love, love of,
 love of the queen of catastrophes.
A star speaks in my ear:
"Believe me, she's a lovely lady,
The seaweed obeys her and the sea itself changes to a crystal dress
 when she appears on the shore."
Beautiful crystal dress you resound at my name.
Vibrations, oh supernatural bell, perpetuate themselves in her being
Her breasts tremble from it.
The crystal dress knows my name,
The crystal dress said to me:
"Fury in you, love in you
Child of the numberless stars
Master of the wind alone and the sand alone
Master of the carillons of fate and eternity,
Master of everything at last save the love of his lovely one
Master of everything he has lost and a slave to what he still retains.
You will be the last guest at the round table of love.
The guests, the other thieves have taken the silver setting.
Wood cleaves, snow melts.
Master of everything save his lady's love.

You who command the ridiculous gods of humanity and do not use
 their power which is subject to you.
You, master, master of everything save your lady's love."
That is what the crystal dress said to me.

Sky Song

The flower of the Alps said to the seashell: "you are shining"
The seashell said to the sea: "you resound"
The sea said to the boat: "you quiver"
The boat said to the fire: "you are glowing"
The fire said to me: "I glow less brightly than her eyes"
The boat said to me: "I quiver less than your heart when she appears"
The sea said to me: "I resound less than her name in your love"
The seashell said to me: "I shine less than the phosphorous of
 desire in your empty dream"
The flower of the Alps said to me: "she is lovely"
I said: "she is lovely, she is lovely, she is touching."

Of the Flower of Love and of the Migrating Horses

Once in the forest was an immense flower for love of whom all the
 trees almost died
All the trees loved her
Toward midnight the oaks assumed serpent shapes and slithered to
 the flower's stem
The ashes and the poplars bent over to its corolla
The ferns grew yellow in the earth
And she was more radiant than the nightly love of moon and sea
Paler than the great extinct volcanos of this planet
Sadder and more nostalgic than the sand drying up and moistening
 at the will of waves
I speak of the forest flower and not of towers
I speak of the forest flower and not of my love

And if, too pale and nostalgic and adorable loved
 by the trees and ferns she causes my breath to catch it is
 because we share the same essence
I met the flower one day
I am speaking of the flower and not of trees
In the trembling forest where I went
Greetings butterfly who died in her corolla
And you rotting fern my heart
And you my eyes ferns almost coal almost flame almost flood
I speak in vain of the flower but of myself
The ferns have yellowed on the moon-like earth
At that precise moment similar to the agony of a bee lost
 between a cornflower and a rose and again a pearl
The sky is not so closed
A man appears wearing a chrysanthemum and says his name
 for which doors open
It's of the motionless flower I speak and not of the ports of
 adventure and solitude
The trees one by one died about the flower
Who fed on their rotting death
And thus the plain grew like the pulp of fruit
The towns sprang up
A river nestles at my feet and remains at my mercy, twine of
 images in their greeting
Somewhere a heart stops beating and the flower arises
The flower whose perfume triumphs over time
The flower who chose to reveal itself to the denuded plains
 like the moon the sea and the arid space of dolorous
 hearts
One quite red lobster claw lies beside the kettle
The sun projects the shadow of the candle and the flame
The flower stands proudly upright in a fabled sky
Your nails my friends are like her petals and as pink
The murmuring forest stretches out below
A heart stopping like a dried-up spring
It is no longer time to love, it is no longer time, oh passers-by
 on the road
The forest flower whose tale I tell is a chrysanthemum
The trees have died the fields turned green the towns appeared
The great migrating horses snort in their distant stables

Soon the great migrating horses leave
The towns watch the herd passing in the streets whose pavings
 resound glinting with their hoofs
The fields are shaken by this cavalcade
While, trailing their tails in the dust and their smoking
 nostrils, they pass before the flower
Their long shadows extend
But what became of the migratory horses whose spotted covering
 was a mark of distress
From time to time a strange fossil is found by digging in the earth
One of their horseshoes
The flower which saw them still flourishes with neither spot
 nor weakness
Leaves grow along her stem
The ferns catch fire and lean toward the windows of houses
But what became of the trees
Why does the flower flourish
Volcanoes! oh volcanoes!
The sky crumbles
I am thinking of great distance in the depths of myself
The abolished moments like fingernails broken on the closed
 doors

When in the countryside a peasant is about to die surrounded
 with Indian summer's ripe fruits with the frost crackling
 against the panes of boredom withered faded like cornflowers
 on the lawn
The migrating horses appear
When a traveler wanders lost among the fireflies with more
 furrows than an old man's forehead and when he lies down
 on the moving earth
The migrating horses appear
When a little girl lies down naked at the foot of a birch and
 waits
The migrating horses appear
They surge forth in a gallop of shattered flasks and creaking
 closets
Into a hollow they disappear
No saddle has ever withered their spine and their shining rump
 reflects the sky

Their passing splatters the walls freshly replastered
And the frost crackling the ripe fruit the depetaled flowers
 the stagnant water the marshy terrain slowly formed
See the migrating horses pass by

The migrating horses
The migrating horses
The migrating horses
The migrating horses.

With Oaken Heart and Birchbark

With the tender and hard wood of these trees, with oaken
 heart and birchbark, how many skies could one make, how
 many oceans, how many slippers for the pretty feet of
 Isabelle the Vague?

With oaken heart and birchbark.

With the sky how many glances could one make, how many
 shadows behind the wall, how many slips for the
 body of Isabelle the Vague?

With oaken heart and birchbark, with the sky.

With the oceans how many flames could one make, how many
 reflections at palace edge, how many rainbows above the head of
 Isabelle the Vague?

With oaken heart and birchbark, with the sky, with oceans.

With slippers how many stars could one make, how many paths
 in the night, traces in the ashes, how many stairs could
 one climb to meet Isabelle the Vague?

With oaken heart and birchbark, with the sky, with oceans, with
 slippers.

But Isabelle the Vague, you know, is only an image of dream
 seen through the polished leaves of the tree of death
 and of love.

With oaken heart and birchbark.

May she come to me telling in vain the fortune held in my
 clasped fist, remaining there when I open my hand where
 it is sketched in strange lines.

With oaken heart and birchbark, with the sky.

She can look at her face and her hair in the depths of my
 soul and kiss my mouth.

With oaken heart and birchbark, with the sky, with oceans.

She can undress, I shall walk by her side throughout the
 world, at night, frightening the nightwatchmen. She can
 kill me, trample me or die at my feet.

For I love another more touching than Isabelle the Vague.

With oaken heart and birchbark, with the sky, with oceans, with
 slippers.

Ancient Clamor

A stalk stripped of leaves in my hand is the world
The keyhole is closed on the shadow and the shadow puts its eye
 to the keyhole
And here is the shadow gliding into the room
Here is the beautiful mistress the shadow more carnal than
 the great bird of white fur lost in its blasphemy imagines
 perched on the shoulder of the beautiful the incomparable
 whore watching over sleep
The path suddenly calms waiting for the tempest
A green butterfly net sweeps down on the candle
Who are you, taking the flame for an insect
A strange battle between the gauze and the fire
At your knees I should like to spend the night
At your knees
From time to time on your forehead shadowy and calm in spite
 of nocturnal apparitions I put back in its place a strand
 of hair
I shall watch over the slow swaying of time and of your breathing
This button I found on the ground
It is mother-of-pearl

And I look for the buttonhole that lost it
I know a button is missing on your coat
On the side of the mountain the edelweiss withers
The edelweiss flowering in my dream and in your hands when they
 open

Early morning greetings when drunkenness is shared when the
 adolescent river nonchalantly descends the colossal marble steps
 with its retinue of white clouds and thistles
The most beautiful cloud was a moonlight recently transformed
 and the tallest thistle was covered with diamonds
Early morning greetings to the flower of coal the good-hearted
 virgin who'll put me to sleep tonight
Early morning greetings to the crystal eyes the lavender
 eyes the gypsum eyes the eyes of dead calm the eyes of
 sobbing the eyes of tempest
Greetings morning greetings
The flame is in my heart and the sun in the glass
But never more alas shall we say again
Good morning to all of you! crocodiles crystal eyes thistles
 virgin flower of coal good-hearted virgin.

Despair of the Sun

What strange noise was sliding along the staircase at whose base
 the transparent apple dreamed.
The orchards were closed and the sphinx far off stretched lazily
 in the sand crackling with heat in the night of fragile cloth.
Was that noise to last until the waking of the tenants or would
 it go away in the shadow of the morning twilight? The noise
 persisted. The watchful sphinx had heard it for centuries and
 wanted to test it. So it was not surprising to see its supple
 silhouette in the shadows of the stairs. The beast
 scratched with its claws the waxed steps. The doorbells gleamed
 their light onto the elevator shaft and the persistent noise
 aware of the arrival of the one whom it had been awaiting for
 millions of shadows clung to its mane and suddenly the
 shadow paled.

It's the poem of the morning beginning while in her warm bed with
 her hair undone pulled over her face and the sheets more
 wrinkled than her eyelids the wanderer waits for the moment
 when her door still closed on the floods of sky and of night
 might open on the landscape of resin and agate.
It's the poem of day when the sphinx lies down in the bed of
 the wanderer and in spite of the persisting noise swears an
 eternal fidelity to him and love.
It's the poem of the day beginning in the perfumed vapor of chocolate
 and the monotonous slapping cloth of the bootblack astonished to
 see on the stairs the claw tracks of the night traveler.
It's the poem of the day beginning with the flames of matches
 to the great dismay of the pyramids surprised and saddened
 to see their majestic companion crouched at their feet
 no longer.
But what was the noise? Tell us while the poem of the day begins
 while the wanderer and the beloved sphinx dream of the
 landscapes thrown into chaos.
It was not the noise of the clock nor that of footsteps
 nor that of the coffee mill.
What was the noise? what was it?
Will the staircase always descend still lower? will it always ascend still
 higher?
Let us dream let us welcome the dream it's the poem of the day
 beginning.

Words of the Rocks

The queen of the azure and the crazed man of emptiness
 pass in a cab
At each window manes of hair lean out
Calling "See you soon!"
"See you soon!" say the jellyfish
"See you soon!" say the silks
Says mother-of-pearl say the pearls say the diamonds
Soon a night of nights without moon or star
A night of all the littorals and of all forests
A night of all love and of all eternity
A pane shatters in the watched window

A rag is clacking over the tragic countryside
You will be alone
Among the mother-of-pearl dust and the carbonized diamonds
The dead pearls
Alone among the silks like dresses emptied at
 your approaching
Among the tracks of jellyfish fleeing when you lifted your gaze
Alone perhaps the manes of hair will not flee
Will obey you
They will bend in your fingers like irrevocable condemnations
Long hair of girls who loved me
Long hair of women who loved me
And whom I did not love
Remain at the windows oh manes of hair!
A night of all the littoral nights
A night of luster and of funerals
A staircase unwinds under my feet and the night and day reveal
 to my fate only shadows and failure
The immense column of marble doubt alone sustains the sky
 above my head
The empty bottles whose glass I shatter into dazzling splinters
The smell of cork abandoned by the sea
The nets of boats imagined by little girls
The debris of mother-of-pearl slowly powdering
An evening of all the evenings of love and eternity
The infinite profound pain desire poetry love revelation miracle
 revolution love the profound infinite envelops me with
 talkative shadows
The eternal infinites shatter in splinters oh manes of hair!
It will be a night of nights without moon or pearl
Without even broken bottles.

Never Anyone But You

Never anyone but you in spite of stars and solitudes
In spite of mutilated trees at nightfall
Never anyone but you will follow a path which is mine also
The farther you go away the greater your shadow grows

Never anyone but you will salute the sea at dawn when tired
 of wandering having left the tenebral forests and thistle bushes
 I shall walk toward the foam
Never anyone but you will place her hand on my forehead and
 my eyes
Never anyone but you and I deny falsehood and infidelity
This anchored boat you may cut its rope
Never anyone but you
The eagle prisoner in a cage pecks slowly at the copper bars turned
 green
What an escape!
It's Sunday marked by the song of nightingales in the woods
 of a tender green the tedium felt by little girls before a
 cage where a canary flies about while in the solitary street
 the sun slowly moves its narrow line across the heated sidewalk
We shall pass other lines
Never never anyone but you
And I alone like the faded ivy of suburban gardens
 alone like glass
And you never anyone but you

Startled

On the road returning from the summits met by the crows
 and the chestnuts
Jealousy hailed and the pale flatterer
Disaster finally disaster announced
Why turn pale? why shiver?
Jealousy hailed and the animal reign with fatigue disorder
 jealousy
A sail unfolding above bare heads
I have never spoken of my dream of straw
But where have they gone the solitary trees of theater
I don't know where I'm going I have leaves in my hands
 leaves in my mouth
I don't know if my eyes closed last night on the precious
 shadows or on a river of gold and of flame
Is it the day of encounters and pursuings
I have leaves in my hands leaves in my mouth.

From The Marble Rose to the Iron Rose

The marble rose immense and white was alone on the deserted square where the shadow stretched out to infinity. And the marble rose alone under the sun and the stars was queen of the solitude. And odorless the marble rose on its rigid stalk at the summit of the granite pedestal was streaming with all the floods of the sky. The moon paused pensive in her glacial heart and the goddesses of the gardens the goddesses of marble came to try their cold breasts against her petals.

The glass rose resounded with all the sounds of the littoral. There was not one sob of a broken wave which didn't make it tremble. About its fragile stalk and its transparent heart rainbows were turning with the planets. The rain slid in delicate globes down her leaves set moaning by the wind sometimes with fear of streams and glow worms.

The coal rose was a black phoenix which the powder transformed to a fire rose. But ceaselessly come forth from the shadowy corridors of the mine where the miners gathered her respectfully to take her to daylight in her vein of anthracite the coal rose kept watch at the portals of the desert.

The blotting paper rose used to bleed sometimes at twilight when the evening came to kneel at her feet. The blotting paper rose guardian of all secrets and a bad counselor bled with a thicker blood than seafoam and which was not her own.

The cloud rose appeared over the condemned cities at the hour of volcanic eruptions at the hour of fires at the hour of riots and above Paris when the commune mixed the irised beings of petrol and the smell of powder she was lovely on the twenty-first of January lovely in the month of October in the cold wind of the steppes lovely in 1905 at the hour of miracles at the hour of love.

The wood rose presided at the gallows. She flowered at the top of the guillotine then slept in the moss of the immense shadow of mushrooms.

The iron rose had been hammered for centuries by forgers of sparks. Each of her leaves was great like an unknown sky. At the slightest shock she gave off the noise of thunder. But how gentle she was to despairing girls in love the iron rose.

The marble rose the glass rose the coal rose the blotting-paper rose the
cloud rose the wood rose the iron rose will always flower again
but today they are depetaled on your carpet.

Who are you? you who crush under your naked feet the fugitive debris
of the marble rose the glass rose the coal rose the blotting-paper
rose the cloud rose the wood rose the iron rose.

From La Liberté ou l'amour! (Freedom or Love!) 1928

Corsair Sanglot was bored! Boredom had become his cause. He let it
grow in silence, while he marveled every day that it was still increasing.
It was Boredom, a large sunny square, lined with rectilinear colonnades,
perfectly swept, perfectly clean, deserted. An unchanging hour had
sounded in the corsair's life, and now he understood that boredom is
synonymous with Eternity. In vain was he awakened every night by the
pendulum's strange tick-tock in crescendo, its pulse filling the room
where he lay, or either, toward midnight, a dark presence interrupted
his dream. His pupils, dilated in the darkness, sought the person who
must just have entered the building. But no one had forced the door
and soon the calm sound of the clock mingled with the sleeper's
breathing.

Corsair Sanglot felt a new esteem growing for himself and in himself.
Since he had understood and accepted the monotony of Eternity, he
advanced straight as a stick through adventures like slithering vines,
not stopping his progress. A new exaltation had replaced his depression.
A sort of reverse enthusiasm led him to consider the failure of his most
cherished enterprises as totally without interest. Time's freedom had
finally conquered him. He had merged with the patient minutes in se-
quence, each resembling the others.

It was boredom, the great square where he had one day ventured.
It was three o'clock in the afternoon. Silence covered everything, even
the sonorous buzzing of bumblebees and of the heated air. The colon-
nades cast their rectilinear shadows over the yellow ground. No
passer-by, except on the other side of the square, which might have
been two miles wide, a minuscule personage strolling with no definite
goal. Corsair Sanglot noticed with terror that it was still three o'clock,

that the shadows were immutably turned in the same direction. But this terror itself disappeared. The corsair accepted this pathetic hell at last. He knew that no paradise is permitted to the man who has taken account of the existence of the infinite, and he consented to remain, a sentinel eternally standing, on the square warmed and brilliantly lit by an immobile sun.

Who then has compared boredom to dust? Boredom and eternity are absolutely pure of any spot. A mental sweeper carefully surveys the despairing cleanliness. Did I say despairing? Boredom could no more engender despair than it could end in suicide. You who have no fear of death, try a little boredom. Death will henceforth be of no use to you. Once and for all, there will have been revealed to you the immobile torment and the distant perspectives of the mind freed of all sense of the picturesque and of all sentimentality. . . .

Let a tumultuous catastrophe topple the screens and the circumstances and there they are, grains of sand lost in a flat plain, united by the imaginary straight line which links every being to no matter what other being. Neither time nor space, nothing opposes these ideal relations. A life overturned, worldly constraints, earthly obligations, everything crumbles. Humans are nevertheless subject to the same arbitrary rolling of dice.

In the desert, lost, irremediably lost, the white-helmeted explorer finally realizes the reality of mirages and of unknown treasures, the dreamed-of fauna, the improbable flora which make up the sensual paradise where he will from now on evolve, a scarecrow without sparrows, a tomb without epitaph, a man without name, while, in a formidable displacement, the pyramids reveal the dice hidden under their weighty mass and pose once more the irritating problem of bygone fatality and of future destiny. As for the present, that beautiful eternal sky, it only lasts the time it takes to roll three dice over the town, a desert, a man, a white-hatted explorer, lost more in his vast intuition of eternal events than in the sandy expanse of the equatorial plain where his genius, that clever guide, led him step by step towards a revelation ceaselessly contradicting itself, causing him to stray from his own unrecognizable image, because of the position of his eyes or the lack of a point of comparison and the legitimate doubt entertained by a well-bred mind in regard to the mirrors whose worth cannot be proved, leading him to the chaotic image of the skies, of other beings, of inanimate objects and of the ghostly incarnations of his thoughts. . . .

But finally I salute you, you whose existence grants a supernatural joy to my days. I have loved you, even because of your name. I have followed the path which your shadow traced in a melancholy desert where, behind me, I left all my friends. And now I find you once more when I thought I had fled you, and now the difficult sun of moral solitude illumines once more your visage and your body.

Farewell, world! And if I must follow you to the abyss, I shall follow you! Night after night I shall contemplate your eyes shining in the darkness, your face scarcely lit but visible in the clear night of Paris, thanks to the reverberation of electric lights in the rooms. I shall contemplate your tender eyes, touching in their dampness, until the dawn which, awaking the condemned man with the finger of a top-hatted ghost, will remind us that the hour of contemplation has passed, and that one must laugh and speak and suffer—not the difficult and consoling noontime sun over the deserted beaches, in the face of the stunning sky traversed by playful clouds, but rather the harsh law of constraint, the prison of elegance, the pseudo-discipline of life's relations and the inexpressible dangers of the fragmentation of dream by utilitarian existence.

And if I must follow you to the abyss, I shall follow you!

You are not the passerby, but the one who remains. The notion of eternity is linked with my love for you. No, you are not the passerby nor the strange pilot guiding the adventurer through the labyrinth of desire. You have opened to me the country of passion itself. I lose myself in your thought more surely than in a desert. And so, at the moment of writing these lines, I have not confronted your image with your "reality" in me. You are not the passerby but the eternal lover, whether you wish it or not. Grieving joy of the passion revealed by meeting you. I suffer, but my suffering is dear to me, and if I have some esteem for myself, it is because I have encountered you in my blind rush toward mobile horizons.

Sirène-Anémone (Mermaid-Anemone) 1929

. . .

It was a spring evening of one of the years lost to love
One of the years won to love forever
Remember that evening of rain and of dew when the stars became
 comets hurtling earthwards

Most beautiful and fatal the comet of destiny of tears and of
 eternal wanderings
Departed from my sky to be reflected in the sea
You were born from that mirage
But you departed with the comet and your song died out among
 echoes
Was your song to die out forever
Did it die and must I seek it in the tumultuous choir of waves breaking
Or will it rise again from the depth of echoes and spray
When the comets are lost forever in space
Will you rise mirage of flesh and bones from out your desert
 of shadows
Remember this landscape of midnight of basalt and granite
Where detached from the sky a mane of radiant hair flowed upon
 your shoulders
What radiant hair of shipwake and light
Not in vain do the silk dresses tremble in the night
As coming from the depths they are washed ashore on the banks
Vestiges of loves and shipwrecks where the anemone will not
 shed its petals
To cede to the wish of waters and of vegetal fates
With small steps the lonely one reaches then a refuge of high
 station
And says that it is a thousand regrets by the clock
No not in vain do these damp dresses tremble
Salt crystals of frost flowers form there
Emptied from lovers' bodies
And from the hands which held them
They flee tuberous abysses
Leaving in the awkward hands which used to lace them
Breastplates of steel and satin corsets
Did they not feel the bright comet hair
Which on a night of dew cascaded over your shoulders
I saw it fall
You were transfigured
Will you ever reappear from the shadows
Naked and more triumphant on returning from your travels
Than the envelope sealed with five wounds of bleeding wax
Oh a thousand regrets will never cease
Filling this clock in the nearby clearing

Your gulf-weed hair is lost
In the immense plain of meetings missed
. . .
Farewell so soon among the porcelain hours
Look the day is darkening by the fire beginning in the hearth
Look again at the living grasses departing
And the women plucking petals from the daisy of silence
Farewell in the black mud of stations
In the imprints of hands on the walls
Each time a stairstep collapses a timid child appears at a garret
 window
It is no longer he says the time of the leafy packs
Endlessly I crush larvae under my feet
Farewell in the flapping sails
Farewell in the motors' monotonous roar
Farewell oh butterflies crushed in the doors
Farewell garments soiled by scampering days

Lost forever in the shadows of corridors
We summon you from the depths of earthly echoes
Sinister benefactor anemone of light and gold
And which broken into a thousand twirls of mercury
Bursts forth in new embers forever incandescent
This love this mirror which for seven years flowered in its cracks
And waxes the staircase of the sinister descent
Abyss we summon you from the depths of earthly echoes
Generous mistress of light of gold and of falling
In the foam of death and rocky coast
Balancing the supple body of lovers
In the currents marked with illegible initials
Sinister and benevolent mistress of eternal loss
Angel of anthracite and coal
Clear depth of roadsteads mythology of tempests
Purulent water of rivers shining water of rains and dews
Bleeding and vegetal creature of swamps

From the hammer on the anvil to the assassin's knife
Everything you shatter is star and diamond
Angel of anthracite and coal
Gleam of the darkness osprey of display

Heavy smokes drape you when you place your feet
On the snow crystals covering the roofs

Gasping with a thousand papers flaming after a night of fresh
 ink
The tall mannequins flayed by the storm
Show us this path by which no one has come
. . .
I am marked by my loves and for life
Like a wild horse escaped from the gauchos
Who, finding once more the prairies' freedom
Shows the mares his hair burned by the branding iron

While on the deep sea with great virile gestures
The mermaid, singing toward a carbon sky
Amid reefs murderous to vessels,
In the heart of whirlwinds, makes the anemone flower.

From Siramour (Siren-love) 1930–31

*It is midnight at the foot of the castle which is neither Sleeping
Beauty's, nor the only one in Spain, nor is it the king of clouds but
rather the one whose walls rising on the mountaintop overlook the sea
and plain and other castles whose towers are white in the distance like
sails lost upon the deep. It is midnight in the plain and on the sea, it is
midnight in the constellations visible from here and now the star, partly
black and partly blue, rises beyond the foam burst like a low cloud in
the liquid shadows. In its light, the bottle abandoned in the grass and
jonquils is lit with the Milky Ways it seems to hold but does not, for
tightly corked, it conceals within its sides the masked mermaid, the
captive and awesome masked mermaid, called the Unheard in the sea
where she never deigns to sing and called Fantomas in dreams. And in
truth she should be imagined dressed in frock coat and top hat striding
through an ill-omened forest while the music from a far off celebration
vainly commands the echoes to bring back this charming transvestite. Or
again she can be imagined sidesaddle on a horse in this same forest in
autumn, clutching against her a bouquet of roses too full-blown, whose
petals fly off in the combined effort of the wind and the horses' trotting.*
 A prisoner for the moment she awaits deliverance in her prison

tightly corked by a loving hand while a letter, never delivered to its in-tended owner, lies molding on the ground. It is the hour where the dice and clocks make strange noises that surprise the watchmen. It is the hour when the lover undressing his mistress is astonished by the musical and unaccustomed rustling of the silk and undergarments. Pale and dreaming, all are listening to these signals of the invisible which is only their own thoughts and dreams and some, on the fateful numbers, and some on the hour which once marked the missed meeting and some, let their gaze linger some seconds on the gleam of handsome flesh suddenly seeing far, far off beyond the stakes and changes of cal-endar, beyond caresses and vows, beyond even the indecipherable songs of mermaids. It is midnight on the castle, on the plain, and on the sea.

It is midnight on the games and gambling.
It is midnight on the face of clocks.
It is midnight on love and lost letters and the mermaid sings, but her
 voice does not penetrate the glass walls, but the drinker comes and
 imbibes the song to free the mermaid, called the Unheard and called
 also Fantomas.
. . .
Let the drinker, drunk on the song, depart on an irregular path bor-
 dered with frightening trees with the sound of the sea howling and
 roaring and raising the greatest tide of all time, flowing not from
 its real bed, but flowing rapidly from the bottle overturned while
 the mermaid freed and stretched out on the ground not far from
 this waterfall, gazes at the star, black and blue in turn, thinks she
 recognizes her and does recognize her.

This takes place, let's not forget, in a real plain, on a real riverbank, under a real sky. And it's really a matter of a real bottle and a real mer-maid, while the flux of a real sea carries away the letter and rises in assault against the castle. . . .

Oh mermaid! I shall follow you everywhere. Despite your crimes (con-sidering the right of self-defense), you are seductive to my heart and by your look I enter a universe of feeling where the mediocre preoccupa-tions of life never reach.

I shall follow you everywhere. If I lose you, I shall find you again, rest assured of it, and even though it takes courage to approach you, I

shall do so, for I could wish neither for victory nor defeat, in view of the splendor of your weapons and of your eyes when you are in battle.

Walk along in this deserted castle. Your shadow is bound to surprise the staircases. Your forked tail stretches out lengthily from floor to floor. A short while ago you were in the deepest of underground passages. Now you are at the dungeon's summit. Suddenly you rise, climb, depart into the sky itself. Your shadow, immense at first, disappeared rapidly and your tiny silhouette stands out now on the moon's surface. Mermaid you become a flame burning the night so violently that no light subsists near you in the terraces of unknown flowers haunted by fireflies.

. . .

Here we are old already both of us.
We are thirty years older than today,
We can speak of former times without regret, if not without desire.
All the same we could have been happy,
If it was said that one could be so
and that things work themselves out in life.
But from unhappiness itself our insatiable, our fateful, our astonishing
 love was born.

And from this love the only happiness which two insatiable hearts like
 ours can know.
Listen, listen to the great vulgar images which we transfigure as they rise.
Here is the sea rumbling and singing over which the sky worries and
 settles down like your bed.
Here is the sea like our heart.
Here is the sky where the clouds are shipwrecked in the sad flashing of
 a lighthouse beam sent out by each star in its turn.
Here is the sky like our two hearts.
And now here are the fields, the flowers, the steppes, the deserts, the
 plains, the springs, the rivers, the abysses, the mountains
And that all can be compared to our two hearts.
But tonight I wish to say one thing only:
Two mountains were alike in form and dimension.
You are on one
And I on the other.
Do we recognize each other?
What signs do we make to each other?
Perhaps you love me?
I love you already.

But these distances between us, who will traverse them?
You say nothing but you look at me
And, for this look,
There is neither day nor distance
My only friend my love.

I have not finished telling you everything.
But what good is it . . .
Indifference in you rises like a voracious rosebush destroying the walls,
 twisting and growing,
Stifling the drunkard with its smell . . .
And then, does it die?
In the street washed by the morning, the night and springtime, there
 sounds a clear refrain.
The geranium at the closed window seems to guess the future.
It is then that the hero of the drama comes forth.
I am only telling you this story with no sense because I dare not con-
 tinue as I began.
For I believe in the power of words and formulated things.
. . .
The mermaid meets her double and smiles at her.
She goes to sleep then to the adorable sleep from which she will not
 waken.
Perhaps she dreams. She certainly dreams. We are in the morning of a
 day of luminous harvests and of earthquakes and of diamond tides,
 the first falling on your hair and spilling forth from your eyes, the
 second marking your going out and the third rising to assault
 your heart.
It is five in the morning in the pine forest where the mermaid's castle
 rises, but the mermaid will awake no more for she has seen her
 double, she has seen you. From now on your empire is immense.
From a path a woodchopper comes forth on whom the dew trembles
 and shines like a star.
At the first tree he chops down a horde of dragonflies comes forth!
They scatter in territories of twigs.
At the second tree the first waves break
At the third tree you said to me:
"Sleep in my arms."
. . .
But I know a far lovelier song

That of a dawn in the street or among the fields ready for harvest or on
 a deserted bed
At this start of spring they have burned the last logs of winter
Old griefs become sweet in the memory
Younger eyes are opened on a universe freshly washed
I have known this dawn thanks to you
But will it ever rise
On the griefs you cause?

You know of what apparition I speak
And of what reincarnation
Flow flow tears and rivers
And wings in glasses.

It is not as it used to be, when we laughed
Intoxicated.
. . .
Ferns, razors, lost embraces, all crumbles and is born once more on a
 lovely morning while, down a deserted path, leaving behind on the
 grass the cards of a certain success, the mermaid departs in the dis-
 tance toward the beach that she left at the outset of this disjointed
 story.
Goes back to the beach at the foot of the fortress
The sea has gone back to her bed
The star shines no longer but its place discolored like an old dress
 gleams with a sinister light.
Goes back to the beach.
Goes back to the bottle
Lies down in it.
The drunkard replaces the cork
The sky is calm.
All will fall asleep in the sound of the whitened rush of foam.

Oh nothing can separate the mermaid from the seahorse!
Nothing can undo this union
Nothing
It is night
Everything sleeps or seems to sleep
Let us sleep, let us sleep,

Or let us seem to sleep.
Do not handle this book lightly
Lightly lightly lightly lightly.
I know what it means better than anyone.
I know where I am going,
It will not always be agreeable.
But love and I
Will have wished it so.

From The Night of Loveless Nights 1930

I inhabit when I choose to a shadowy ravine above which the sky is cut out in a diamond shape nicked on the edges by the shadow of firs, larch trees and rocks covering the abrupt slopes.

In the grass of the ravine strange tuberoses grow, and ancoly, and poppies over which swoop dragonflies and praying mantises and so alike are the sky the flora and the fauna where morose crows and muskrats follow closely on the insects, that I do not know what immutable season has fallen on this always nocturnal ravine with its canopy of a constellated diamond traversed by no cloud.

On the tree trunks two initials, always the same, are inscribed. By what knife, by what hand, for what heart?

The valley was deserted when I came there for the first time. No one had come there before me. No one other than myself has traversed it.

In the swamp where the frogs swim about in the shadow with regular movements reflect immobile stars and the marsh peopled by the sad and sonorous cry of toads there is a firefly, always the same.

The season of sad and immobile love hangs over this solitude.

I shall always love her and shall probably never be able to cross the boundary of the larch trees and the firs, or climb the baroque rocks to reach the white road where at certain hours she passes. The road where the shadows lie not always in the same direction.

Sometimes it seems to me that night has just fallen. On the road pass hunters whom I do not see. The song of hunting horns resounds under the larch trees. The day has been long, among the lands of ploughing, in pursuit of the fox, of the badger or the roe. The nostrils of the horses smoke white in the night air.

The hunting songs die out. And I decipher with difficulty the identical initials on the larch trees' trunks on bordering the ravine.

. . .
Sweetbriars withered among the lofts
O yellow leaves
Everything creaks in this room
As in the nocturnal alley grasses crunch under the foot.
Invisible great wings pin down my arms and the pounding of a distant
 sea reaches my ears.
The bed rolls to the dawn its edge of foam and the dawn does not
 appear.
Will never appear.
Shattered glass, rotted woodwork, interminable dreams, withered
 flowers,
A hand completely white touches my forehead through the darkness
And I shall listen until the improbable day
To the bird of paradise as it bumps against the walls and the furniture
 the bird I carelessly shut in
By merely closing my eyes.

From Bagatelles (Trivialities) in section marked
1930–39 in *Destinée arbitraire* (Arbitrary Fate), 1975

The Airtight Room

The room is closed and empty, quite empty
The sun alone, at certain hours, shifts its line over the bedclothes in
 disorder and the wrinkled pillow;
A dress on a chair shudders at moments in the breath of a mysterious
 draft
One hair trembles also on the sheet folded back,
And the clock still ticking will stop soon, sounding in the desert.
Hummingbird of evening, hummingbird of morn,
My lovely hummingbird comes in the room,
Beating its wings,
Bursting in lively colors on the pillow.
The rainbow pales in the sky around the flowerbeds of stars.
My lovely hummingbird, hummingbird of evening and of morn,
Fly.
Dash your delicate head against the images of your double in the mirror
 whose silvering flakes off.
Bleed.

Die
So that in the empty room the sun may shift its line about your corpse
Where the window is reflected in the blood spotting your down,
For an identical song, for an equal flight,
Bedecked with the same colors,
Hummingbird of evening, hummingbird of morn,
You will be reborn.
And in the empty room, the clock will sound once more
Hummingbird, hummingbird,
Hummingbird of evening, hummingbird of morn,

The bird flying toward the coast
Is not near the edge where, stretching out its lips,
The sky of earth offers to the sky of sea
a kiss of foam.

The bird lost at sea is not wrong to fly,
he is not wrong, the sailor affixing to the aft of his ship,
a figurehead, figure of dream,
the very image of the one he loves.

This happens far from all continents,
Far from the grassy continents where wild bulls run,
Far from the humid continents where the manatees and the hippo-
 potamus
Splatter lazily in the mud shimmering, drying and cracking,

Far from the continents of town and love,
Far from the continents of eternal jealousy,
Far from the continents of steppe and snow and sand,
Far from the continents of sun

This happens where I want it to,
In the country of mermaids and typhoons,
In the country of thunderclaps
Near the continent of the arid sky,
In the eternal archipelago of clouds.

Roll, roll, clouds, while the bird flies.
Not far off,

A fiancée receives for her birthday
The postcard of eternal promise.

The dove holds the sealed letter in his beak;
"I swear to you an eternal love."
Roll, roll, clouds, archipelago of clouds,
Sea, arid sea.

The fountains are lamenting far away from the birds
Far from the wind's murmur in the plane-trees.
His mouth wide open, the fish held by the mermaid
Spits water in the gleam of the gas lamps and the reflections of asphalt

And this whole story ends,
Far from the eyes, far from the heart,
Near the eternal oath.
In Paris, Place de la Concorde
A most beautiful and touching woman passes by
Alone, sad, on foot.

And, far from her, above the sea a bird flies
And never will the woman see the flight of this bird, never with his
 shadow will this bird's flight mark
The path the woman follows.
Never? Is that certain?
oh, meetings—
oh, fountains sighing in the heart of towns,
oh, hearts sighing throughout the world.

Long live life!

The terrible, menacing bird
Perches on the branch of a frightening tree
And death is hidden in a knife.
The laughter of the furies
Opens your mouth in vain.
I know you to be condemned,
I refuse to save you.

The tree is aflame
And death is inscribed in capital letters,

Hanging from your hair,
Linked to your nape by subterranean flowers,
Mingled with your glances.

Your forehead is an insult,
A stone in an abyss,
My tongue in my mouth.

I know there is no longer time.

Tour of the Tomb

From loving, I have gotten lost in the ocean. And what an ocean!
A tempest of laughter and tears.
If you climb aboard a ship take care to look at the figurehead who
will stare at you with her eyes eroded by the wave and the salt water.
But what am I saying? The spectacles of love scarcely interest me.
I no longer want to be other than a sail carried along at the pleasure
of monsoons towards unknown continents where I shall find only one
person. The one for whom you have a name already.
I undress, as an explorer lost on an island should, and I remain unmov-
ing like a figurehead.
Hail to you, wind of the open sea and to you, desert, and to you, for-
getfulness.
I will be forgotten. Some day, my name will no longer be known, but I
shall know her name. One evening, covered with wealth and glory,
I shall return to knock at her door, naked, but no one will answer me,
even when, having opened the door, I appear before her eyes.
I have earned, at least, the sense of perpetuity. Not the ridiculous sense
of cemetery concessions.
I wish in vain for the apparition of guillotines, but I can only offer to the
sanguinary crowds my suicide wish.
Revolution! You will only shine after my death, on the immense square
of white marble covering my immense corpse.
France is a wasps' nest, Europe a rotted field, and the world a peninsula
of my consciousness.
But luckily I still have the stars, and the consciousness of my moral great-
ness opposed to the thousand obstacles the world sets up against
my love.

From Les Sans cou (The Neckless) 1934

Devils' Feast

The last drop of wine is lit in the depth of the glass where a castle just
 appeared.
The knotty trees bordering the road bend toward the traveler.
He comes from a nearby village,
He comes from the distant town,
He is only passing at the foot of the bell-towers.
He sees at the window a red star moving,
Descending, walking unsteadily
On the white road, in the black countryside.
It comes toward the traveler who watches it approach.
For an instant it shines in each of his eyes,
It sticks to his forehead.
Astonished by this glacial gleam lighting him,
He wipes his forehead.
A drop of wine pearls on his finger.
Now the man goes off and his silhouette shrinks in the night.
He has passed by that spring where you come in the morning to pick
 fresh watercress,
He has come by the deserted house.
The man with the drop of wine on his forehead.
Now he is dancing in an immense room.
A brilliantly lit room
Resplendent with its polished floor
Deep as a mirror.
He is alone with his partner
In this immense room, and he dances
To the sound of a ground glass orchestra.
And the creatures of the night
Gaze at this lone couple dancing
And the most beautiful of the creatures of the night
Mechanically wipes away a drop of wine from her forehead,
Returns it to a glass,
And the sleeper awakes,
Sees the drop shining with a hundred thousand rubies in the glass
Which was emptied when he fell asleep.
Gazes at it.

The universe oscillates during a second of silence
And sleep takes its rightful place again,
And the universe takes up its movement again
Across the thousands of white roads traced by the world
Across the shadowy countryside.

The Ox and the Rose

In agreement with the saltpeter and the mountains, the black ox with
 his eye closed tight by a rose undertakes the conquest of the valley,
 the forest, and the moor.
Where the dandelions light up awkwardly in the green firmament of a
 sparse grass,
What fat dungs shine splendidly, with the bad-tempered suns and the
 precious brush.
Where the wheat is ripe, where the clay cut and cloven in gulleys offers
 ravines for the scarabs joisting,
Where the yellow scorpion loves and dies of his love and stretches out
 stiffly,
Where the sand in a golden powder blinds the tramp.
With massive step, his giant head swaying on his furry neck, his tail
 swishing in regular rhythm against his fleshy rump,
The ink-black ox comes forth, passes and disappears.
He dominates and ornaments the gleaming landscape by his blackness
And his horns wait for him to choose the right direction
To carry a sun to its death in their orbit opened on emptiness,
Casting multiple reflections on his brillant hide and projected, black-
 ness issued from blackness,
His fabled shadow over the earth avid for an imminent rain
And for the uncertain flight of butterflies.
Or perhaps a brilliant rose born just from the atmosphere and growing
 between the branches of their crescent like a phantom of a flower.

From C'est les bottes de sept lieues, cette phrase "Je me vois"
(It's the Seven League Boots, This Sentence "I See Myself")

Arbitrary Fate

Here comes the time of the crusades.
Through the closed window the birds insist on speaking
like fish in an aquarium.
At the shop window
a pretty woman smiles.
Happiness you are only sealing wax
and I go by like a firefly.
A number of guardians pursue
an inoffensive butterfly escaped from the asylum.
Under my hands he becomes lace pants
and your eagle flesh
oh my dream when I caress you!
Tomorrow burials will be free
there will be no more catching colds
the language of flowers will be spoken
light will be cast by lamps unknown to this day.
But today is today.
I feel that my beginning is close
like June wheat
Policemen hand me the handcuffs.
The statues turn away without obeying.
On their base I shall write insults and the name of my worst enemy.
There in the distant ocean between tides
a lovely woman's body causes the sharks to draw back.
They rise to the surface to look at themselves in the air
and dare not bite the breasts
the delicious breasts.

From Domaine public (Public Domain) 1953

While I Remain

While I remain, those whom her love favors illegitimately, if I consent to call by that name the miserable chance which brings them together, succeed each other like phantoms. I await their fugitive apparition. How should I be jealous of them, unconscious instruments of a poetic and pathetic fate, pawns of a fatality higher than theirs which only moves them forward so as to test the invincible patience with which I face events and tribulations. Patience, but not resignation. I keep the secret of my tempests and my despair. The reef in the middle of a cyclone does not suffer the reach of the foam. The foam slides over its smooth ridges and if the water streaming over it leaves a little salt in the fissures, it is then transformed into fairy-like crystals (I love the gleam left by inner tears on deep eyes).

For years I have awaited the wreck of the lovely ship which I adore. I see the cyclones piling up in the sky in such quantity that long ago the catastrophe should have fallen on the becalmed sea, and since it has not yet fallen, there is no doubt it will be terrible and fabulous.

I aspire to this shipwreck, I aspire to the tragic conclusion of my patience. The lovely impassive vessel which appears sometimes to me under the aspect of a ghost ship will not claim the loss of body and chattels without engulfing too the reef which is the cause.

While I remain, her illegitimate loves succeed each other. There are some days when I think she knows, days when I fear I am duped. But I remain and they pass. She accepts in her life the presence of my open thoughts, she will accept someday the tragic and crushing witness that I shall bear to my love and to hers.

And to hers. For doubtless she loves or will love me. I could not condescend to submit this question to the illusory condition of time.

But nonetheless I am not among those who humiliate and who accept. I shall be the author of the tempest and one of its victims. Loving thoughts become more awful and more serene. Imminent day of the settling of accounts, arise.

I remain, they pass.

And let them pass thus, vague phantoms prisoners of sexual rites, having forgotten the spiritual laws of love which they claim to feel. Living through soul and matter I shall, on the desired day, need only to lift my finger for these derisory mirages to be swept away with the first castoffs, in the breath of reciprocal love.

Lautréamont (translated from Alejo Carpentier,
Tientos y diferéncias) 1967

How many centuries will it take, according to the allegorical hourglass of time, for the colossi of Memnon to be buried forever in the desert!
Thus do idols die.

In order for them to disappear, some need hurricanes and tempests of the ocean, and the spatterings of the dejected Atlantic.

Others need the vines of the virgin forest; others the torch of the iconoclast; others, the shifting sands of generations of human's prayers to disappear within themselves.

Had they had just one adorer, the simple second of power that they extract from mythologies, from cemeteries, from ethnological museums, or from literary histories, they would still be authentic idols, putrid in the certain and derisive prerogatives of divinity.

I have today the honor of saluting the cadaver of the last idol who, favored by the most beautiful legend of the world, was born on the day of his death and died assassinated by his adorers. Long ago, in the mysterious paths of certain regions, on the pediment of the temples a lugubrious law used to be inscribed: "the initiated will kill the initiator."

Isidore Ducasse, who called himself the Count of Lautréamont, has so far given birth only to those we might call initiates. And behind the baroque vehicle which carries the small coffin where his immense body was buried, there walk finally only sad employees of funeral establishments, unkempt men of letters, and hypocritical professional mourners.

Cast astray for some time among the members of his family, the author of these lines has now taken refuge in the life of the sidewalk. Now he contemplates the passing of the funeral procession. Now it is going by. Now it is disappearing with its wreaths of artificial flowers, with its porcelain flowers, with its poor branches of evergreen and of depetaled roses.

Farewell. Rest in peace. In a moment, on the marble of your tomb and the emptiness of the sepulchre, the writer with a trumpet's tongue will become enraptured with the mere pronouncing of your name; it will be a worthy task for the astute orator who can mix philosophical considerations about your work with a melancholy dissertation on the destiny of clouds made just as they are to disintegrate in rain, and thus he will fill the tempting vessel of the tomb. To the slippery curlicues of pretended grief, he will add the pigment of what has never been said and what has never been heard—which is not always the same thing. . . .

Absolutely nothing is known of the man who was Isidore Ducasse, Count of Lautréamont.

Perhaps he was an ignoble individual, a truant of the worst kind, a despicable being. Nothing authorizes us to negate this since we know that talent and moral virtue are unfortunately two different things.

About Isidore Ducasse, all that is known is:

1. the date of his birth,
2. the date of his death,
3. some facts about his family and his years of schooling,
4. the *Chants de Maldoror,*
5. *Poésies,*
6. some letters which reveal preoccupations with money and literary preoccupations.

Nothing more.

Nevertheless, with these facts, and in complicity with literature, the cards of this game of chance were disarranged to such a point that today one could almost write a "novelistic life of Isidore Ducasse."

Have no fear. People have tried to see in this personage of whom I shall say neither good nor evil, a sort of Don Quixote of anti-literature, without thinking that his work is presented as a work of art only by itself since we only know it and scarcely know anything of its author—as we know the *Iliad* and the *Odyssey* without knowing anything about Homer.

Nothing seems to show that Lautréamont wanted to leave an enigma for posterity. Besides, such a wish would do him little good and it would corroborate the idea that he was only a man of letters.

At least we know that he wrote and that he was preoccupied with being published.

And his work constitutes the only conjunction of authentic proofs that we have about him. We don't have to prove that this work is genial.

But it is equally certain in 1931 that under the weight of certain persons' admiration, this work has lost all power of influence, or virtue of germination, and that it represents a past and not a future.

Besides being a sort of preface to surrealism, the *Chants de Maldoror* are the consequence of all romantic literature from Sade to Eugène Sue, from Byron to Hugo. The romantic culture of Ducasse was enormous. To realize this, one has only to read *Poésies*, a work with which he burns all that he has adored, familiarly citing the names of the heroes of philosophic novels and of the black heroes the shadowy personages who live between *Justine* and the books of Sue, books among which is found his pseudonym (Lautréamont [*sic*], novel by Eugène Sue).

It is an undeniable fact that he practiced automatic writing before the surrealists. That the term of "automatic writing" is still an expression of charlatans used to designate the inspiration of the poet and, finally, the delirium of the pytoness, of the sybll, and of the prophetess, and the triumph of the senses over reason.

Now we know that the importance of Lautréamont in this realm was immense. But in any case it does not surpass that of the admirable and surprising Gérard de Nerval, his predecessor by a number of years—or that of Hugo or Poe (in spite of the genesis of the *poem*), or that of Byron . . . of many others.

If Lautréamont had not existed, surrealism would have been born without him, and it would have lacked none of its elements. That he should have served as a standard, fine! He was and he still is a fine standard.

Still we have to deal with the question of his work. We have from him the following:

1. the *Chants de Maldoror*. Black poem.
2. *Poésies*. A conformist article, written in an admirable and romantic style.
3. the letters we have already mentioned.

It remains for us to know:

1. if Lautréamont was writing a humorous work when he wrote *Les Chants* and when he wrote *Poésies*.
2. only in *Les Chants*.
3. only in *Poésies*.
4. or if he was humorous neither in the *Chants* or in *Poésies*.

Nothing permits us to affirm one or the other of these suppositions.

Nevertheless, the tone of the letters inclines towards the hypothesis of a young Lautréamont, permitting himself liberties and then finally "settling down." We are not quite convinced when he says—or almost says—that youth must pass quickly, that he is not taken in by what he writes, that he is not sincere.

But this hypothesis of a Lautréamont evolving in agreement with bourgeois customs, from anarchy to reaction, is not the one that I accept the most easily, neither do I believe in a Lautréamont full of humor, writing *Poésies* with a smile in his eyes each time that he dips, just as he did before, in the fluid ink of an imperceptible mockery, the pen of a Kingfisher of logic. No; humor has no flavor when it is enjoyed in company. It is a solitary vice. I cannot imagine a meeting of humorists. The humorist listens imperturbably, and he does try to have his neighbor

laugh with him. If he speaks, he does it gravely and does not indulge in brilliant sallies.

But there occurs to us the possibility of another hypothesis (at least a hundred more could be expounded).

Lautréamont, at twenty, writes the *Chants de Maldoror* which are the consequence and the balance of the whole century past, that rose up upon the ruins of the castle of Otranto, that revisited the gigantic armory and, still older than Melmoth, wrote *Don Juan* from the bloody scenes of Sade's boudoir to the llamas of Missolonghi and of the cloister of St. Meri, passing by Bicêtre and the square of the Revolution.

A man of that incredible century, which saw Napoleon born from Juan Jocobus, and San Martin from Napoleon, a century in which freedom and tyranny engendered each other, Ducasse was born in Montevideo, in a young republic, drunk with great symbols and with beautiful sentences. His childhood was probably lulled by the sonorous songs in which the word *freedom* came back again and again with the insistence of a refrain. Moreover, his father is a businessman in Montevideo in the legation of France, of a France anointed by the prestige of three revolutions, of a hundred riots and of fifteen years of repression; of a France which in spite of Austerlitz, of the Spanish war, and of the conquest of Argel, had the reputation of being champion of a freedom which some countries of South America had obtained at the cost of enormous efforts. The Ducasse family is originally from Toulouse. The accent of the native country is not so different from the accent resounding along the luminous coast which separates a Buenos Aires from a Montevideo.

The child whom the Ducasse family sent to France to study took with him not only the vision of astral constellations, of skies covered with the eves of great torments, of plains, of the blue sea and the blue sky. He took with him also the ideal of '93 and of '48, revised and exaggerated in the lyric domain by those serious men, at once talkative and heroic, who under a lead sky upset the whole continent from the Mexican to the Argentian pampas.

And perhaps, in the greatness of Lautréamont's images, in the absolute quality of his lyricism, we can look for a trace of racial influence, and a memory of his earliest childhood impressions.

Lautréamont is twenty. He arrives in France filled with admiration and veneration for the writers of his century. He thinks he is imitating them and in the loneliness of his room on the rue Vivienne he writes the *Chants* (perhaps they were begun in the college of Toulouse since there is, it seems to me, a surprising resemblance between the first ver-

sion of the first song and the first version of *Ubu-Roi*), the *Chants* which are a summary of all the poetry of the nineteenth century and the preparation for the following century.

Once the book had been published and transformed by printing, it seems that Ducasse wanted to undertake a complete revision of his own values and his own moral beliefs.

He must then have found himself in the situation in which the men of my age have found themselves in the years 1918–1920. He realizes that he lives in a world which is finishing, on the edge of an abyss . . . and he chooses the ultimate solution, the only solution. He makes the leap. He denies his own image. He offers us then the spectacle of a crisis similar to that which Dada provoked.

Where he had defended the bad, where he had defended evil, he will defend the good. Where he once wrote "black," he will write "white."

Such an enterprise should not be described as futile. It is the only possible one.

If a man changes his attitude in life to such a degree that his second attitude is the contrary of the first, then the contrary of the second cannot be once again the first attitude. A third attitude appears in the distance.

Morals and life are not Euclidean. Lautréamont died young. So far, no one has tried to show us that he died a Catholic. But judging from the posthumous destiny of Rimbaud and the religious ending of all those great cadavers, it seems to us urgent to proceed to Lautréamont's incineration, before the worms of divinity take up their lodging in his brain and in his heart. And perhaps it is already too late.

Unfortunately, a fatal law demands that everything that was great must be, after death, a prey to this peculiar sort of putrification.

Lautréamont is dead, damned be his body! And now that his work is about to found new academies, let us throw it in the flames.

And let us be watchful, so that we can tear down any new idol.

From La Papesse du diable (The Devil's Popess) 1966

Nadia placed the book on a low lectern, opened it at random, and seated on the floor by the sofa where the Beloved lay, she began quietly, as if chanting:

"That evening, the signal lights grew ever larger like the enamel

waves at twilight in distant isles; through the window opened on the soul of plantain trees a breeze entered as gentle as the sound of flutes made from nymphs' bones and the cadenced walking of the dancers revealed the nakedness of three bodies on the violet path.

"Thoughts following the interior stream, the steps of the Chinese mandarin lead the fate of the three dancers toward the lost palace; but the jade bracelets too heavy for these thinnest arms give a sad tinkle like the death bell at home on November evenings. Perhaps, after all, a thousand years ago, the knight with snowy beard had trod this same riverbank and the few steps of his horse whose color no one could remember any longer, awoke in their marble tombs the emperors perished from love between the thighs of courtisans.

"The pipe, its rose-colored smoke, and the aroma of green tea will soon lull the yellow princesses to sleep, and the cheerful aspect of the imperial palace will once more become grave and noble as in the times of the bearded knight. Oh silences, if the liquid gestures of the moon's guardians hung the falling stars on the horizon, we should be greater and stronger; but our open hands let the heavy azure slip through them and then, unable to close once more, they rise near enough our faces to wipe away the eternal tear forming on our fatigued eyelids.

"Behold in the distance how the shadows pass; I know you must have seen, pointing toward the grey earth the peak of the phantom knight's snowy beard; otherwise, your eyes as blind as ours shall never glimpse again the soul of things, and the prophet imprisoned in the tower of dreams will announce the fall of this people mad enough to still believe in the omnipotence of three poor virgins who blossomed forth one day on the banks of a river whence sprang the terrible fabled and fabulous lotus . . ."

Calixto, suivi de Contrée
(*Calixto,* followed by *Contrée*) 1962

The Landscape (from *Calixto*)

I had dreamed of loving. I love still but love
Is no longer that bouquet of lilacs and roses
Drenching with perfume the forest holding
A flame at the end of unswerving paths.

I had dreamed of loving. I love still but love
Is no longer that storm where the lightning
Builds bonfires on castles, confuses, unsettles,
Illuminates fleeing the crossroad farewell.

It's the flint afire under my step in the night,
The word that no lexicon contained,
The foam on the sea, in the sky this cloud.

As one ages all becomes bright and hard,
Nameless boulevards and knotless cords.
I feel myself growing rigid with the landscape.

Epitaph (from *Contrée*)

I lived in those times and for a thousand years
I have been dead. I lived, not fallen but haunted.
All human nobility being imprisoned
I was free among masked slaves.

I lived in those times and still I was free.
I watched the river and the earth and the sky
Turn about me, keeping their balance
And the seasons bearing their birds and their honey.

You who are living what have you made of these fortunes?
Do you regret the times when I struggled?
Have you farmed the land for common harvests?
Have you enriched the town where I lived?

O living men, fear nothing from me, for I am dead.
Nothing survives of my mind or my body.

Notes

Unless otherwise stated, the place of publication for books in French is Paris, in English, New York.

Introduction: The Poet-Adventurer

1. The colorful side of Desnos' personality is abundantly illustrated in the tales of the dinners, for twenty or more, in his apartment in the rue Blomet, when the mood was either joyful or fierce: Desnos had from time to time, it seems, to be forcibly prevented from attacking certain of his friends with a knife.

Situation

1. The information for the biographical résumé comes from Marie-Claire Dumas' preface to the number of *Europe* devoted to Desnos (May-June 1972), from Theodore Fraenkel and Samy Simon, "Biographie de Robert Desnos," *Litterair Paspoort*, Tweede Jaarg, no. 7 (January 1947) and Rosa Buchole, *L'Evolution poétique de Robert Desnos* (Brussels: Palais des Académies, 1956).
2. But he professed not to share the other surrealists' untempered veneration for Lautréamont. Always suspicious of cults and idols, as is plain from

his *Troisième manifeste,* he warned against the erecting of a new religion about the violent ambiguities of that haunting writer, whose cadaver he damns and whose work he recommends to the flames (in the text referred to in note 4). Nevertheless, he uses many of Lautréamont's techniques to brilliant advantage, both in his lyric intensifications and in his ironic destructions of the momentum accumulated and the alienating deflections of the reader's attention.

3. Who, going out one day to buy cigarettes, simply departed for Japan.

4. His essay on "The Future of Latin America" shows much the same spirit. It was published with the text on Lautréamont (simply entitled "Lautréamont") as "ineditos" in Alejo Carpentier's *Tientos y diferéncias* (Montevideo, 1967), pp. 107–10, although both had been published before in France, in the unique number of *Iman,* 1931, where they were printed in Carpentier's Spanish translation. Desnos says here that it is "the destiny of the proletariat" which interests him above all.

> Finally, at the present moment, in this time when all the powers of capitalism come from its long experience with society, from the relevance of its technology, from its projects brought to realization exactly according to plans, it is essential that the proletariat of Latin America not let themselves be vanquished by this science, by the capitalism in the service of which they work, whether they want to or not. . . . Future movements must be class movements and not minority movements, animated by the best intentions but exempt of all the suffering caused by the shock of individual relationships one against the other. The state of the working classes of Latin America is of greater interest to us than the burning of such and such a palace, the name of such and such a revolutionary leader, the great deeds of such and such a hero. . . .

5. See the following section, "The Landscape of Surrealism."

6. As a further indication of Desnos' continuing interest in language itself, the titles of his works are often recognizable word plays: *Deuil pour deuil* is "sorrow for sorrow," just as we say "an eye for an eye and a tooth for a tooth," but it is also "sorrow for sorrow's sake." *La Liberté ou l'amour!* is, according to Marie-Claire Dumas, of the same order as "your money or your life" whereas we read it here also as "the Freedom which is also Love." *Corps et biens* is a play on "corps et âme," "body and soul," but here the possessions have replaced the soul, whereas *P'oasis* is perfectly clear in its two senses of poetry/oasis telescoped ("poésie/oasis") and of the plural of "poésies."

7. In Georges Neveux, "Robert Desnos," *Confluences 5,* no. 7 (September, 1945), p. 679.

8. *Une Vague de rêves,* privately printed, 1924. English translations from

Maurice Nadeau, *The History of Surrealism* (Macmillan Co., 1967), pp. 82–83.

9. Ibid.

10. "Le Surréalisme en 1929," *Variété,* June, 1929.

11. *Le Vin est tiré* (Gallimard, 1943).

12. *Calixto, suivi de Contrée* (Gallimard, 1962).

13. For a discussion of the "cygne-signe" play in Mallarmé, see Robert Champigny, *Essai sur le genre poétique* (Monte-Carlo: Ed. Regain, 1963), p. 170.

14. The drawings, in the Camille Dausse collection of the Museum of Modern Art of New York, are reproduced in the unpublished documents which accompany this essay.

15. These "explorateurs" are reminiscent of the "explorateur casqué de blanc" in *La Liberté ou l'amour!,* but the beast looks strikingly like a swan.

16. See also Michèle Elsass, "L'Etoile et la sirène," *Europe,* May–June, 1972.

17. Et voici l'amour semblable aux mers et aux fleuves
Et voici l'amour semblable aux flammes.
L'amour avec ses courants, ses marées,
Ses ténèbres.

Et voici l'amour avec ses fers et ses chaînes
Et voici l'amour tapis magique
L'amour qui tue le désir, voici l'ombre,
Les ténèbres.

(And here is love like seas and rivers
And here is love like flames.
Love with its currents, its tides,
Its shadows.

And here is love with its irons and chains
And here is love the magic carpet
Love killing desire, here is the darkness,
The shadows.)

("Les Quatre Eléments," quoted in article of Smoular in *Signes du temps,* no. 5, 1951.) "Et l'ombre contient une critique de la présence et du 'non' dans la présence (Pierre-Jean Jouve) de la même façon que les histoires mythiques comprennent, reprises ici, leur propre démythification sans pour cela se perdre." (Michel Bouvier, "Les Ombres sur la place vide," *Europe,* May–June, 1972.)

18. In his comprehensive and challenging judgment of Desnos ("Robert Desnos aujourd'hui," *Critique* 31, nos. 219–20 [August–September 1965]) Jean Tortel maintains that the obvious "moral evolution" Desnos undergoes—demonstrated in the late and sermonizing *Le Vin est tiré* and the sad poem "J'avais rêvé d'aimer"—is in reality not the cause but the con-

sequence of his poetic evolution. He sees in the earlier Desnos a certain sincere but stumbling nature, akin to that of the poet Musset. The specific preoccupation with the desert as it swallows up the steps of lover and poet leads him to repetition and prolixity, Tortel believes. But the source of his greatness is his unending "passion for passion" and his refusal to permit us to assume anything whatsoever about him. This judgment seems as apt as any that has been passed on the poet.

19. "La Moisson," in Contrée. From Calixto, suivi de Contrée (Gallimard, 1962).
20. "Le Paysage" is complemented also by another poem of utopia, "L'Asile," (The Resting Place), where wisdom and action, adventure in the waking and sleeping worlds mingle in the community of men and poets:

Où le sage s'éveille, où le héros s'endort.
Que le rêve de l'un et la réalité
De l'autre soient présents bientôt dans la cité.
(C, p. 57)

(Where the wise man wakes, where the hero sleeps,
Let the dream of one and the other's
Reality be present soon within the city.)

It is in this combination that Desnos finally puts his hope.

21. Compare the concluding line of "La Chambre close" of Peine perdue (Destinée arbitraire, Gallimard, 1975, p. 129) applying also to the passing of love and of poetry: "Il n'est jamais plus temps."

Film and Possibility

1. See the passages on ennui in La Liberté ou l'amour! (Gallimard, 1962), analysed in Reinhard Kuhn's The Demon of Noontide (Princeton, 1976).
2. André Tchernia, who in editing Cinéma (Gallimard, 1966) put all of these with the critical writings of 1925–30 on the cinema just discussed, surmises that most of the scenarios are posterior in date to the essays, and that Desnos attached a certain importance to the latter, having decided to publish them together.
3. But Michel Bouvier, "Les Ombres sur la place vide," includes this inscription on the tree trunk as part of the bunch of useless keys—with the other images of the wound, the tattoos, the writing on walls, the various traces, steps, paths cleared in the forest, waves furrowed by the bow of a ship—which seem to unlock the meaning of works and, in fact, do not. In another light, these traces signal only the transgressive nature of writing itself, and lead nowhere beyond that. The graphic variations lead only to emptiness, "un vide immédiat," so that, as Bouvier says, "Les mots tendent

à une mise en scène productrice, comme l'ennui, de son propre espace" (*Cinéma*, p. 88).

4. The other two scenarios published in the poet's lifetime ("Les Mystères du Metropolitain," published in 1930, and "Y a des punaises dans le rôti de porc," published in 1933) are of another sort altogether, being the kind of "surrealist creations" which partially inspire the theatre of Arrabal, Ionesco, and the like. The self-consciousness which marks much of Desnos' work is apparent, here, but with precious overtones, which the early, often tragic references to the poet's own writing never had. ("On this screen with no sets appear a metteur-en-scène and a spectator. The Spectator: What is the point of all this? The Metteur-en-scène: That I just don't know. The Spectator: This is a swindle!")

5. "La Rédaction publicitaire radiophonique," *Arts et métiers graphiques, Publicité,* 1939, pp. 43–44.

Direction, Distance, and Myth in the Early Novels

1. On the duality of the name, see Tatiana Greene, "Le Merveilleux sur-réaliste de Robert Desnos," *French Review* (November 1966) and Iris Acacia Ibañez: *Apuntaciones estilísticas sobre "chantefables et chantefleurs"* (La Plata: Centro de Estúdios de Estilística Literária, 1964), where a line of parallel contrast is quoted: "votre sang charrie des grelots au gré de vos sanglots?" In this context, Miss Ibañez reminds us of Jacques Prévert's comment on Desnos, as perceptive as it is self-contained: "C'était un homme de gai malheur" (p. 17).

2. The oracle of the "Dive bouteille," the holy bottle in the Fifth Book of Rabelais' *Pantagruel,* from which issues a sort of self-contained prophecy, simply *Trinc!* Desnos' own humour comes very often close to that of Rabelais, whom he much admired. The episode of the famous Club of the Sperm-Drinkers in *La Liberté ou l'amour!* is, in its humorous eroticism and its serious lyricism, a good example of ingenious elaboration from the quite ordinary starting point of bottle or flask.

3. As a certain ordering is essential even to the seemingly haphazard illumination of Dada: see, for instance, the chapter on Tzara in my *Inner Theatre of Recent French Poetry: Cendrars, Tzara, Péret, Artaud, Bonnefoy* (Princeton: Princeton University Press, 1972).

4. See, as an example, the celebrated poem beginning "Loin de moi et cependant présente à ton insu" in *A la mystérieuse*. Rosa Buchole (*L'Evolution poétique de Robert Desnos* [Brussels: Palais des Académies, 1956]) points out the link between this poetry and the medieval poetry of distant love sung by the provençal poets like Jaufré Rudel.

5. The following passage (again from *La Liberté ou l'amour!*) also exemplifies this form:

Rien ne pourra désormais consoler ces âmes en peine. En dépit des années passant sur la pelouse unie et les allées et les arbres de la forêt proche. En dépit des années passant sur ces fronts soucieux, sur ces yeux amoureux des ténèbres, sur ces corps énervés. Et, quelque nuit, l'orage roulant sur la plaine et le marécage éclairera de nouveau la façade sévère et le marais aux feux follets. Mais plus jamais le Corsaire Sanglot ne reparaîtra.... (P. 109)

6. Compare, in *Les Nouvelles Hébrides* (*Europe*, May–June, 1972, p. 173):

— Robert Desnos, vous aimez cette femme. Pourquoi ne le lui dites-vous pas?
— J'ai honte.
— Robert Desnos ce n'est pas la honte qui vous fait taire et pourtant vous n'êtes pas sentimental.
— Je ne suis pas sentimental mais je suis un être capable d'affection....
— Robert Desnos vous aimez vos amis.

7. For the theoretical basis of such techniques, see especially Michel Butor's "Le Livre comme objet," *Répertoire*, reprinted in *Essais sur le roman* (Gallimard, 1969). For the self-controverting discourse, see Monroe Beardsley, *Aesthetics: Problems in the Philosophy of Criticism* (Harcourt, Brace, 1958), p. 138.

Lautréamont (the subject of a long essay found among the texts translated here) was in all probability Desnos' master in this form. See, for instance, from the Sixth Canto of the *Chants de Maldoror* (éd. Livre de Poche, 1963), these passages, each calling attention to the props and the situation of the writer or forcing the reader into complicity with the artificial scene.

"Avant d'entrer en matière, je trouve stupide qu'il soit nécessaire (je pense que chacun ne sera pas de mon avis, si je me trompe) que je place à côté de moi un encrier ouvert, et quelques feuillets de papier non mâché." (P. 317)

"Pour le ratissage de mes phrases, j'emploierai forcément la méthode naturelle...." (P. 319)

"... m'emparant d'un style que quelques-uns trouveront naïf (quand il est si profond) ... Par cela même, me dépouillant des allures légères et sceptiques de l'ordinaire conversation, et, assez prudent pour ne pas poser ... je ne sais plus ce que j'avais l'intention de dire, car, (sic) je ne me rappelle pas le commencement de la phrase." (P. 319)

("Ce serait bien peu connaître sa profession d'écrivain à sensation, que de ne pas, au moins, mettre en avant les restrictives interrogations

après lesquelles arrive immédiatement la phrase que je suis sur le point de terminer.") (P. 323)

Compare also Raymond Roussel's "La Vue" quoted by Jean Ricardou in *Pour une théorie du nouveau roman* (Seuil, 1971), p. 110:

> Le vue est mise dans une boule de verre
> Petite et cependant visible qui s'enserre
> Dans le haut, presque au bout du porte-plume blanc
> Où l'encre rouge a fait des taches, comme en sang.
>
> . . .
>
> Je tiens le porte-plume assez horizontal
> Avec trois doigts par son armature en métal
> Qui me donne au contact une impression fraîche.

Given Roussel's predilection for the poetry of ships, yachts, boats, the comparison could easily continue.

And finally compare J. M. G. Le Clézio, in an "Autocritique" from *Le Livre des fuites* (Gallimard, 1969), p. 41:

> Pourquoi continuerai-je ainsi? N'est ce pas un peu ridicule, tout cela? . . . J'ai déjà écrit des milliers de mots sur les grandes feuilles de papier blanc 21 x 27. J'écris serré, en appuyant très fort le crayon à bille, et en tenant les feuilles un peu de travers. Sur chaque feuille, j'écris en moyenne 76 ou 77 lignes. A raison de 16 mots par ligne environ, j'écris donc 1,216 mots par page. Pourquoi continuerai-je ainsi?

But this special alienation Desnos purposely creates must be distinguished from the tragic distance he unwillingly acknowledges in a poem to be examined later which ends "Qui qui et qui?" or in the pathetic lines from "Si tu savais": "Loin de moi et cependant présente à ton insu . . . / O toi, loin-de-moi à qui je suis soumis . . ." (*DP*, p. 100).

8. See the discussion of closed doors in the next chapter.
9. Parallel with the uncertainty as to the efficacy of his voice is the doubt touching all *écriture*.
10. Like the postcards in Claude Simon's *Histoire*.
11. Another important example of the same process appears in *LA*, pp. 82–85 where the intensified gaze is concentrated on one object, in this case sponges (an object familiar to the readers of surrealist literature, particularly Aragon's *Le Paysan de Paris*, where the barber's sponge serves as the soft form of coral, as the intermediary between the ocean, privileged place of encounter, and the erotic imaginings of the city dweller). The sudden *ritardando* in rhythm is paralleled by the sudden halting of a second boat (this incident reminiscent both of Breton's image of the locomotive suddenly stopped in the forest and of his wish that all machines might be

immobilized by water). Half symbolist and half mocking, the images of the North Pole where the ship is caught in the ice floes and the human pilgrimage ends at a wall of ice are found respectively in Apollinaire's play *Couleur du temps* and Gide's *Le Voyage d'Urien*. The latter, with its extraordinary contradiction of the preceding lyricism, its allusion to the mermaids, to the mirages, and to the "fumées" of the dream, is like Desnos' later references to his own surrealist dreams in the poems of *Contrée*. The *Envoi* begins:

> Madame! je vous ai trompée:
> nous n'avons pas fait ce voyage.
> Nous n'avons pas vu les jardins
> ni les flamants roses des plages;
> ce n'est pas vers nous que les mains
> des sirènes se sont tendues.

(André Gide, *Romans*, Pléiade ed. [Gallimard, 1958], p. 66.)

In this fashion, Desnos' use of this imagery already calls into play a complex series of allusions, and begins to function as one of his idiosyncratic myths. (One could also compare the tone of certain parts of the Gide *sotie* with that of *La Liberté ou l'amour!*)

More significantly, these techniques seem to us characteristic of what we might call a baroque perspective and sensibility, in which there is, for instance, a sudden aggrandizement of the ordinarily small, the construction of a verbal edifice is subsequently knocked down with one rapid blow, and an intense self-awareness is at least partially responsible for the unexpected alterations in tone.

12. One of the more involved linguistic / etymological spoofs is called the "fameuse proclamation . . . *Pater du faux messie*"; the ironic location of this passage in a footnote, as if it were a pedantic and verifiable elaboration, underlines the ambiguous value of verbal play as a basis for—or a footnote to—the prose poetry of *La Liberté ou l'amour!* (*LA*, p. 35n.).

13. Compare, in *Les Nouvelles Hébrides*, the identical theme of corporal punishment as well as the parallel figures of Miss Flowers, Louis Morin and le Capitaine, and the same rhythm characteristic of the passages of processions: "Et à travers Paris c'était une poursuite inconnue du poursuivi sous l'œil des horloges pneumatiquement affoles" (*LA*, p. 178).

14. One of the most revealing ways to read the text and some of the poems of Desnos is in a parallel comparison with *Le Point Cardinal* of Michel Leiris (in *Mots sans mémoire* [Gallimard, 1969]). Since many of the dominant themes, images, and even formulations are similar, the juxtaposition furnishes a valuable *ground* against which to see what is distinctive in the style of Desnos.

Leiris	Desnos
"comme la mer en se retirant abandonne sur le rivage mouillé de vielles algues mi-rongées, des tessons de bouteilles . . ." (p. 30)	"l'amour des algues" (*DP*, p. 117); "Les infinis éternels se brisent en tessons . . ." (*LA*, p. 143)
"la scène métamorphosée en le désert qui précède toute création" (p. 31)	"Dans le désert, perdu, irrémédiablement perdu" (*LA*, p. 100), and passim
"Le nouveau corsaire" and "l'Ingénue" (p. 35); the chase after her (p. 66)	Corsair Sanglot and Louise Lame; their chase
"un gigantesque doigt de plâtre" (p. 34); "Le doigt restait pointé dans son immuable direction" (p. 34)	"Bossuet dresse son index blanc" (*LA*, p. 128); "le doigt indicateur" in drawing here
inscriptions: on "une longue banderole blanche" (p. 37); on Christ's cross (p. 48); the "annonces merveilleuses" (p. 52); the "mystérieux écriteaux" (p. 53); and the "affiches lumineuses" (p. 61); (see pp. 50, 52, 55, 62 for examples)	in *Deuil pour deuil,* the "écriteaux," the billboards (*DPD,* in *LA,* p. 25) and neon signs (Bébé Cadum) in *La Liberté ou l'amour!,* calendar page (p. 29)
the "ténèbres prismatiques" (p. 45)	*Les Ténèbres* (1927), and passim; "à la date voulue tout arrivera en transparence"
"au Nord de glaces et de feu"; "marche vers le Nord" (p. 40); "Le Signal de l'Arctique" (p. 46); "Moi . . . je connais le Pôle, le vrai Pôle Arctique" (p. 51); "le Pôle de sa tête" (p. 49); (see pp. 54–56); "Pôle Nord perdu corps et biens" (p. 59)	Le pôle Nord of *LA,* passim (see long discussion here)

Corps et biens (1930) |
| "Pour se distraire, trois voyageurs qui font le tour du monde se racontent leurs aventures" (p. 46) | the "raconteurs" or adventurers telling tales in the Sperm-Drinkers' Club |
| the galley ship | the galley ship |

"Ces corps étaient couchés autour de moi" (p. 39); the "dormeur remonté à la surface et qui s'en allait lentement, nageant entre deux eaux" (p. 52)

"le corps des naufragés" (*LA*, p. 39); cadavers in the water, passim

"oiseaux migrateurs" (p. 55)

"les chevaux migrateurs" (*LA*, p. 123)

"la voix du dormeur"; "la parole folle d'elle-même," "la voix monstrueuse" (p. 58); "la voix carnassière" (p. 66), "un chaos dont seul pouvait me sortir une voix" (p. 67)

sleeper in *Les Trois Solitaires*, voice of the singer, and the voice of the poet: "La Voix de Robert Desnos" (*LA*, pp. 109–11), "le son de ma voix"; passim

word and letter games (see p. 60, and passim); "je verbe un substantif impérativé" (p. 64)

word and letter games, *P'oasis* and early novels (see *LA*, p. 70); *Langage cuit* (see examples here)

"Chiffre blanchi, qui a noirci le ciel?" (p. 60)

passage on "chiffres blancs" and "ciel noir" discussed here

"la feuille maintenant flétrie" (p. 68)

the "feuilles flétries" passim

L'Eternité (p. 69, conclusion of novel) and passim

"L'Eternité, voilà le théâtre somptueux où la liberté et l'amour se heurtèrent pour ma possession" (*LA*, p. 62)

There are many other similarities; no one of these details alone would be convincing, any more than a proliferation of the terms "merveilleux," "mystérieux," and so on would convince the reader of the "surrealist" atmosphere of any particular work. But the parallels between Leiris and Desnos are multiple, and the convergence of images in these two authors seems to go far beyond the expected, as a complete list of similarities would show.

Poetic Structures

1. See, in *Europe*, May–June 1972, Manuela Girod's "Mécanique métaphysique: Rrose Sélavy 1922–3," where she discusses the anaphonic play of these poems ("le glissement anaphonique") and what she calls the *para-dogme* (for paradigm and dogma). In the same issue, Serge Gaubert's "Desnos et le naufrage," which discusses Desnos' deliberate un-anchoring of words and his perversion of rhetoric, his playing off of the elements of

verbal collage one against the other in order to sink the whole—that is, shipwreck taken as a metaphor for the transgression against the normal verbal code. Finally, René Plantier ("L'Ecriture et la voix," same issue), underlines with enviable skill the techniques of expansion and shrinking, of amplification and laconism in the poems, and represents part of Desnos' aim as that of making ordinary tautologies unbearable: for example, "Quelle angoissante angoisse!" (What anguishing anguish!)

See also Iris Acacia Ibañez, "Apuntaciones estilísticas sobre 'Chantefables et Chantefleurs,' " on such ambiguous repetitions and implied doublings as "œillé . . . œillets" or "fleur d'orage . . . fleur d'oranger," and on the implicit doubt in such expressions as "digitale" (dis-je?) of which she says it indicates "a major and even total doubt." Compare with the other discussion in these pages of the self-destructing discourse. The psychological unease betrayed by and even aggravated by similar expressions is evident.

2. See discussion of the sound [o] in the next section.

3. "Every day he lunches with this family / Every day he drinks the same camomile with them / Every day he eats BOURGEOIS COOKING with them." From the collection of poems Desnos was planning to publish, entitled "Sens." See the Desnos issue of Europe, May–June 1972.

4. A brief résumé of the interconnection of imagery may be welcome: the sea water representing the potential of voyage changes as it is drunk by sailors from the bottles (possible carriers of a mysterious message), into the blood of mermaids—and then the shards of broken bottles, glistening like diamonds, mirror in one poem the discarded "tessons" on the beach in another, before the latter are denied altogether. The blood left on the hands by these broken bottles is at once a proof that the bottle existed, and the exterior sign of the tide of our blood pulsating ("flux de notre sang battant") at the rise of the ocean.

5. The image works in two senses: a) "pomme" as apple indicates the attraction or temptation doubled by clarity, while b) "pomme" as the short form of "pomme de pin" (the name of a Dada publication edited by Picabia) indicates a knob in the shape of a pine-cone used often on four-poster beds, the association of bed and stair perfectly fitting the multiple transformations of images under discussion here.

6. Compare also the following lines from La Liberté ou l'amour!:

> "Le nouveau corsaire vêtu d'un smoking est à l'avant de son yacht rapide qui, de son sillage blanc singeant les princesses des cours périmées, heurte dans sa course tantôt le corps des naufragés errant depuis des semaines . . . tantôt le troublante arête-squelette d'une sirène défunte pour avoir, une nuit, traversé sans son diadème de méduses les eaux d'une tempête éclairées par un phare puissant perdu loin des côtes et proie des oiseaux fantômes."

7. The same feeling is manifest in this line from "Paroles des rochers": "Une étoffe claque sur la campagne tragique" (*DP*, p. 142) (A piece of cloth clacks over the tragic countryside).

8. *Les Trois Solitaires: œuvres posthumes, nouvelles et poèmes inédits de Robert Desnos* (Les Treize Epis, 1947), s.p.

9. Compare, in "Jamais d'autre que toi," the poet's lament: "Et moi seul seul seul..." (And I alone alone alone...).

10. Compare, in chapters 1 and 2, the allusions to "maints éventails flétris" (many withered fans) and the other images of aging and downfall, to the icy prison as an end to the voyage. The ubiquitous references to the shards of glass from broken bottles are closely tied to this set of images. The poem of 1930 called "A l'aube / At Dawn" begins with a representative passage:

> Le matin s'écroule comme une pile d'assiettes
> En milliers de tessons de porcelaine et d'heures
>
> (*DA*, 70 and 151)
>
> (The morning crumbles like a pile of dishes
> In thousands of shards of china and of hours)

11. In her interesting study of some of Desnos' stylistic procedures already referred to (*Apuntaciones estilísticas sobre "Chantefables et Chantefleurs"*), Iris Acacia Ibañez discusses at length the static emphasis of his poetry, and its abstract quality. Among the points she makes are the following: that Desnos uses most frequently the abstract singular form ("J'ai cueilli la rose" [I plucked the rose]), in a technique less objective than psychological. ("La rosa se idealiza, se hace símbolo, busca la singularidad de la abstracción por intensificación interna, esenciál" [The rose becomes ideal, a symbol, seeking the singularity of abstraction by an internal and essential intensification.]) All the surrounding elements are softened—imprecise adjectives, few verbs and those descriptive rather than narrative—in order to bring about "un ensimismamiento intenso" (an intense in-itselfness), an intensification at once immobile and idealizing, of an evocative monotony resembling in its extraordinary fixity a magic conjuration. Reflexive verbs are preferred for their purely atmospheric action, for their inevitable return to the subject; tenses are confused (see "Les Espaces du sommeil" and "Dans bien longtemps"), so that time is effectively suppressed; images and terms are chosen for their possible prolongations or their atemporality. A frequent ternary balance aggravates the motionless character rhythm.

Often, according to Miss Ibañez, Desnos brings about a "retroceso hasta el punto de partida, lo cual demuestra que efectivamente no hay aquí intención progresiva, que la contemplación es interiór, y por eso mismo estática..." (retrogression to the starting point, which shows that in effect there is no intention of progress here, that the contemplation is

interior and static for that very reason ...). The strong vocative sense of the poems is analyzed here, as is the way in which the adjective intensifies the noun, again impeding motion: for instance, "rose rose." (Compare Max Jacob's poem "Cimetière," in which the rosy rose is played against the white rose: "Rose blanche et rose rouge . . .")

12. See also the drawings by Desnos among the unpublished documents, where the swan figure is apparent in different guises. And compare Mallarmé's famous symbolist sonnet of the swan stuck in ice, "Le Vierge, le vivace et le bel aujourd'hui" with Desnos' spoof in *L'Aumonyme:* "Aux lacs des lacs / Meurent les paons / Enlisés dans la gomme laque." (*DP*, p. 66) (In the lakes of lakes / Die the peacocks / Stuck in shellac.)

The Continuity of the Surrealist Adventure

1. "L'absence de l'eau gêne certainement le transfuge des mythologies . . ." (*LA*, p. 80). (The absence of water definitely impedes the transformations of mythologies. . . .) For the importance of water as a ground for surrealist metamorphosis, see my *Surrealism and the Literary Imagination: A Study of Gaston Bachelard and André Breton* (The Hague: Mouton, 1966).

2. See the drawing called "Le Poisson rencontre les croisés," among the unpublished documents accompanying this essay.

3. Compare the ending of "Que voulez-vous que je vous dise?": "qu'on me donne à boire durant toute la mort / qu'on me fiche la guerre." (*C'est les bottes de sept lieues.*)

4. These changes (marked by between the printed lines which he wanted run into each other) are found in copy no. 28 of this poem, located in the Department of Drawing and Prints of the Museum of Modern Art, New York. Only a few of the corrections are made in Jean-Louis Bédouin's anthology of *La Poésie surréaliste* (Seghers, 1964); The *Poètes d'aujourd'hui* edition of Desnos (Seghers, 1965) makes none.

5. Arthur Petronio asserts in "Robert Desnos et le complexe du sang," *Signes du temps,* no. 5, 1951, that all the references to blood, to executioners and to "tessons" reflect the tragic interior of the poet. There seems to be little reason to disagree.

6. The handwriting changes from upright to slanting, from closely spaced to cramped, with several new beginnings plainly marked: the central part of the poem, for instance, in which two pages of different handwritings converge as illustrated here, is numbered 1, 2, 3, and then 68, 69, 70, before its final placing as 11, 12, 13. The writing paper is as diverse as the handwritings, including grey, blue-green, light blue, pink, and yellowed oncewhite paper, and either bears the headings of *La Hune* or *Paris-Matinal,* or is unmarked; all these are interspersed, most probably showing the collage-type composition of the famous poem.

7. Again the imagery of Mallarmé: "flétri," "fané," "usé," abîmé," all in *The Night of Loveless Nights.*
8. [Jehan Sylvius et Pierre de Ruynes], *La Papesse du diable* (Losfeld, 1966).
9. By way of example see, in the 1962 Gallimard edition of *La Liberté ou l'amour!* (first published in 1927), pp. 49, 66, 79, 88, 100–101, 113–14; in *Deuil pour deuil,* which follows *La Liberté ou l'amour!* in the 1962 edition, p. 121. For the image of the starfish, see *Deuil pour deuil,* p. 136.
10. See also *Deuil pour deuil,* in *LA,* p. 158:

> C'est le sommeil et son bruyant cortège de chevaux bigarrés.
>
> . . .
>
> C'est le sommeil, c'est le sommeil et son bruyant équipage de lionnes rousses et d'automobiles.
> C'est le sommeil.
>
> (It is sleep with its noisy procession of variegated horses.
>
> . . .
>
> It is sleep, sleep with its noisy pack of red-maned lionesses and automobiles.
> It is sleep.)

And in *La Liberté ou l'amour!,* p. 36:

> La rencontre eut lieu dans une plaine désertique.
>
> . . .
>
> La rencontre eut lieu . . .

Conclusion and Question

1. Quoted in the second part of the "Biographie de Robert Desnos" (*Litterair Paspoort,* Tweede Jaarg. no. 7 [January 1947], see Introduction), called simply "Les Dernières Années."

Bibliography

Works by Desnos
Except where indicated, the place of publication is Paris.

Deuil pour deuil. Kra, 1924.
C'est les bottes de sept lieues cette phrase 'Je me vois'. Galerie Simon, 1926.
La Liberté ou l'amour! Kra, 1927.
Corps et biens. N.R.F., 1930 (contains most of the poems from 1919 to 1929).
The Night of Loveless Nights. Anvers: Privately printed, 1930.
Les Sans cou. Privately printed, 1934.
Fortunes. Gallimard, 1942 (contains poems written after 1929).
Le Vin est tiré. Gallimard, 1943.
Etat de veille. Gallimard, 1947.
Le Bain avec Andromède. Flore, 1944.
Contrée. Robert Godet, 1944 (reprinted with *Calixto,* Gallimard, 1962).
Trente chante-fables pour les enfants sages. Librairie Grund, 1944.
Felix Labisse. Sequana, Les peintres d'imagination, 1945.
La Place de l'étoile (antipoème). Rodez, collection "Humour," 1945 (written in 1927).
Choix de poemes. Ed. Minuit, 1946.
Nouvelles inédites. Rue de la Gaité. Voyage en Bourgogne. Précis de cuisine pour les jours heureux. Les Treize Epis, 1947.
Les Trois Solitaires. Longtemps après hier. Poèmes pour Marie. A la Hollande. Mon tombeau. Les Treize Epis, 1947.

Oeuvres posthumes. Les Treize Epis, 1947.

Chantefables et chantefleurs. Grund, 1952.

De l'érotisme considéré dans ses manifestations écrites et du point de vue de l'esprit moderne. Cercle des Arts, 1953.

[Jehan Sylvius et Pierre de Ruynes.] *La Papesse du diable.* Eric Losfeld, 1966.

Domaine public. Gallimard, 1953 (includes *The Night of Loveless Nights* and *Corps et biens* of 1930 and *Fortunes* of 1942, with a selection of other writings).

Mines de rien. Broder, 1960.

Calixto, suivi de Contrée. Gallimard, 1962.

La Liberté ou l'amour! Reprint, with *Deuil pour deuil.* Gallimard, 1962.

Cinéma, ed. André Tchernia. Gallimard, 1966.

Corps et biens. Gallimard, collection "Poésie," 1968.

Fortunes. Gallimard, collection "Poésie," 1969.

Destinée arbitraire, ed. M.-C. Dumas. Gallimard, collection "Poésie," 1975 (includes a selection of previously published texts and several texts published for the first time: in particular, *Peine perdue* and *Bagatelles,* as well as a group of resistance poems under the title *Ce coeur qui haïssait la guerre*).

See also such journals and pamphlets as *Documents, Les Feuilles libres, Littérature,* and *La Révolution surréaliste,* as well as the newspapers mentioned here to which Desnos was a regular contributor.

Brief Selection of Works on Desnos

Books and prefaces

Berger, Pierre. *Robert Desnos.* Poètes d'aujourd'hui. Seghers, 1949.

Bertelé, René. Prefaces to *Domaine public* and to *Corps et biens.*

Buchole, Rosa. *L'Evolution poétique de Robert Desnos.* Brussels: Palais des Académies, 1956.

Carpentier, Alejo. *Tientos y diferéncias.* Montevideo, 1967 (with two so-called "inéditos" on Lautréamont and on the political situation in Cuba previously published in the one issue of the journal *Iman,* 1931).

Caws, Mary Ann. *The Poetry of Dada and Surrealism: Aragon, Breton, Tzara, Eluard, Desnos.* Princeton: Princeton University Press, 1970; reprinted in 1971.

Desnos, Youki. *Les Confidences de Youki.* Fayard, 1957.

Ibañez, Iris Acacia. *Apuntaciones estilísticas sobre "Chantefables et Chantefleurs."* La Plata: Centro de Estudios de Estilística Literária, 1964.

Matthews, J. H. *Surrealist Poetry in France.* Syracuse University Press, 1969.

———. *Surrealism and the Novel.* University of Michigan Press, 1966.

Articles

Mary Ann Caws. "Techniques of Alienation in the Early Novels of Robert Desnos." *Modern Language Quarterly,* vol. 28, no. 4 (December 1967), pp. 473–77.

———. "Robert Desnos and the Flasks of Night." *Yale French Studies,* Intoxication issue, 1974, pp. 108–19.

Marie-Claire Dumas. "Un scénario de Robert Desnos." *Etudes cinématographiques,* nos. 38–39, 1965. (Issues devoted to *Surréalisme et cinéma.*)

Tatiana Greene. "Le Merveilleux surréaliste de Robert Desnos." *French Review,* November 1966.

Margit Rowell. "Magnetic Fields: The Poetics." *Joan Miró,* Guggenheim Museum (catalogue), 1972 (especially pp. 55–60, on Desnos).

Jean Tortel. "Robert Desnos aujourd'hui." *Critique,* August–September 1965.

Théodore Fraenkel and Samy Simon. "Biographie de Robert Desnos." *Litterair Paspoort,* Tweede Jaarg., no. 7 (January 1947).

See also the issues of *Signes du temps,* no. 5, 1951, and *Simoun,* nos. 22–23, 1956, Oran, both devoted to Desnos.

Europe 50, nos. 517–18 (May, June 1972), has previously unpublished material and a wide range of articles concerning Desnos.

Le Siècle éclaté: dada, surréalisme et avant-gardes. Minard, Lettres Modernes, no. 1, articles by Marie-Claire Dumas, Sydney Lévy, Mary Ann Caws on Desnos; no. 2, by Barbara Ann Kwant.

Index

Index of concepts and names. N.B. Personages such as Bébé Cadum, Corsaire Sanglot, Isabelle la Vague, Louise Lame, Bibendum Michelin, and Nadja are assumed but not included, while le Cristi, Rrose Sélavy, and Zeus are indexed. The reader may draw his own conclusion as to the (fictive) assumptions of the listing.

Library of Congress Cataloging in Publication Data

Caws, Mary Ann, 1933–

The surrealist voice of Robert Desnos.

Bibliography: p.

Includes index.

1. Desnos, Robert, 1900–1945—Criticism and interpre-
tation. I. Title.

PQ2607.E75Z6 841'.9'12 76–25145

ISBN 0–87023–223–1